020 BRISTOL SUGAR CUBE 024 ESHE
OUSE 028 ATTWOOD HOUSE 034 CH
AM WATER TOWER 044 ... SU
048 CLAPHAM COACH HOUSE 050 L
Y FARMHOUSE 054 HUNSETT MILL 05
62 CHISWICK GARDEN HOUSE 070 H
THE STRAW HOUSE 078 CRUCK-FRA
LT HEXAGON HOUSE 084 THE GROU
UNGALOW 092 THE WOODEN BOX 0
TIMBER ECO HOUSES 102 LIME KILN
SMALL HOUSE 110 CLONAKILTY CLIF
NORDIC LONGHOUSE 116 ARCHITE
ASSERTIVE SUBURBAN HOME 124 UN
AN 130 DUCKETT HOUSE 134 DRUMI
VIOLIN FACTORY 144 HILL HOUSE 1
56 FUTURISTIC BUNGALOW 158 INDE
CASTER HOUSE 164 SURREY THRESI
S 174 THE CROSSWAY HOUSE 180 TU
RE 186 THE CHESTERFIELD WATERWO
ARN 190 BRAINTREE BARN 196 HELL
RINCELET STREET 204 BLETCHLEY M
EK 214 KILGALLAN CONVERTED CHA
WOLDS STEALTH HOUSE 224 BAVENT
AU SUN HOUSE 232 GAP HOUSE 234
USE 246 SUFFOLK SLIDING HOUSE
FOR EVERYBODY 258 SLICE HOUSE

KT-383-264

THE
BEST OF
GRAND
DESIGNS

Kevin McCloud

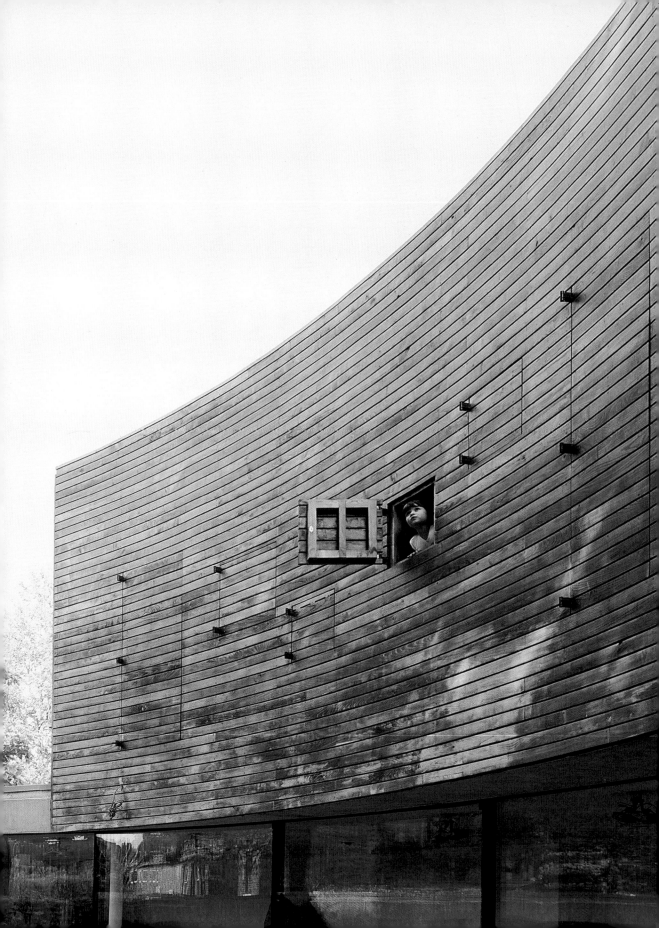

THE
BEST OF
GRAND
DESIGNS

Celebrating Innovative Houses
from Architecture's Iconic TV Series,
Magazine and Awards Programme

Kevin McCloud

First published in 2012 by Collins
An imprint of HarperCollins*Publishers*
77–85 Fulham Palace Road,
Hammersmith, London W6 8JB

www.harpercollins.co.uk

1 3 5 7 9 10 8 6 4 2

A catalogue record of this book is available from the British Library

ISBN: 978-0-00-748562-8

Publishing Director – Iain MacGregor
Senior Project Editor – Georgina Atsiaris
Designer – Lucy Sykes-Thompson
Copyeditor – Katy Denny
Picture Research – Francesca Eames and Chloe Slattery

Colour reproduction by FMG. Printed and bound in Spain by Graficas Estella.

This book is dedicated to all those self-builders
who have the gumption to risk all and commission
adventurous buildings from their architects. For your
passion, your determination and your self-belief,
I salute you.

CONTENTS

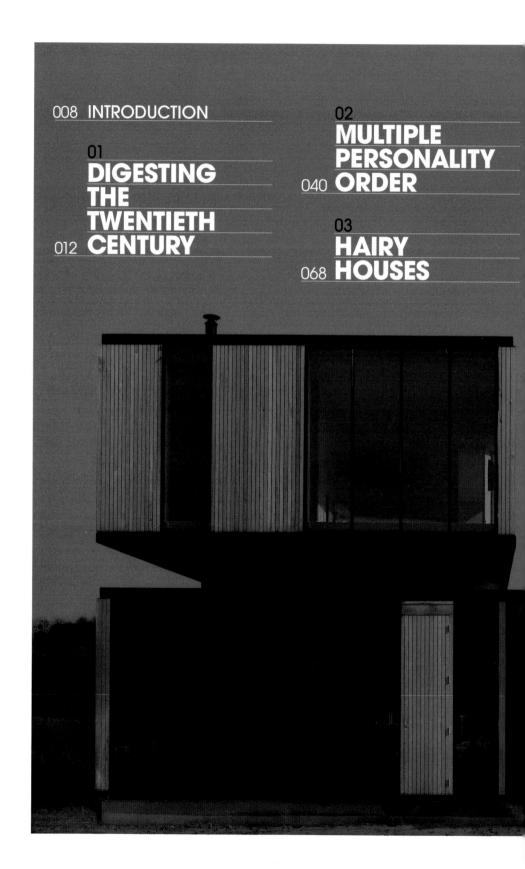

008 INTRODUCTION

01
012 DIGESTING THE TWENTIETH CENTURY

02
040 MULTIPLE PERSONALITY ORDER

03
068 HAIRY HOUSES

04
**THE
SMOOTH
AND
090 POLISHED**

05
**COSY
112 HOMES**

06
**SPACE
138 SHIPS**

07
**GADGET
154 BOXES**

08
**WRECKS
AND
THEIR
186 FLOTSAM**

09
**DISAPPEARING
216 ACTS**

10
**PERFORMANCE
244 ARTISTS**

262 INDEX

268 FULL PROJECTS LIST

270 PICTURE CREDITS

272 ACKNOWLEDGEMENTS

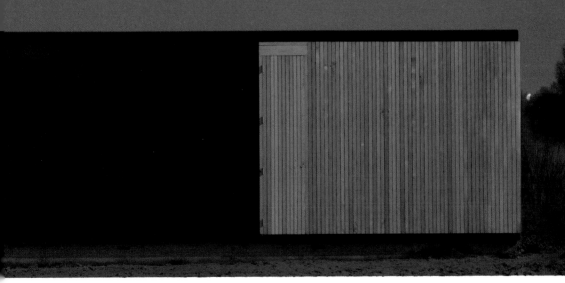

INTRODUCTION

'**Buildings, if they are to succeed, must be able to receive a great deal of human energy and store it and even repay it with interest.**'
Charles Moore

Le Corbusier said we all need light, space and order just as we need to eat. He forgot to add white emulsion and bifold doors to his list but otherwise was pretty spot-on in identifying the core architectural attractants for modern man and woman. Philip Johnson, the American architect of skyscrapers, said that 'All architecture is shelter, all great architecture is the design of space that contains, cuddles, exalts, or stimulates the persons in that space.' Architects have wrestled with these ideas for centuries and each generation has sought to express these ideas in a language that responds to a place and a time. *Grand Designs* has been broadcasting in Britain for 14 years as I write – a mere historical blink of an eye – but it has charted a change in architectural tastes and ideas over the threshold of a new millennium. I've seen architects come up with lots of ways to define the word 'cuddle', some of them involving concrete. I've certainly visited plenty of exalting homes.

This book, like the television series, celebrates the very best of domestic design. It captures some of the change in the way we view our homes in the early 21st century. It brings together the best of the series and many of the homes that have won Grand Designs Awards. The awards were started in 2003 and have been described as 'the Oscars of British domestic architecture' so it seems fitting to include some of the most luminary projects alongside the better-known broadcast houses. There are several national awards given to homes, not least the Manser Medal awarded by the RIBA, but this volume draws its inspiration from tight within the *Grand Designs* fold, because the approach of the series, at its core, is about the relationship between a building and the people who built and live in it.

So is it possible, among all these projects, to identify the Big Changes of the last

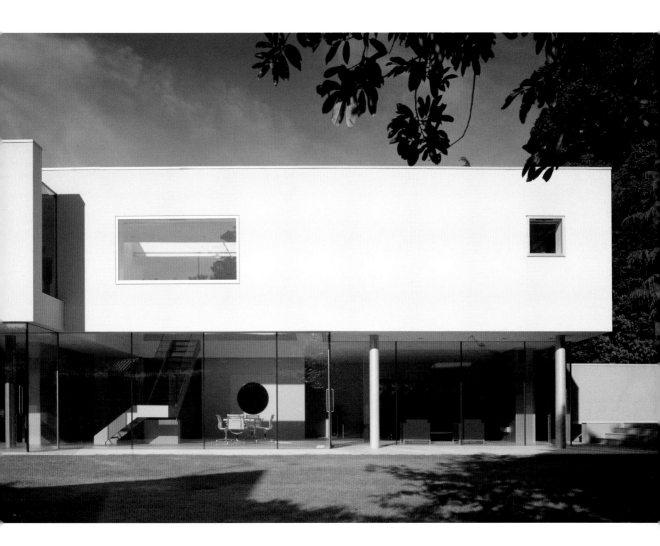

Above **Space, light and white emulsion are as much in demand as ever on such a small European island stuck in the Atlantic with the highest incidence of low cloud in the Northern Hemisphere.** (Esher Modernist Villa, page 24)

fifteen years or so? Oh yes. It is with the benefit of hindsight and distance. Some of the changes in the built environment have been slow and accretive. We saw the Commission for Architecture and the Built Environment (CABE), the child of Blair's labour government, grow into (generally) a force for good. Planning law acquired yet more detailed legislation and grew into the beast with a thousand tentacles – or pages. The law eponymously introduced by environment minister John Gummer in the 1990s (and that resulted in wealthy landowners building questionable faux-Georgian piles in open countryside) was

amended into a greener Planning Policy Statement 7 and has now spawned a clutch of sustainable one-off exemplar buildings that are amply supplying *Grand Designs* with interesting projects.

Architectural taste has also slowly moved in the last decade or two: from white modernist boxes to grey modernist boxes; from riven oak cladding to cedar shingle cladding; from picture windows to those bifold doors. Space, light and white emulsion are as much in demand as ever on such a small European island stuck in the Atlantic with the highest incidence of low cloud in the Northern Hemisphere.

There has also been fast change: the rapid decline of CABE and the pulling of the last of its few teeth by the coalition government; rapidly introduced legislation around housing; the National Planning Policy Framework which in 2012 swept away 65 years of planning policy; the Green Deal for home refurbishment; the Localism Bill and a national drive to promote self-build. When *Grand Designs* started few people built their home and an infinitesimal number employed an architect. Now it is seen as normal, if still adventurous.

And there has been change which has crept up on us and bitten us on the ankle. Context and contextual design have become mainstream obsessions of the best young practices. Sustainability, once a word nobody understood, can now be used with discretion in our programmes before the nine o'clock watershed. The green agenda, where once it was the subject of a specialist eco-build, nowadays runs through almost every project we cover, I'm pleased to say.

Meanwhile the spoken language of architecture itself has changed. Once architects began seeing themselves on television, many realised they should ditch the archispeak and enrol in a course in How to Speak Client. The result reflects a big change in the way the profession now models itself as a service industry that wants to understand its clients.

Below **The green agenda used to be the subject of specialist eco-builds, but nowadays is a feature of almost every project we cover.** (The Straw House, page 72)

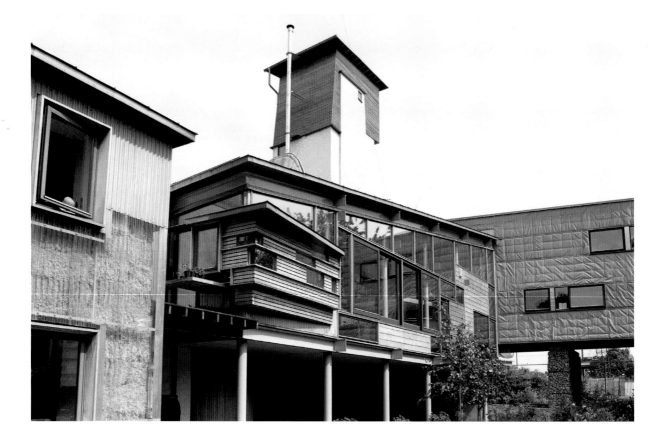

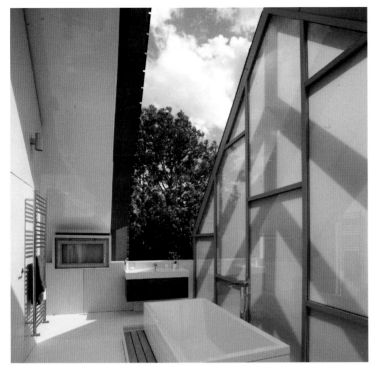

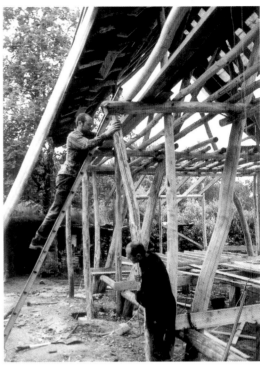

Above **A place on the margins of the mainstream where people risk all to experiment with technology, architecture and their own lifestyle, all for our entertainment and awe.** (Suffolk Sliding House, page 246)
Above right **We have also promoted craftsmanship in a big way.** (Cruck-Framed Woodland House, page 78)

Consequently I didn't want to mark any stylistic or developmental ideas in this book with the usual, arcane, archispeak tags. Terms like 'Contextual Modernism' or 'Concrete Regionalism' are already familiar shorthand for architectural journalists but need detailed explanation in long articles only to be picked to pieces in further long articles. In conversation with my favourite architectural journalist, Isabel Allen, co-author of this volume and ex-editor of *Architects' Journal* (and now my colleague in my housing business, Hab), we dreamed up new, more accessible chapter headings for this book that reflect, if anything, a more anthropological classification of buildings – headings that describe and reflect the motives of the people who built the buildings: their owners.

Some things haven't changed at all. Mediocre buildings still look mediocre. Misled individuals still massacre old buildings with heavy-handed alterations in the name of 'restoration'. People with more money than braincells still build Toblerone houses on private gated estates that are distinguished by their labyrinthine arrangements of interpenetrating red tiled roofs piled one on top of another. That isn't architecture, it's just triangles and lots of maths.

But *Grand Designs* has shown, repeatedly, another way. A place on the margins of the mainstream where people risk all to experiment with technology, architecture and their own lifestyle, all for our entertainment and awe. We showcased eco lifestyles based only upon coppiced wood and dog lick. We have also promoted craftsmanship in a big way. We have held a mirror up to the world of building and home-making and have gently enquired what those ideas mean; we have reflected a taste of the times, and, in a modest way, influenced the taste and ideas of the times. Not many television programmes have been able to do that.

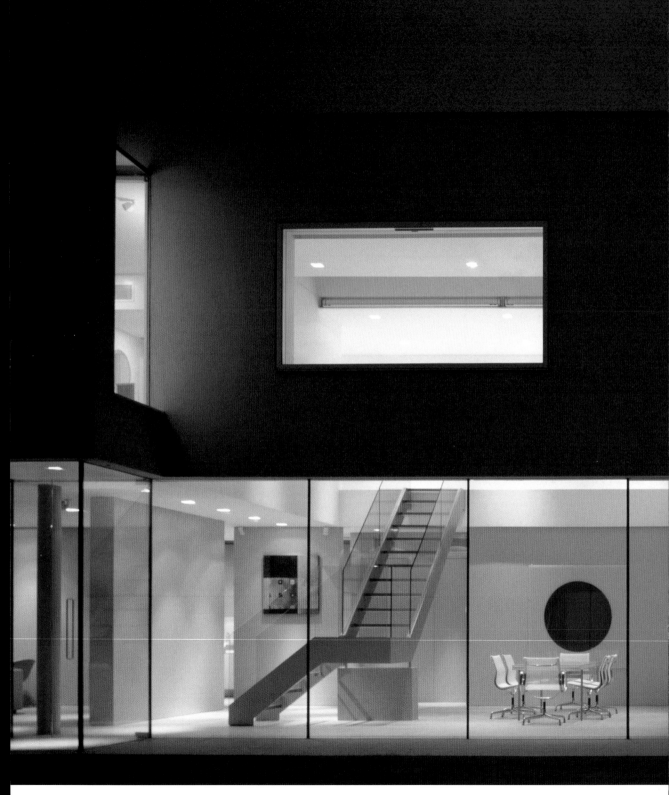

01
DIGESTING THE TWENTIETH CENTURY

It's inevitable that we take the first few years of every century, let alone a new millennium, to absorb fully the nutrients of the best of the previous hundred years. This is a vintage gourmet menu that reworks twentieth-century Modernism with a sauce of panache that is fresh enough to appease even the most jaded palate.

WATSON HOUSE

▼

With a few honourable exceptions, the key to a really great one-off house is the quality of the dialogue between architect and client. It's all too easy for architect to be reduced to technician, wholly subservient to the client's designs, or for the client to become sidelined by the architect's agenda or tastes.

John Pardey is one of a handful of architects who tends to get the balance right, designing homes that reflect their owners' aspirations and sense of style, whilst clearly belonging to his own highly respected on-going body of work. Which could explain why he appears not once, but three times, in this book as the architect for Attwood House, which appears later on in this section, and the cosy Duckett House featured on pages 130–32 as well as Watson House in the New Forest shown here.

Charles and Fiona Watson approached John Pardey partly because he lives, works, and builds most of his houses in the New Forest, and partly because they liked his particular brand of poetic, site-sensitive Scandinavian Modernism. The brief was to design a holiday home that would offer an antidote to urban life; an unobtrusive house with a strong connection to the outdoors and plenty of space for the family to gather together.

The result is an elegant pavilion constructed – at breakneck speed – from prefabricated cross-laminated timber panels clad in sweet chestnut strips. Floors and most walls have been left exposed

Left **The open-plan kitchen/dining/living space has sliding glass doors onto an external timber deck.**
Right **The house was conceived as a simple pavilion that sits lightly on its site.**

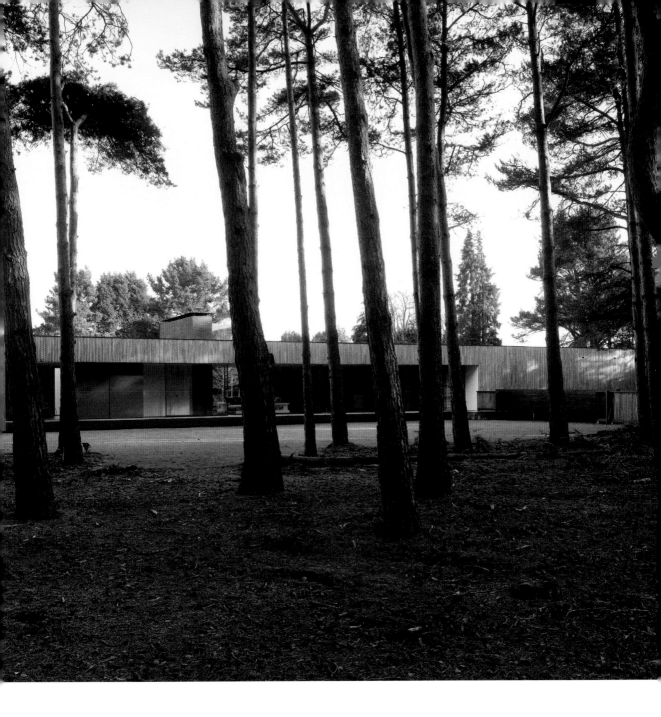

giving the feel of a log cabin and a subtle woody scent. Floor-to-ceiling sliding glass doors wrap round the living space creating a direct relationship between the house and its forest site. In a classic John Pardey move, a central chimney rises above the roofline and anchors the house to its site: a visual celebration of the importance of hearth and home.

The working relationship was not without its tensions. The architect tried to resist the request for a basement cinema on the grounds that it undermined the idea of a house that sits lightly on its site. But the house doesn't look like a compromise. It is gentle, confident, simple and strong – a happy manifestation of the empathy between architect and client.

WELCH HOUSE

▼

One of the most intriguing things about *Grand Designs* projects is identifying the way in which aspects of the owners' experience and interests weave their way into the design, imbuing the clearest of concepts with a secret code of nuances, clues and references. If you look carefully you can often find secret portraits of the personalities that brought the project into being.

Sometimes, this is a deliberate process – a conscious move to produce a building that is a reflection of the self. At the Welch House, on the Isle of Wight, owned by sail-maker John Welch and his family and designed by architect Jonathan Manser of the Manser Practice, the nautical references seem to have seeped in by osmosis. The gang-plank leading to the front door is a practical solution to the challenge of accessing a house built into a steeply sloping site. The porthole is... just a porthole. Easy to do once you've decided to reduce costs by using opening panels and rooflights for ventilation and having fixed glazing elsewhere. The deck-like top floor balcony is the result

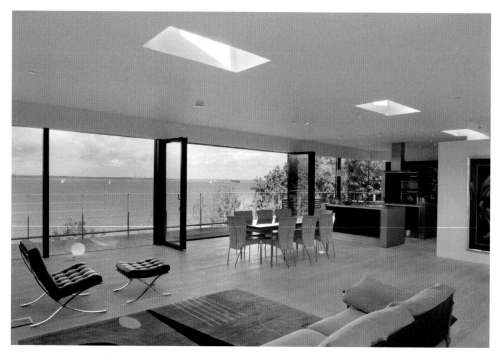

Left **The top floor living space takes full advantage of the spectacular sea view.** Right **Slick, glossy and inscrutable, the Welch House has a dash of cosmopolitan jet-set chic.**

Grand Designs Award | 2009 | Isle of Wight | Architect **Jonathan Manser**

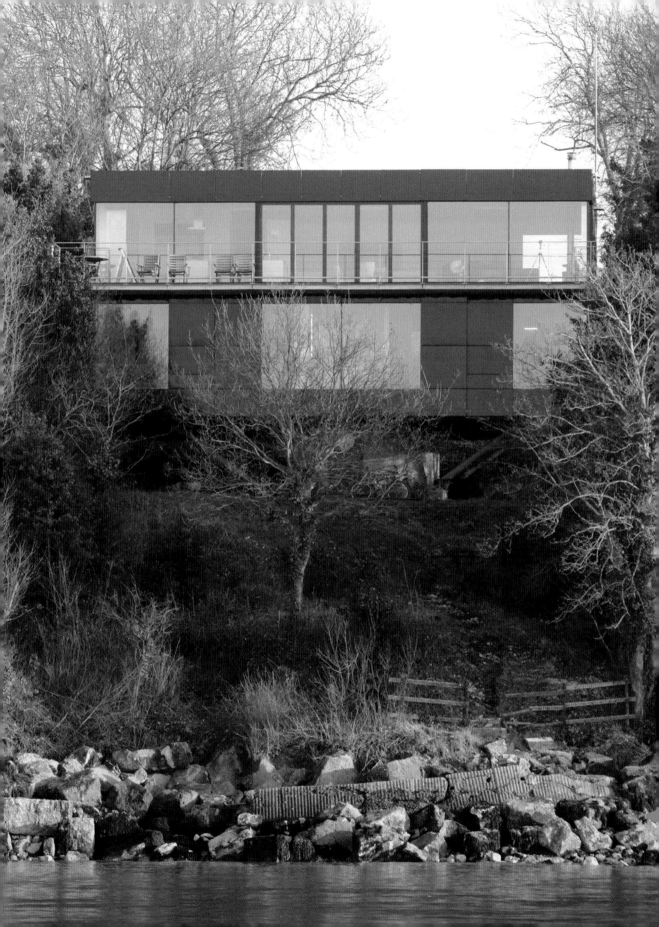

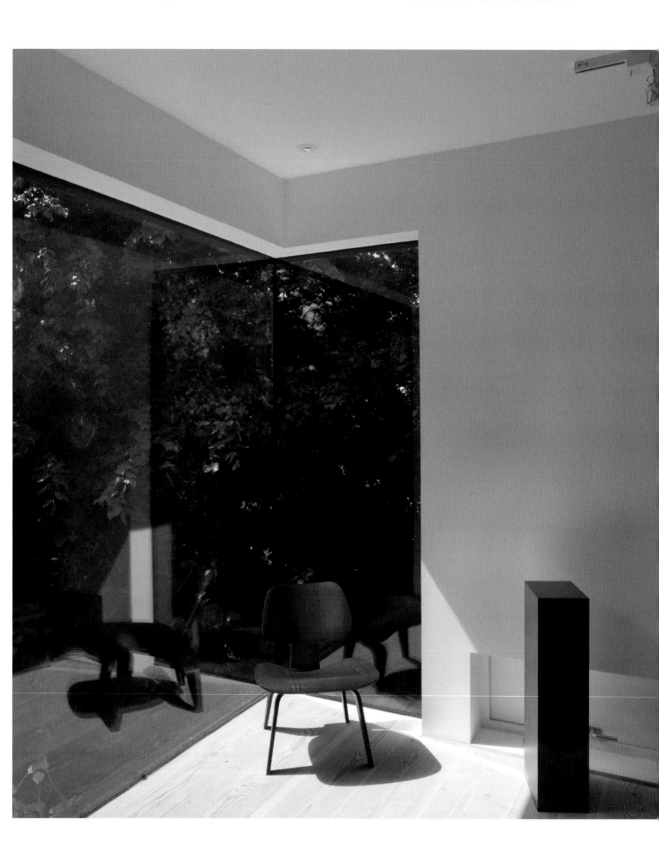

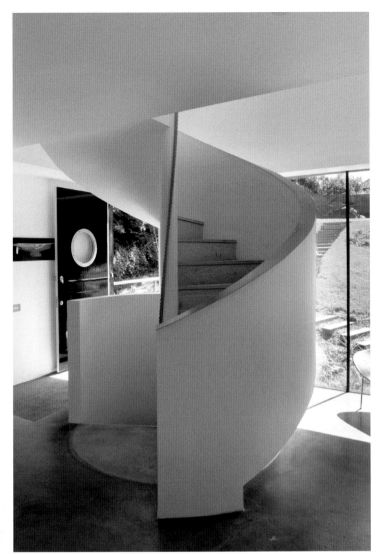

Far left **Glazed corner windows, made from fixed double-glazing, afford woodland views** Left **The spiral staircase contrasts with the sharp lines of the house.** Above **The black lacquer façade blends in beautifully with the surrounding trees.**

of the perfectly logical decision to put the living space on the top floor and take full advantage of the spectacular sea view.

And the arresting black lacquer façade? Well that would be concrete cladding spray-painted with high performance marine paint. Its rich dark hue responds to the desire for the house to blend in with the surrounding trees when viewed from land or sea. And the fact that it's designed to withstand stints at sea makes it a dead cert for withstanding the unforgiving environment of the site.

A series of apparently expedient decisions have stacked up to create a house that is a far cry from the quaint whitewashed cosiness – or the bright-white Art Deco bling – associated with British seaside architecture. In fact, it doesn't really look British at all. For all its modesty and pragmatism, there is a distinct dash of cosmopolitan jet-set chic. Slick, glossy and inscrutable, it has nothing to do with bucket-and-spade homeliness and everything to do with the glamour – and the mystery – of the ocean.

BRISTOL
SUGAR CUBE

▼

Martin and Katherine Pease's super-smooth Bristol home falls into that category of simple white-walled Modernist houses that sparkle with lots of glass. Boxes. Sugar cubes. Indeed Martin, an architect, was perhaps too easily drawn into the challenge of producing another, even more rarified, example of the genre.

And rarified it is – although there are some welcome inventive touches like the jettied first floor overhang at the rear that sneaks in a little more room for bedrooms whilst comfortably allowing cars to pass the ground floor of the building.

The core tension that results from White Box Syndrome hovers between the excoriating rigour of a home that's minimal and white both outside and in – an almost colour-free place that suggests no-one lives here let alone a family with dogs – and the architectural purity of the idea. You can admire something built to such a demanding regime. But can you live in something so perfect?

Well, I think you can. There's nothing wrong with a building setting the tone or even dictating how you might live in it. Most of us live in pre-war homes quite unsuited to modern lifestyle. I've chosen to live in a 500-year-old house that imposes all kind of privations and stresses but it's a building that I adore for its ancient character and its architecture too. So what's wrong with subjugating your natural instincts to be dirty and messy to a house that sets up an uncompromising demand to be clean and tidy?

Left **Martin and Katherine Pease prove that it's possible to combine minimalist perfection and pets.** Right **White-walled Modernism offers a clean-lined contrast to its more conventional brick-built neighbours.**

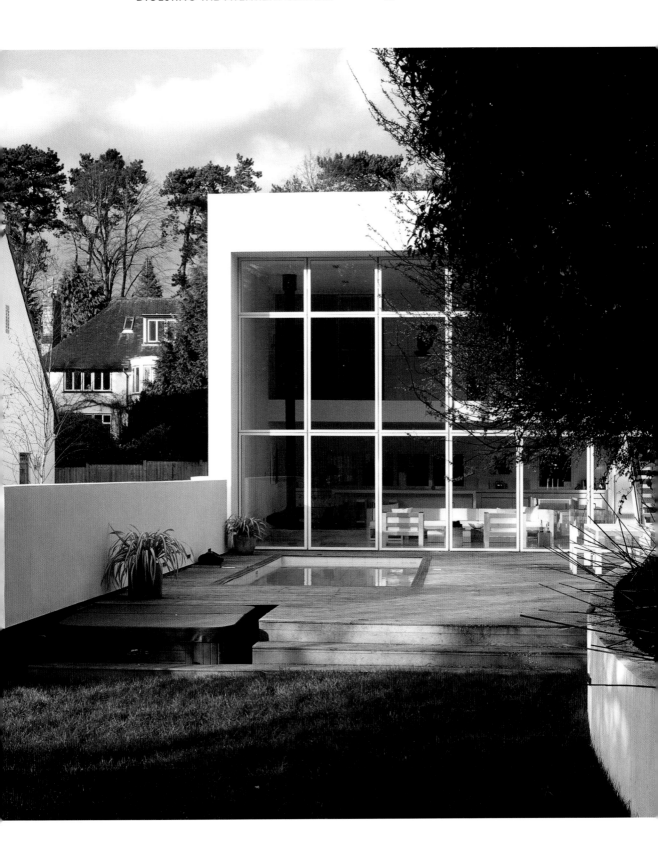

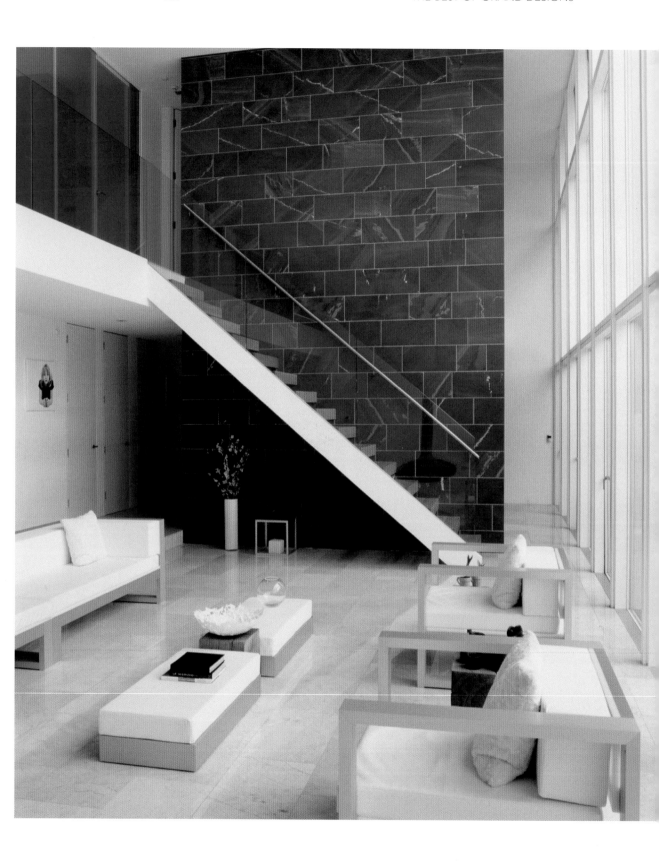

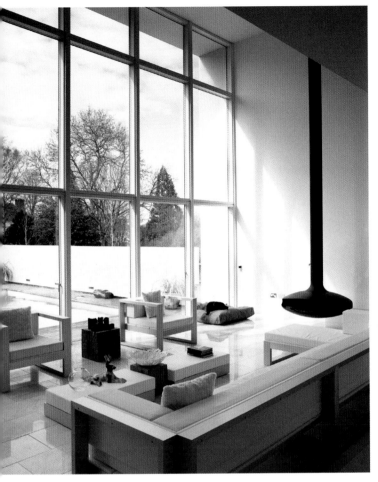

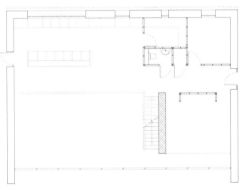

Left and above
The main living area, complete with glass balustrade (left) and suspended fireplace (above), bears the high-gloss glamour of the commercial world, whilst the Cumbrian slate wall (left) provides a dash of texture and warmth.

I made great play in the television programme about Martin's roots in commercial architecture and whether this house would end up feeling like an office or – more likely – the foyer to an advertising agency. There were certainly moments that reminded me of high-class business premises but I suspect that's because Martin was able to bring to this building the high-gloss finish of the commercial world. This is a house that fairly bludgeons you into submission with its glamour. High-gloss, high-class, yes. A sort of white shiny pvc-clad dominatrix of a house. Uncompromising, expensive and very seductive.

Bedrooms and bathrooms are stacked above the kitchen, TV room and office leaving the living room as a full-height space. The first floor bedrooms have opaque glass walls. With a flick of a switch the glass turns transparent giving views over the living room and to the garden beyond.

ESHER MODERNIST VILLA

▼

It might look impossibly exotic in the well-heeled suburb of Esher in Surrey, but this house by Wilkinson King Architects is pretty straightforward when judged against the manifesto for housing design championed by the great Modernist architect Le Corbusier.

In his quest to design the perfect *machine à habiter* – machine for living in – Le Corbusier set out five core design principles, perhaps best expressed in his design for Villa Savoye at Poissy, on the outskirts of Paris, which was built between 1929 and 1931.

First, he argued that the bulk of the structure should be supported by *pilotis* – slender stilts – freeing up the ground below. The Esher house follows this edict, with a 'floating' first floor raised above a transparent ground floor that melts into its surroundings, giving the impression that the landscape flows under the house.

The second principle was that façades should be 'free', meaning that they should be independent of the structure holding up the building, and simply a means of providing enclosure and window space where desired. At Esher, the façade is an abstract composition of solid and void, designed to frame the best possible views of the grounds whilst ensuring that neighbouring properties are not overlooked. Living space on the ground

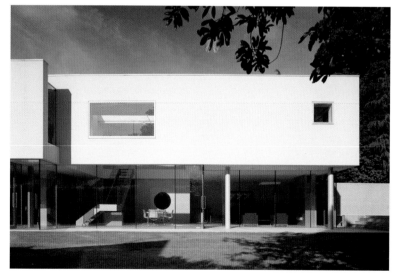

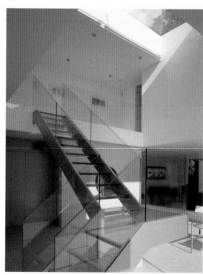

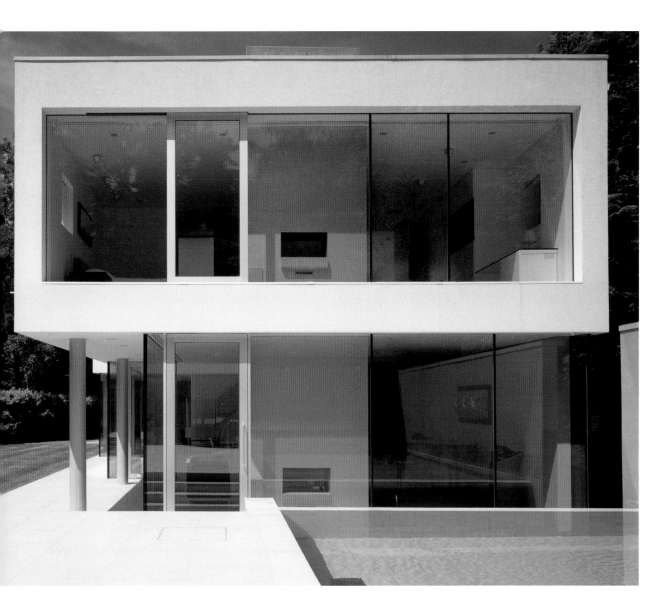

Above **A 'floating' first floor is raised above a transparent ground floor on slender stilts.**
Far left **The first floor façade is an abstract composition of solid and void.**
Left **The glass staircase adds to the sense of openness and light.**

floor is both open and fluid, in accordance with the third rule: that internal walls should not be structural and hence should not limit the potential for open-plan space. Fourthly, he advocated the use of long horizontal windows to provide ventilation and light – a trick used to great effect in the kitchen of the Esher house.

Finally, Le Corbusier argued that houses should have roof gardens in order to compensate for the loss of the green space they take up. This is one principle

that hasn't been applied. However, since the house replaces a pre-existing building that sprawled across the site, you could argue that there is no 'lost' garden to be replaced.

It may seem odd to find a direct descendant of Le Corbusier's villas in leafy Esher, but it has a close cousin just down the road. One of Villa Savoye's most celebrated descendants, The Homewood, built by Patrick Gwynne in 1938, lies in Winterdown Wood, less than a mile away.

COURTYARD HOUSE

▼

It's the last thing you'd expect to find in a conservation area. Especially one of the oldest conservation areas in London.

The house that architect Suzanne Brewer built at the bottom of a private garden for herself and her husband Andrew Sheehan is an anomaly – a dash of dazzling Thirties glamour amidst the leafy private gardens of London's Blackheath.

Or at least it would be, if you could see it. The terms of the planning permission stipulated that the house should make a minimal impact on the street, whilst issues

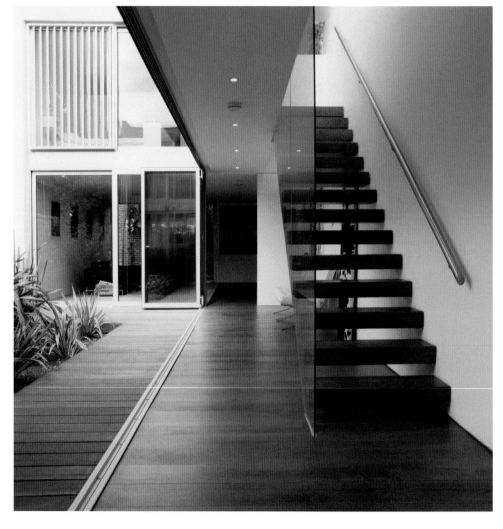

Right **Walls between house and courtyard are fully glazed, blurring the distinction between inside and out.**
Far right above **The streamlined façade provides a dash of dazzling thirties glamour.**
Far right below **The heart of the house is a timber-decked courtyard planted with bamboo and palms.**

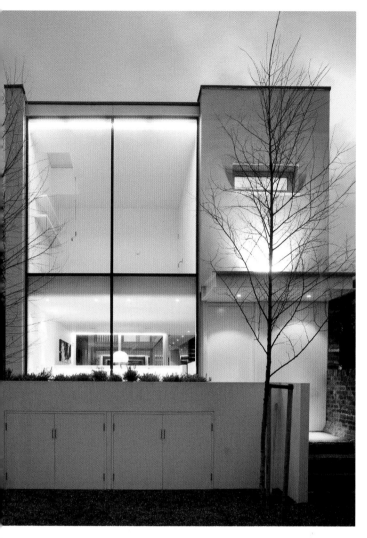

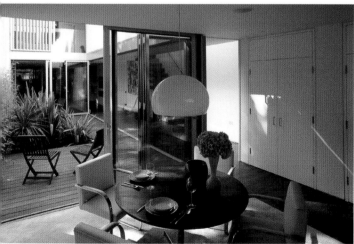

with overlooking precluded the possibility of putting windows on the north and west façades, and allowed for only very limited openings on the southern side.

Which suited Suzanne just fine. The inscrutable street presence simply adds to the sense of drama once you get behind the garden walls. An oasis of zen-like calm, the house is conceived as two linked pavilions built around two courtyards. To the front there is a small pebbled courtyard and herb garden shaded by silver birch trees. The second, south-facing timber-decked courtyard lies at the heart of the house and is planted with bamboo and palms.

The house surrounds this courtyard on three sides, an arrangement which gives the greatest possible expanse of external wall and hence the greatest possible quantity of natural light. The internal layout is designed in response to the movement of the sun throughout the day, which rises in the kitchen, beats down on the garden by day, and settles over the dining area in the evening.

The 'walls' between house and courtyard are all fully glazed and may all be opened, blurring the boundaries between inside and out – and putting every corner of the house very much on show. Such smooth perfection demands a very particular way of life. Fortunately Suzanne and Andrew have the Minimal Modernist lifestyle nailed, with furniture by Eero Saarinen and Mies van der Rohe, as well as spectacular works of art.

And they also have an awful lot of cupboards – which is where those windowless walls come into their own. Deep units line the north and west walls: a reminder that such smooth perfection relies on vision, commitment and, maybe most importantly, an abundance of storage space.

ATTWOOD HOUSE

▼

The most interesting homes, like the most interesting people, are prone to engender love-hate relationships with those who know them best. Having spent many years living in a single-storey steel-framed house that was designed in 1965 by the architect Victor Hutchings, David Attwood and Jane Tranter were all too aware of its weaknesses – but had come to love its strengths.

Freezing in winter, roasting in summer, and prone to flood, it was obstreperous, demanding, and dictated a particular way of life. It was also gutsy, characterful and enjoyed an enviable location. Surrounded by water on three sides, it's hard to imagine a more poetic site.

Having grown to know and love both the building's foibles and its spectacular views, David and Jane commissioned the architect John Pardey to extend and remodel the house in a way that remained true to its origins, created a more comfortable and user-friendly living environment and exploited the full potential of this extraordinary site.

The new design is a descendant of the Californian 'Case Study Houses' of the 1960s. The original square brick building has been retained as a central hub, and is now the double-height living room – the only ground floor room in

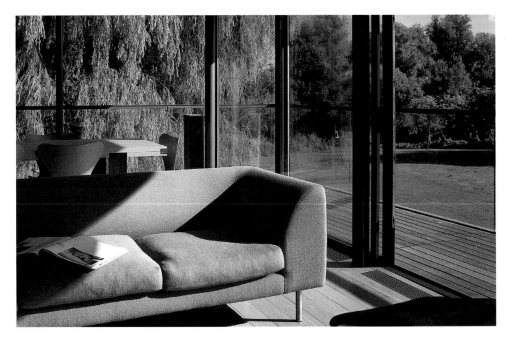

Right **Glazed walls give the main open-plan living/dining space spectacular views over the River Loddon.**
Far right **The house is raised on slender steel columns to provide protection from the ever-present threat of flood.**

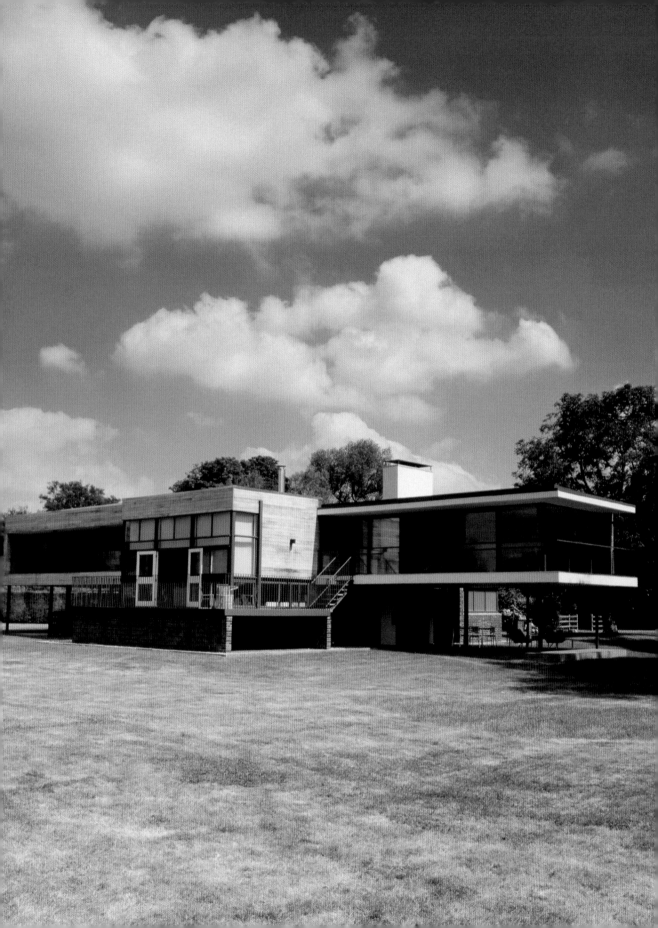

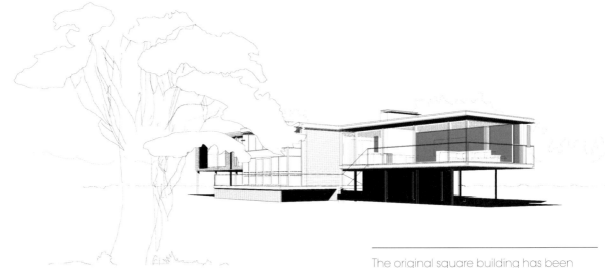

Below **The double-height living space is the only room in the house to occupy the ground floor.**

Right **A minimal fireplace acts as the focal point for the new open-plan living/dining space.**

The original square building has been retained as the core of the house and now houses a living room. It has been extended by two raised blocks supported on slender stilts: a cedar-clad bedroom wing and a glazed living space that reaches towards the river.

the house. Two new wings – a 'closed' cedar-clad wing housing bedrooms and bathrooms, and a glazed 'open' living room stand raised up above the ground on slender steel columns as protection from the ever-present threat of flood. Recessed balconies, cantilevered enclosures and outdoor decks provide a variety of outdoor and semi-outdoor spaces.

The overall impression is of a dynamic, highly sculptural creation that floats above the landscape. Pardey has replaced a self-contained and self-referential object in the landscape with a more fluid composition that allows the outdoor space to flow around, under and into the house whilst taking full advantage of the 360-degree river views. More importantly, he has given his clients a more enjoyable and less dictatorial home; a house that is in easy conversation both with its residents and with its site.

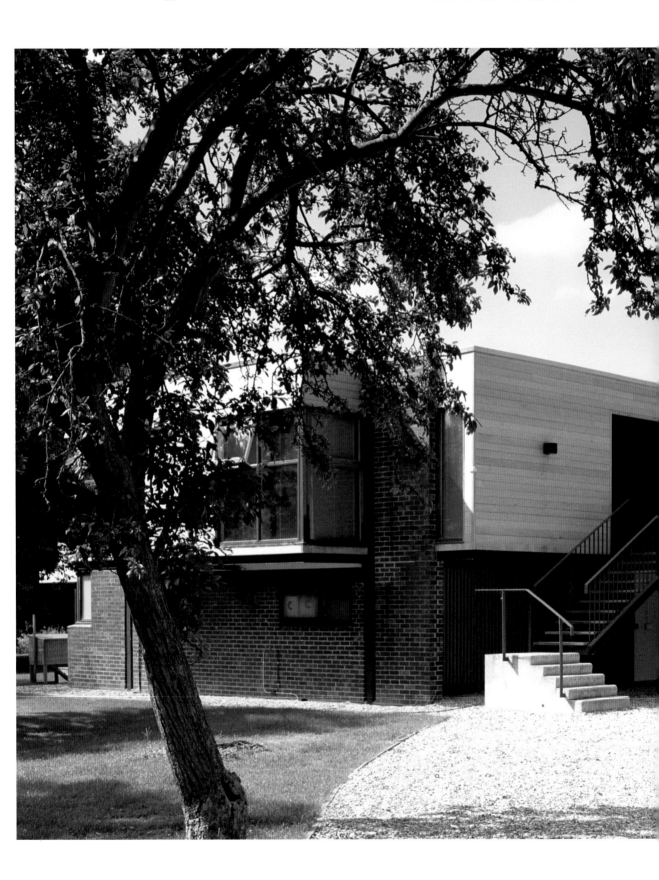

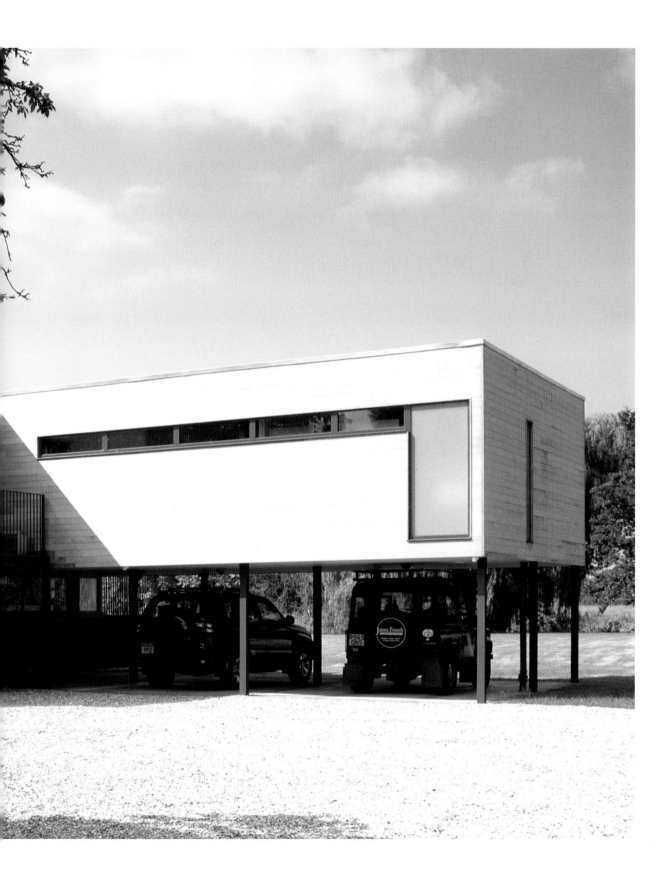

CHESTNUT HOUSE

▼

This west London house, by architect David Long, represents a conscious quest to define a 'new normal'; a modern-day answer to the traditional house.

Just as Edwardian and Victorian architecture expressed the aspirations and construction techniques of a particular period in time, Chestnut House aspires to a new aesthetic, one that is appropriate to the 21st century and its focus on sustainable development.

Built on a dilapidated former garage site and squeezed between traditional terraced housing, it is deliberately, proudly different from its more conventional neighbours. The sweet chestnut cladding was chosen in part because of its intrinsic qualities – it is warm, tactile, enduring and will weather naturally over time – but also as a means of emphasising the distinction between this unapologetic newcomer and its masonry forbears.

But it is also a symbol of the sensible environmental agenda that underpins the scheme. The decision to use a timber frame with timber cladding reflects a desire to use a building material that is renewable, has low-embodied energy and may be locally sourced. Shutters within the cladding can close off the building completely providing privacy and solar shading. Heating is provided by an air source heat pump and green roofs provide thermal insulation and a valuable habitat for wildlife and plants.

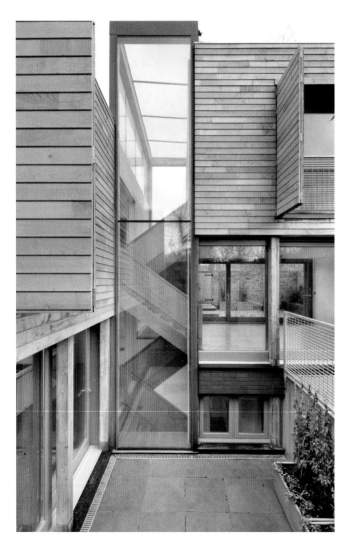

Left **A glazed stairwell brings light into the centre of the house, whilst a sunken courtyard brings light into the lower floors.**
Above right **The house carves out a series of courtyards at different levels.**
Right **Chestnut cladding emphasises the contrast between the newcomer and its neighbours.**

Grand Designs Award | 2010 | London | Architect **David Long**

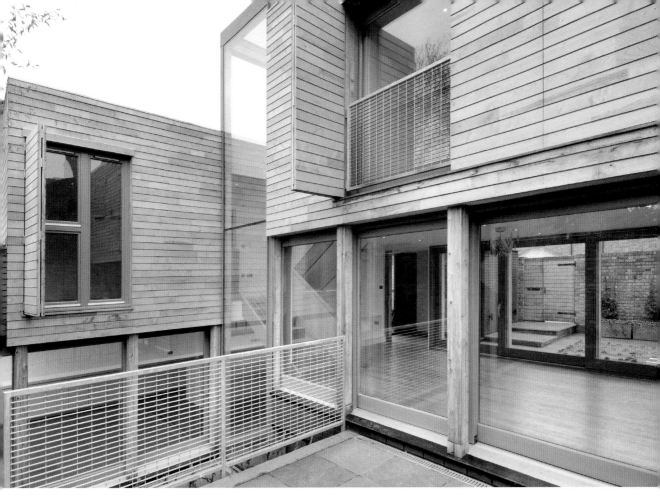

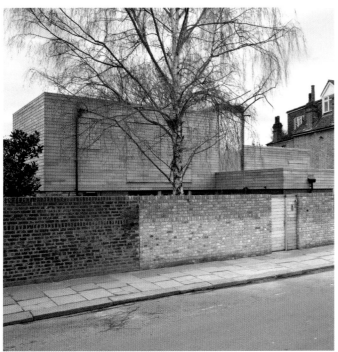

The planning of the building reflects a modern preoccupation with fresh air and natural light. Rather than the traditional arrangement where the house occupies the front of the plot with the garden behind, Chestnut House extends to the boundary walls on all four sides, but 'carves out' a series of garden and courtyard areas, with sliding glass walls creating a seamless relationship between the two. Internal space is arranged as five interlocking half levels, accessed from a glazed stairwell that brings light deep into the house, whilst a sunken courtyard brings daylight into the lower levels.

Amidst its rather staid street setting, this house looks positively quirky. But it is an eminently straightforward response to the urgent need to make efficient use of space, light and the earth's resources, and a worthy successor to its historic counterparts.

TREES

It's the oldest trick in the Modernist book: build a two-storey house, sheathe the ground floor with glass, and create the illusion of a building that 'floats' above the ground. But for architects Jim and Rebecca Dyer, the end game was not to create a house that commands its landscape, but rather one that dissolves into it.

As its name suggests, Trees occupies a secluded leafy site, set back from a quiet lane in a small village in the Chew Valley. Whilst the design follows classic Corbusian principles – open-plan ground floor, full-height wraparound glazing, BIG views, smooth, minimal interiors, orthogonal plan – the first floor is finished not with crisp, white render, but with open-joint western red cedar cladding, designed to complement the branches of the surrounding trees. It's topped, not by a stark white parapet, but with a low monopitch copper roof that will weather over time.

The first floor windows are also shielded by timber, with sliding louvred screens affording varying degrees of light and shade. But whilst the upper floor nestles discreetly behind its woody camouflage, the ground floor is exposed in all its glory.

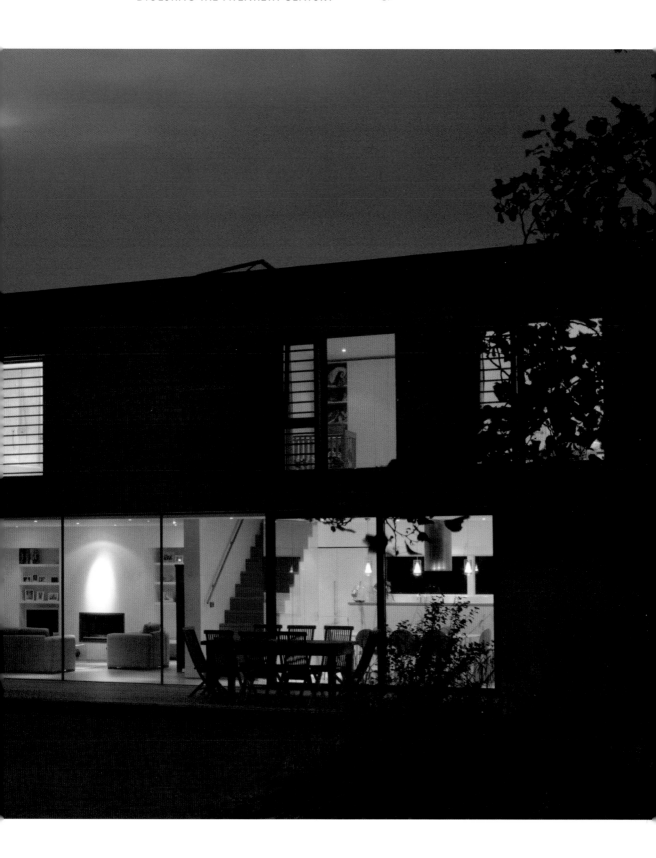

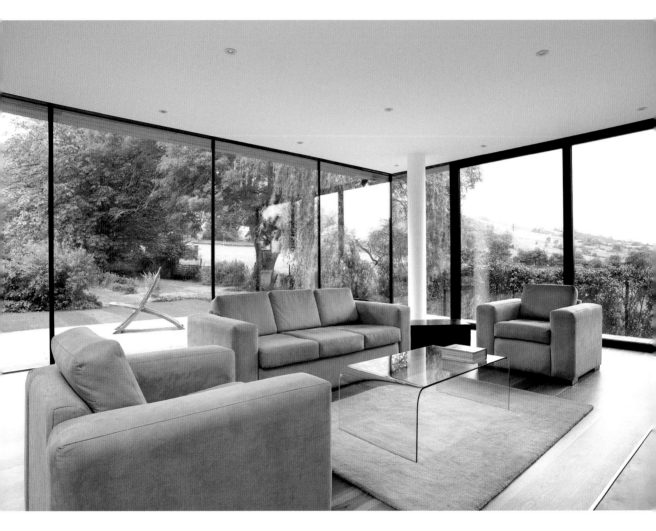

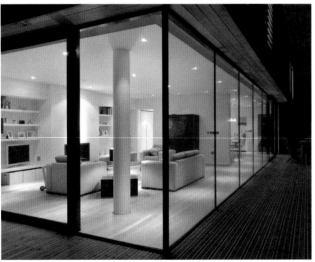

Previous page **The first floor timber box contrasts with the 'barely there' structure of the open-plan ground floor.**
Above **The verdant landscape forms a spectacular backdrop to everyday life.**
Left **Floor-to-ceiling glazing puts the living space very much on show.**

Above right **Local carpenter Phil Clarke built the solid oak staircase.**
Right **The kitchen is tucked against the back wall and designed to screen any clutter from view.**

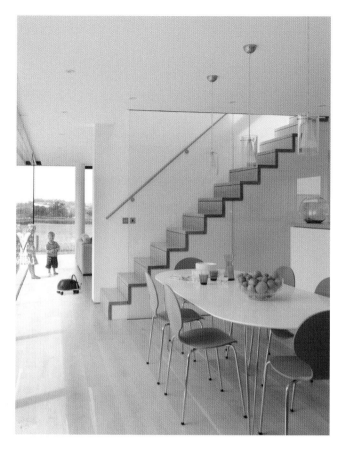

Luckily, it's a secluded site, so privacy isn't an issue, and the views across the surrounding countryside are sublime. And the fact that there's ample storage space makes it relatively easy to contain the paraphernalia of small children and family life and keep the main, open-plan living area looking its picture-perfect best.

But Jim and Rebecca are still coming to terms with the full implications of life behind glass. It's one thing living the Modernist dream in the full blaze of Mediterranean sunshine, but quite another when there is no escape from the brooding menace of driving rain or an overcast day. The Dyers are, quite rightly, thrilled with their house – and their spectacular views – but they've realised the value of being able to create a cocoon against the outside world. The next phase of work will be installing curtains for the ground floor glass wall.

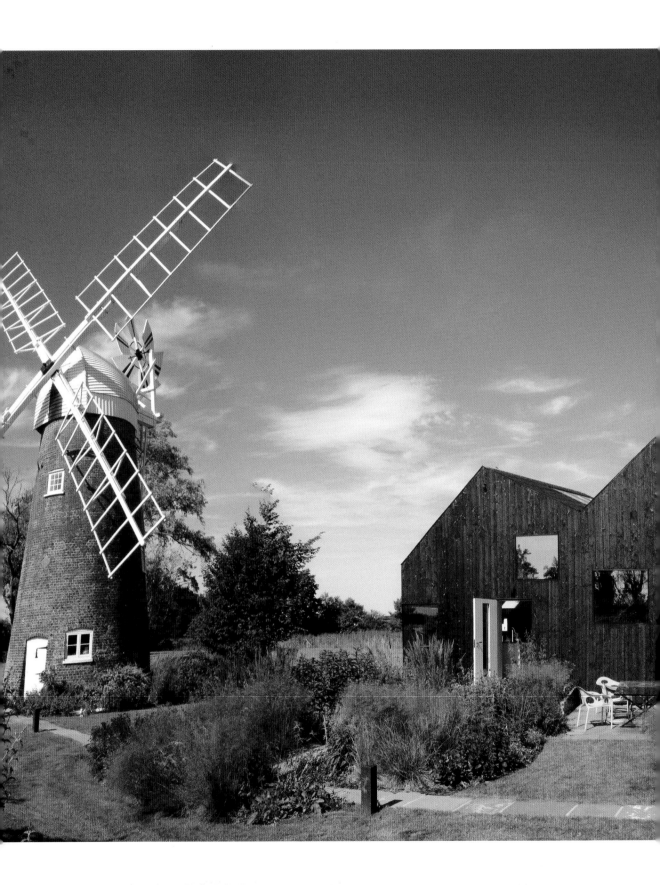

02
MULTIPLE PERSONALITY ORDER

Houses have, for millennia and across the planet, served more than the domestic purpose. After a period when planning restrictions often outlawed home working, it is refreshing to find new buildings in the 21st century that combine home life and work life, often in adjacent buildings. And there are some homes that are just schizophrenic.

AMERSHAM WATER TOWER

It's easy to see why architect Andrew Tate and his wife Deborah Mills fell in love with their 100-foot red brick water tower. It stands amidst beautiful Buckinghamshire countryside and commands views of six counties, from the rolling Chilterns in the foreground to distance views of London's Canary Wharf.

Built in 1916 by German prisoners of war, it fell into disuse when modern tanking was introduced. It was a project waiting to happen. And, as Andrew memorably commented: 'All architects want to build their own house, so I'm like a pig in mud.'

But with the best will in the world, he was never going to turn his tower into the ideal family home. Built to supply water to the surrounding community, it was designed to house a 51,000-gallon tank – not a family of five. At best, it could accommodate one room per floor. Daily life would be a succession of vertiginous climbs – far from ideal for a woman with three children and a fear of heights.

So Andrew and Deborah devised a plan for a house of two parts. The tower would become a bedroom wing, whilst a secondary, low-lying building would provide more conventional accommodation adjoining the tower's ground floor. Designed to blend in with the banks of the surrounding reservoirs, the new-build element was to be grass-roofed and invisible from the road. In stark contrast to the tower, the emphasis was to be on space and light, with open-plan living space and glass walls at either end.

This is prime green belt land where, with very few exceptions, it is strictly forbidden to build anew. But Andrew and Deborah were adamant that their plans to convert the tower into a home simply

Left **Not recommended for those suffering from vertigo: the 100-foot red brick water tower was designed to house a 51,000-gallon water tank, not a family of five.**

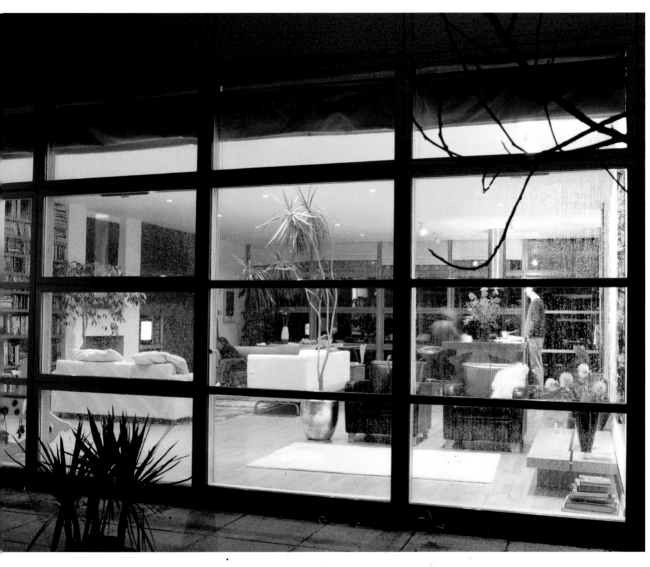

Above **A new, low-lying building provides open-plan living space with glass walls at either end.** Right **Andrew Tate and Deborah Mills with their children, at the foot of the staircase in the renovated tower.**

didn't stack up without the addition of the extra wing. The planners were faced with a dilemma. Either sanction the new part of the house, or face the prospect of a much-loved local landmark going to rack and ruin.

Common sense prevailed and a schizophrenic house was born: two halves that are polar opposites yet symbiotic. The cave owes its existence to the tower; the tower owes its resurrection to the cave.

SEAFRONT SUGAR CUBE

▼

Tom Watkins, a pop Svengali who managed bands including Pet Shop Boys and East 17 in the 1980s and 1990s, enjoyed a globe-trotting existence but decided to settle down by the sea for the sake of his health.

With his boyfriend, Darron Coppin, he hatched a plan to build a home that would allow them to entertain in style and provide a fitting, tailor-made showcase for their formidable collection of twentieth century furniture and art. The couple are avid collectors with a particular penchant for the work of the Memphis Group, a group of Italian architects and designers that was influential in the 1980s.

The result is a clean-lined Modernist sugar cube in the East Sussex village of Pett Level. A very large sugar cube. Easily the biggest resident on this stretch of beach, it is positively gargantuan compared to the wooden shacks nearby. Whilst neighbours grumbled about its chutzpah and size Tom and Darron pointed to the smattering of Modernist seaside houses built on the South Coast during the Thirties and Forties, arguing that there was a strong precedent for their bold approach.

As if to mark its indifference to its nimby neighbours, the Big White House turns its back to the road – the only visible means of entrance is a forbidding garage door. But from the beach, its secrets are revealed: the natural 'sea garden' providing an informal counterpart to the purism of the house.

Above left **The house belongs to the tradition of Modernist seaside houses along the south coast of England.**
Left **The living room is a showcase for the couple's formidable collection of twentieth century furniture, sculpture and art.**

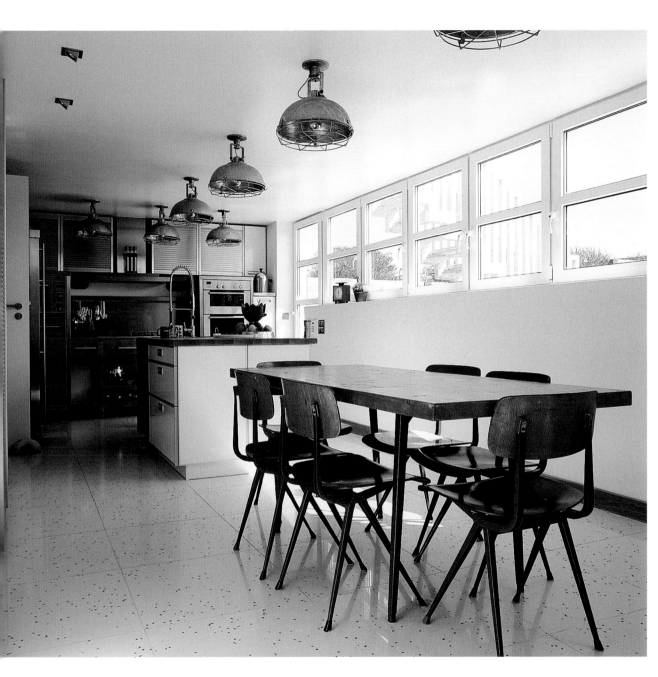

Above **The kitchen/ dining room. Visitors are invited to carve or write graffiti on the dining table.**

It is a little austere from the outside, but the cacophony of designer furniture, sculpture and modern art makes it positively exuberant within. Watkins says he is drawn to irreverence and playfulness in design, which could explain the project's success. For all its cultural credentials, the collection lends itself to

casual coexistence with everyday life. The vast top floor space is a living tribute to the Memphis Group, but it is also very much a living room. And where the typical gallery looks inward, banishing the outside world, this is a space that embraces its setting. With windows spanning the width of the room, the star exhibit is the endless sea.

LONDON JEWEL HOUSE

Like countless Londoners before them, jewellery designer Sarah Jordan and photographer Coneyl Jay dreamt of a place that was part workplace, part home thus eradicating the need for the daily commute.

But where others might have set about converting a spare room into a studio, or extending into the attic, Sarah and Coneyl wanted the feeling of the light and space of a modern loft, and a clear separation between home and work – out of the question when converting a traditional London house.

So they found a site; a long, narrow strip of land at the end of an Edwardian terrace occupied by a mechanic's workshop and a garage, and commissioned the architect Mike Tonkin of Tonkin Liu. Tonkin Liu favours architecture that is rich with references and meanings – not in the post-Modern sense of mixing and matching from different historic styles – but in a way which reflects their belief that buildings should ask questions or tell stories; that architecture, like art, should have something to say.

In this case, Mike Tonkin set out to design a building – or rather two buildings, since house and studio face each other across a courtyard – that said something about the inhabitants and their respective passions. Hence the design of the house is inspired by the idea of a jewel box, with honeycomb-fronted illuminated storage units conceived as glowing pieces of jewellery. The photography studio is a camera obscura: an image of the house is projected onto the front of the studio when the blinds come down at night.

The metaphors sound rather literal, and could easily have been tacky or trite. Thankfully, the references are subtle rather than overt, expressed in a highly architectural way. For all its fashionable tricksiness, the house has a timeless quality. The massing and planning are reminiscent of a Roman villa, an effect reinforced by the covered colonnade that runs down one side of the courtyard connecting the studio and house. It can be almost eerily serene. Yet the optical illusion of the projected image and the shimmering 'jewels' produce an entirely different character by night. This is a space that is both peaceful and energising, and an inspiring place to live and work.

Below **The view from the street. The passageway gives the photographic studio its own entrance.** Right **The courtyard can be filled with water to form a shallow pool.**

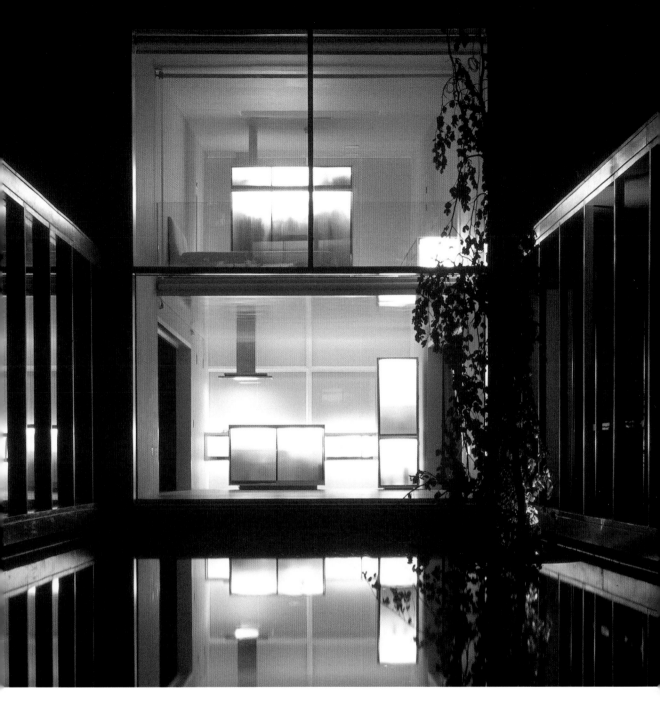

The two-storey house faces the single-storey studio across the courtyard, giving a clear distinction between work and home.
A covered colonnade connects the two buildings and gives the composition a distinctly classical feel. Illuminated storage units, conceived as precious jewels, shimmer by night.

CLAPHAM COACH HOUSE

▼

Barristers David and Anjana Devoy lived with their two children in a dark, cramped Victorian coach house in Clapham. The house was tiny, but the garden was big. So they decided to convert the coach house into an office and garage, and to build the house of their dreams in the garden – a Modernist essay in steel and glass with plenty of space and light.

There were just two problems: the blocks of flats overlooking the garden, and the huge, protected horse chestnut tree standing right in the middle of the prospective building plot. Working with the architect Peter Romaniuk, David and Anjana came up with a design that took both issues into account. The three boundary walls are solid planes of white stucco, a windowless defence against the outside world. By contrast, the fourth wall takes the form of an elegant arc, a concave curve that skirts around the tree.

This concave wall informs the character of every room in the house. There are no formal orthogonal spaces, just a sequence of dynamic spaces of varying size, their width defined by their position on a languid curve. At ground floor level, this inner wall is constructed from faceted double-glazing with sliding doors, a transparent permeable skin that allows the ground floor living space to spill out into a cloistered courtyard. This is a truly magical space, a wonderful secret garden beneath the branches and bathed in dappled light. The two upper floors are wrapped in curved chestnut cladding crafted by boat-builders hired

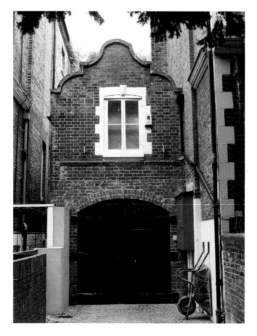

Left **The tiny Victorian coach house at the front of the site was formerly the family house but now serves as an office and garage.**
Top right **An elegant curved wall skirts round the ancient horse chestnut tree that is the focus of the house.**
Right **David and Anjana Devoy with their children.**

Series 4 | 2004 | London | Architect **Peter Romaniuk**

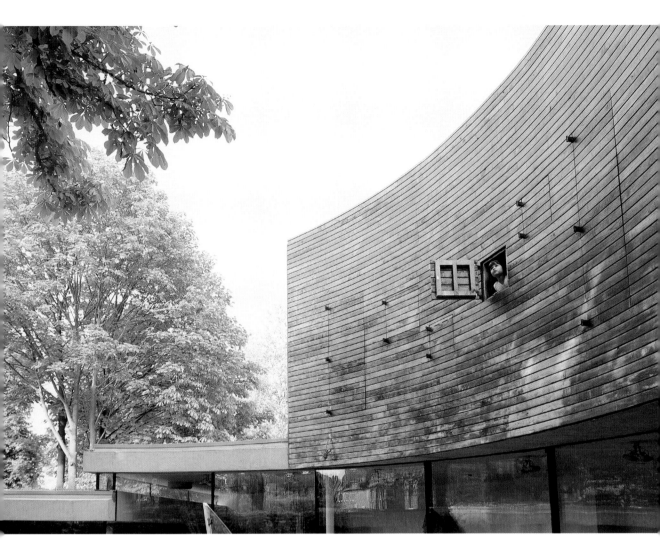

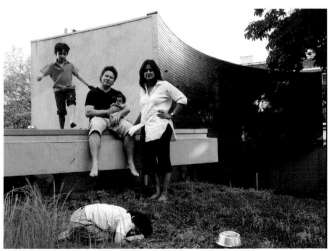

especially for the task, a poetic homage to the intrinsic strength and beauty of the chestnut tree.

This, then, is a building with two very different sides to its character. To the outside world it is an inscrutable fortress. Inside, it is open, transparent and welcoming. It has the space and light David and Anjana yearned for, but it has much, much more besides. It has elegance and spirit and warmth, and a unique – wholly contextual – character that makes it absolutely appropriate and specific to this particular patch of land.

LUTYENS WATER TOWER

▼

I have always believed architecture has a redemptive power, that great buildings have the ability to make you feel like a better human being. I say this because some buildings make me feel like a better human being. But until recently, I had always doubted a building's ability to change who you are.

The plan of the house is compact and redeemed by the rectangular bays that push out between the concrete and steel structure in every direction. A new deck (not shown here) now gives Bruno and Denise some sophisticated outdoor living space.

This project is an unlikely candidate for a life-changing building. It started life before World War I as a water tower designed by Sir Edwin Lutyens and was intended to be clad in clapboard to mimic a windmill. Wartime frugality put paid to that and the structure remained in its naked reinforced concrete (beautifully shuttered and poured by the British firm Michelle under licence from the concrete's inventor, Hennebique in France). It was only in this century that its current owners, Bruno and Denise del Tufo, thought of converting it to live in.

Not surprisingly, for a brutal structure, they employed Brutalist architect Derek Briscoe to produce a design as unusual as the water tower itself. He responded to a purely engineered structure with a series of highly engineered boxes, apparently of zinc and lead (but in truth constructed mainly in timber), materials of pipework and plumbing, as though the old tower had taken on a new lease of life and a new collection of bonkers water storage tanks. When I went back to visit Bruno and Denise in early 2012, they had added a deck to their modest home, out of those same materials. Appropriately it looked like a maintenance platform added to a piece of industrial infrastructure.

Both Bruno and Denise insist on referring to the building as 'she' as though it is a ship. A submarine maybe. Or a stealth caravan slid into and under the concrete tank. But I must bow to their wisdom since both have humbled me with their account of this project. I once told Denise, on camera, that I thought the pair of them (both trained artists and therefore sensitive to the difficulties of taking something out of its original context) were extraordinary people. She replied in an unusually feisty way, 'No. We're not extraordinary people at all. We're very ordinary people. We're

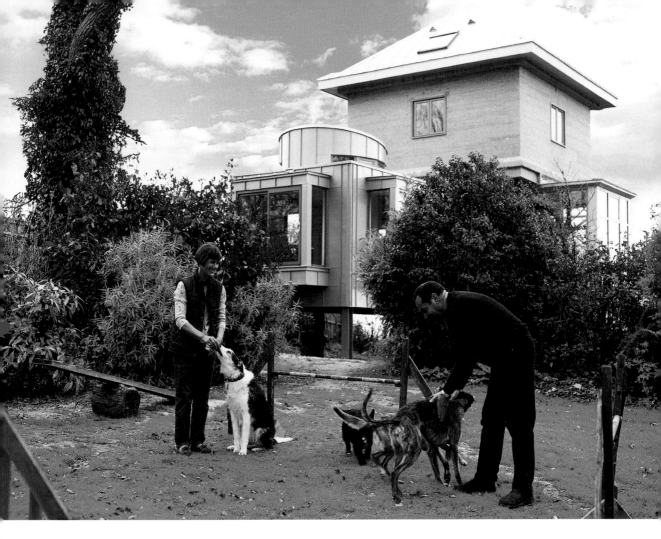

Above and top **The industrial personality of Lutyens' tower is allowed to speak. There is the odd original fitting (above) and the shuttered concrete, dating from before the Great War, is of magnificent quality.**

just doing an extraordinary thing.' That response has stayed with me ever since; I remind myself of it – and often quote it – every day that I make a site visit to film someone building a house, because in those words lies the secret of what makes us all watch *Grand Designs*: the belief that the people we are watching are like us and that we might go on that same adventure.

But I was not prepared for what was to come at our encounter in 2012. When filming our revisit, Bruno mentioned something off camera, in conversation, that stunned me. He described how the building had profoundly changed him. During the original construction phase Bruno had been often absent, working (he taught art to blind children and was suffering appalling stress at work for a variety of reasons). Now, years later, he

was telling me that his new home had given him enormous confidence at a time of serious self-doubt; that its strong identity, popular with all kinds of visitors from nuns to architecture students, had helped him redefine who he was. I was listening to a man in rapture about how the home he had commissioned had changed who he is, for the better. It would be impossible to ask a building to do more.

I mentioned the quality of the concrete. I have by my desk a core sample drilled out of the water tank, a tubular slug of perfectly formed artificial stone, polished smooth by the drill and containing a beautiful array of coloured shingle, a bar or two of steel and not one air bubble. It is a talisman, a piece of this magical, transformative building and I keep it for good luck.

21ST-CENTURY FARMHOUSE

Andrew and Meryl Ainsley's farmhouse in the rolling Wiltshire countryside owes its existence to a benign law that allows farmers to put up a home for themselves or an employee if they can demonstrate a professional need. Not too difficult, since Andrew is a farmer, tending 700 acres of dairy cattle and cereal crops, and the farmhouse they previously occupied wasn't even attached to the farm, let alone on it.

Right **The floating mezzanine, polished concrete floors and lofty open-plan interiors are a far cry from the earthy solidity of the traditional farmhouse.** Above right **The glazed south façade gives views of – and a very direct relationship with – the surrounding farmland.**

Andrew had already proved his credentials as a patron of design by building his stockman a pointy-looking, oak-framed house which augured well for the quality of the new farmhouse – made of the next generation of wooden framing materials, laminated timber. A straightforward structure of columns and beams clad with western red cedar, it is a self-confident celebration of contemporary timber-frame construction.

But it is also the embodiment of a more poetic and subtle set of aspirations. By way of a brief, Meryl presented the architect Timothy Bennett with three objects that she and Andrew hoped would convey what they hoped to achieve: a 1953 farmhouse cookbook that once belonged to Meryl's grandmother,

a cube of green oak and a postcard of a Carl Andre sculpture.

Fortunately, he understood, producing a home that celebrates not only the intrinsic character of its raw materials, but domestic life, sculptural form – most obviously in the sinuous staircase crafted by a boat-builder friend of the architect's – and a sense of being at one with nature.

The floating mezzanine, polished concrete floors and lofty open-plan interiors are a far cry from the earthy solidity of the traditional farmhouse – but this is still very much a farmhouse. Exposed beams, rafters and pig-nose bolts hark back to traditional barn construction,

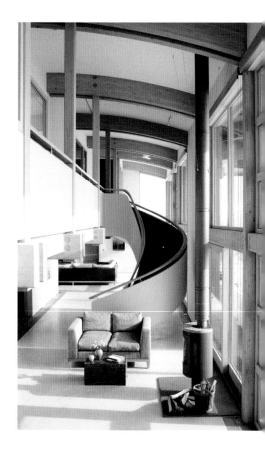

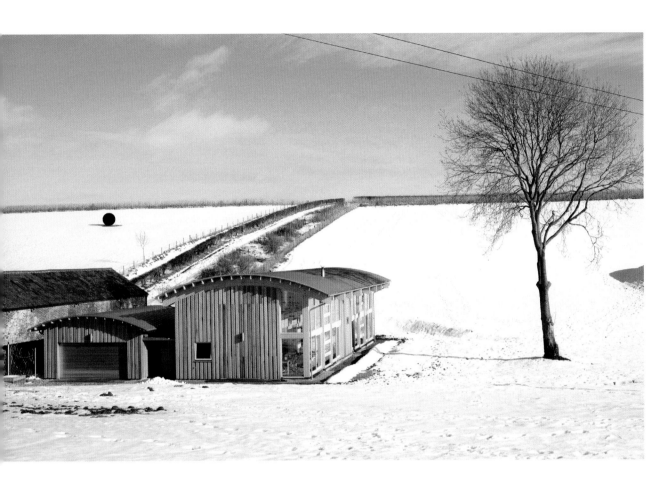

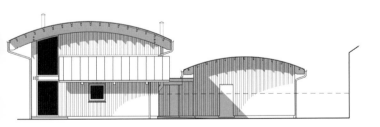

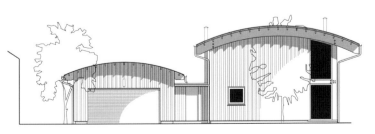

whilst the zinc barrel-vaulted roofs on the main house and the adjacent garage are reminiscent of more contemporary agricultural buildings. The glazed south façade gives views of – and a very direct relationship with – the land that is the house's *raison d'être*.

This is a rare instance of a progressive 21st-century farmhouse: one that combines a passion and respect for farming with an optimistic view of its future.

The simple form and the zinc barrel-vaulted roofs of the house and the adjacent garage are reminiscent of contemporary agricultural buildings. Big enough to accommodate farm vehicles, the garage is a real farm entrance giving access to a generous utility area with plenty of space for wet coats and muddy boots.

HUNSETT MILL

▼

Hunsett Mill is a handsome brick Grade II listed windmill which stands on a river bank at a bend in the River Ant. It's a classic Norfolk Broads landmark; a picture-postcard view. Well it was. Now it's something rather more unexpected.

Having bought the mill and its nineteenth-century mill-keeper's cottage as a shared holiday home Jonathan and Joanna Emery and their friends Catriona and John Dodsworth decided that they needed more space. The cottage had been extended over the years, leaving a complicated layout of cramped and isolated rooms. A particular bugbear was that it was impossible to cook dinner and be sociable at the same time.

They approached the architect Friedrich Ludewig of Acme, who suggested that they strip the cottage back to its original size and build a light and lofty extension to include a continuous, meandering kitchen/living/dining space that would ensure that anybody on kitchen duty was very much connected to the life of the house.

Right **The façade of the extension is folded like origami and clad with charred timber boards – a contextual nod to the local farm buildings and boat sheds.**

RIBA Award | 2010 | Norfolk | Architect **Friedrich Ludewig**

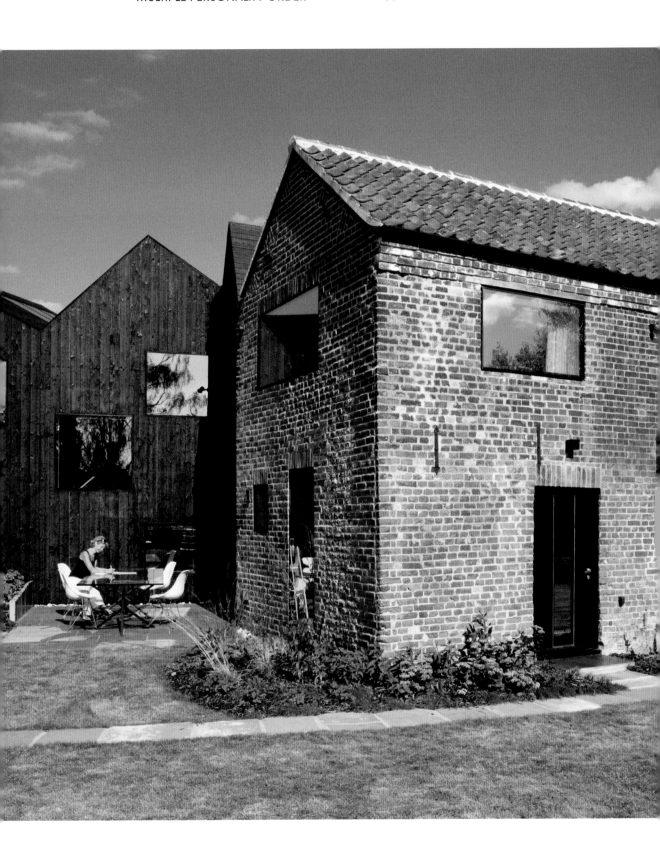

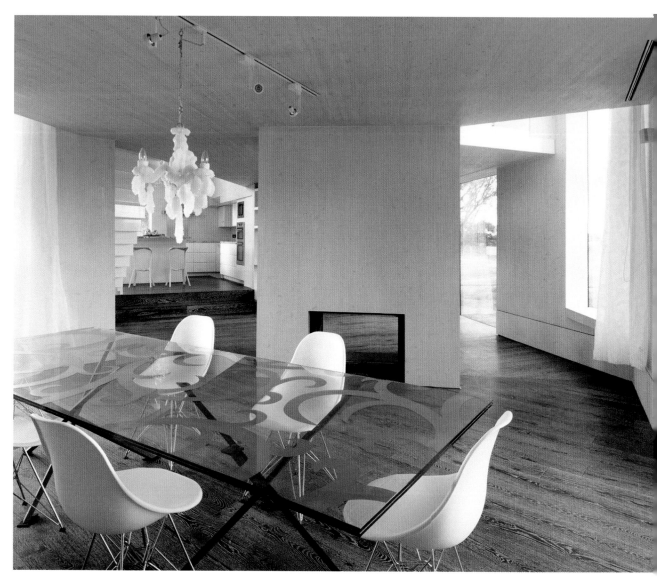

The reworking and substantial extension of the mill-keeper's cottage replaced a series of cramped and isolated rooms with generous, meandering living space. The use of double-height spaces and an open-plan layout means that there are strong connections from room to room and floor to floor.

From inside, the relationship between the house and its surroundings is both strong and direct. Windows are designed to afford the best possible views of river, windmill, marshes and fields. The view from outside is more ambiguous. In deference to the listed setting the addition, though sizeable, is an act of stealth, all but invisible from the river traffic passing by.

Conceived as a 'shadow', it lurks behind the existing cottage, hoving into view only at the last moment. Clad with charred timber boards – a traditional wood preservation technique and a contextual nod to the vernacular farm buildings and boat sheds – the black origami-like façade exudes the mysterious allure of a silhouette. Devoid of guttering or drainpipes, its dark solidity is punctuated only by mirrored windows set flush with the façade. The overall impression is of a single continuous folded plane.

For all its bulk it suggests the elusive fragility of folded sugar paper. Like the shadows in *Peter Pan*, it is disconcerting, elusive and beautiful – playful with a hint of menace. Tourists still stop and stare – perhaps even more so than before. But their holiday snaps have an ethereal element; a ghost that throws a 21st-century challenge to our definition of picturesque.

Above left **Spaces feel connected from floor to floor with double-height windows in the main living space.**
Above and right
The folded roof plane creates dynamic spaces, whilst windows are positioned to afford the best possible views.
Far right **Seating areas enjoy views of the Grade II listed windmill.**

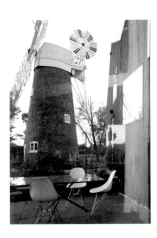

LYMM WATER TOWER

▼

When Russell and Jannette Harris bought a Grade II listed stone Victorian water tower in Lymm, Cheshire, they planned to build a simple cottage in the grounds and to preserve the fairytale tower as a folly. But this relatively modest ambition was overtaken by events.

By coincidence, Russell and Jannette, who both work in television, spent some time filming contemporary houses, including Skywood in Denham, Buckinghamshire, an iconic glass house designed by the Modernist architect Graham Phillips. Inspired, they started to flirt with the possibility of a more radical approach.

So when their own architect, Julian Baker from Ellis Williams Architects, suggested wrapping something modern around the base of the tower, he found a receptive audience. The revised strategy was to swathe the base of the tower in something light, bright and crisp – the polar opposite of the existing four-foot-thick stone walls.

As at the Amersham Water Tower featured on pages 42–3, the new extension houses open-plan living space, with bedrooms in the confined upper floors of the tower. But where the Amersham project opts for seen and unseen, this is a game of two equally visible halves.

The extension is designed as a series of radial spaces of varying heights, spiralling out from the sides of the hexagonal tower. External walls are an elegant composition of crisp white surfaces and full-height glazing topped by a 'floating' roof, separated from the walls by a continuous horizontal band of glass. Inside, the different zones are defined by subtle changes in floor level, but white poured-resin flooring and perfect white walls

Grand Designs Award | 2006 | Cheshire | Architect **Julian Baker**

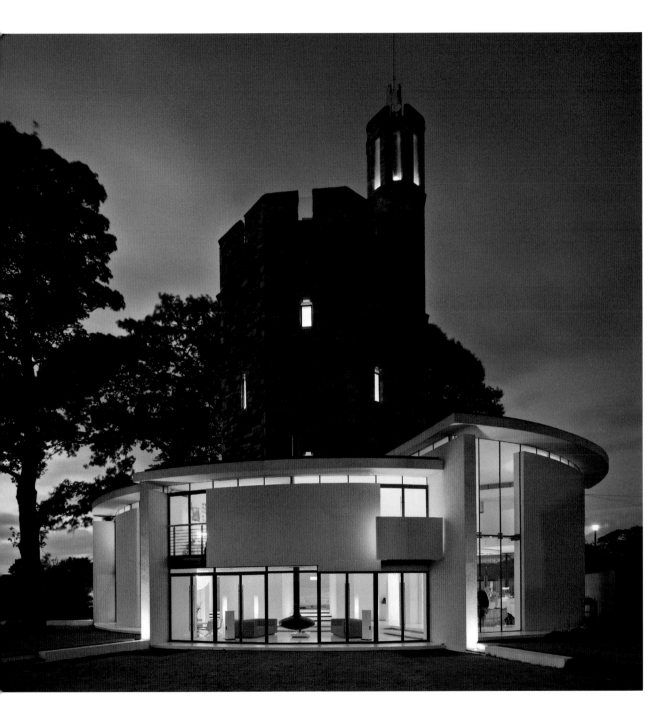

Above and left **The restored tower has Romantic appeal on its side, but the extension has serious va-va-voom of its own.**

ensure that the overall effect is of one of seamless, crystalline perfection.

It was a high-risk strategy – two very different architectural styles jammed up against each other. But against the odds

it works. Despite the overt modernity of the new addition the composition as a whole has an almost organic feel, as though an exotic white fungus has sprung up around the base of an ancient oak.

OAK FARM

▼

Oak Farm, on the outskirts of Liverpool, was once a handsome seventeenth-century farmhouse with red sandstone walls, mullioned windows and a gabled slate roof. But it had been compromised by unsympathetic extensions, and had fallen into disrepair. Owner Jonathan Falkingham had a vision of restoring the Grade II listed building and designing a contemporary annexe.

His solution was to design an extension of equal stature, but contrasting character to the original house: a Modernist extrovert to act as a foil to the traditional introvert.

The new building – joined to the farmhouse by a two-storey glazed walkway – is a sandstone construction, echoing the warm red of the historic house. But this is the polar opposite of historic pastiche. Where the farmhouse is all about enclosure, its solid walls offering protection from the outside world, the extension is about transparency and display. Essentially a one-sided building, its north elevation, facing the entrance courtyard, is entirely without windows, whilst the south elevation, which enjoys views across the adjacent woodland, is fully glazed on both floors. The effect is highly theatrical. The house reads as a dolls' house, or a stage set; an illuminated box that puts its occupants on show.

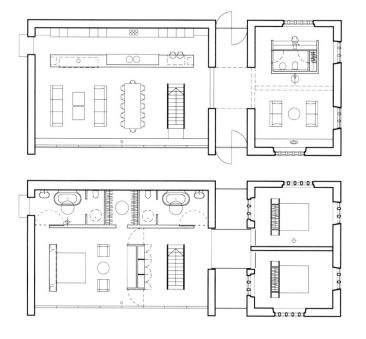

The historic farmhouse, to the east of the glass walkway, is all about protection and enclosure. By contrast, the extension, with its open-plan layout and fully glazed front wall, is all about transparency and display.

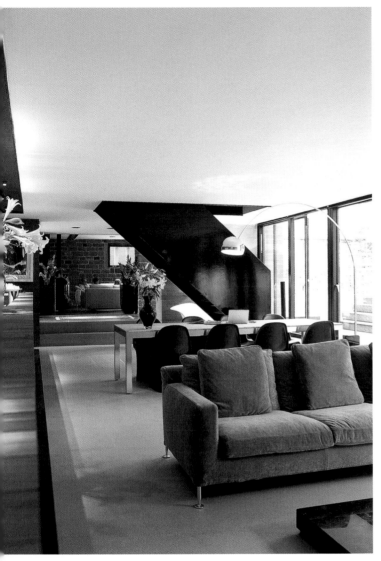

It's a bold strategy, and one that demands a suitably showy interior. Having taken the decision to accommodate all the smaller, more intimate spaces in the original farmhouse, the architects were free to leave the annexe largely open plan on both floors. The ground floor is a single, open-plan kitchen/dining/living room, with a long counter made from Burmese teak running along the length of the room, separating the sitting and dining areas from the run of kitchen units along the back wall and pushing the life of the house to the front of the space.

If the house is a stage set, the front terrace is a stage; a precise square of timber decking that floats above the surrounding lawn as if in anticipation of a drama waiting to unfold. Whilst the farmhouse offers privacy and a link with the past, its new extension treats life as a performance, full of possibility and promise.

Left **The new open-plan living space.**
Below left **Branches provide natural shading to the south elevation and outdoor deck.**

Below **Jonathan Falkingham with his partner Nicole Lawrence and daughter Ella.**

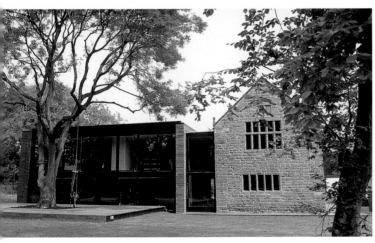

CHISWICK GARDEN HOUSE

▼

Like countless other Londoners, David and Mary Wright nursed a desire to connect with nature, to live in a house with a direct relationship with its garden, to inhabit an indoor-outdoor space. It's an almost primal urge in an environment where space is at a premium, and the great outdoors can seem like a distant dream.

But the realities of bringing up a family in a constrained space make it all but impossible to achieve. All too often, it's an ambition that translates into a pristine designer extension marred by views of a muddy patch of lawn and a sprinkling of plastic toys.

David and Mary commissioned the architect David Mikhail to rework their house in Chiswick, London, replacing the maze of passages and doorways with an airy open-plan layout, knocking down and replacing a tired extension and making the garden the focal point of the house. The new two-storey extension contains the living room on the ground floor and the master bedroom and balcony above. The living room is glazed on two sides, with a wall of full-height doors that fold and slide giving access to an intimate courtyard space.

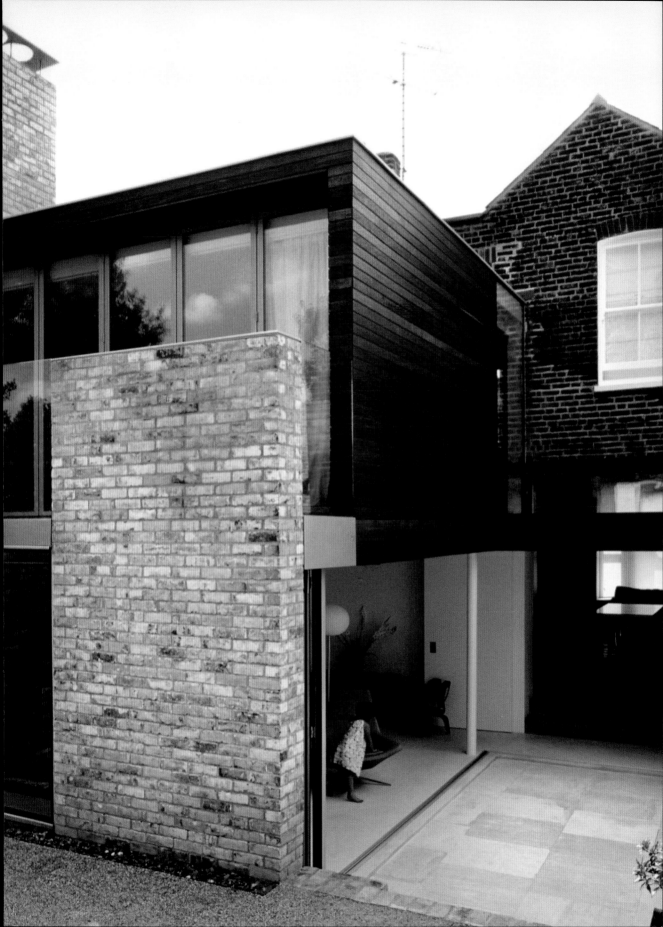

Previous page **The existing, rather tired, extension, was knocked down and replaced with a two-storey extension housing the living room on the ground floor and the master bedroom and balcony above.**
Left **Ceramic wall tiles and timber slats bring texture and tactility to the ultra-modern bathroom.**
Below **Passages and doorways have been replaced with bright, airy spaces including a kitchen/dining room which runs the length of the house.**

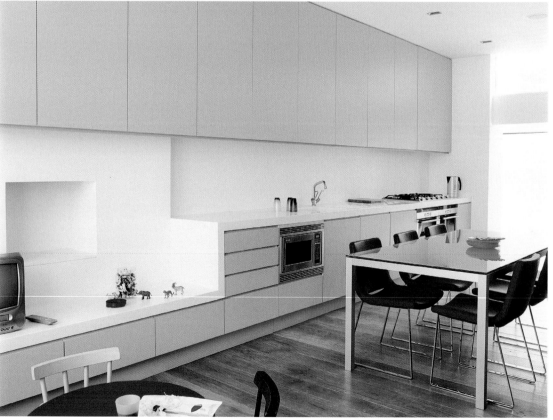

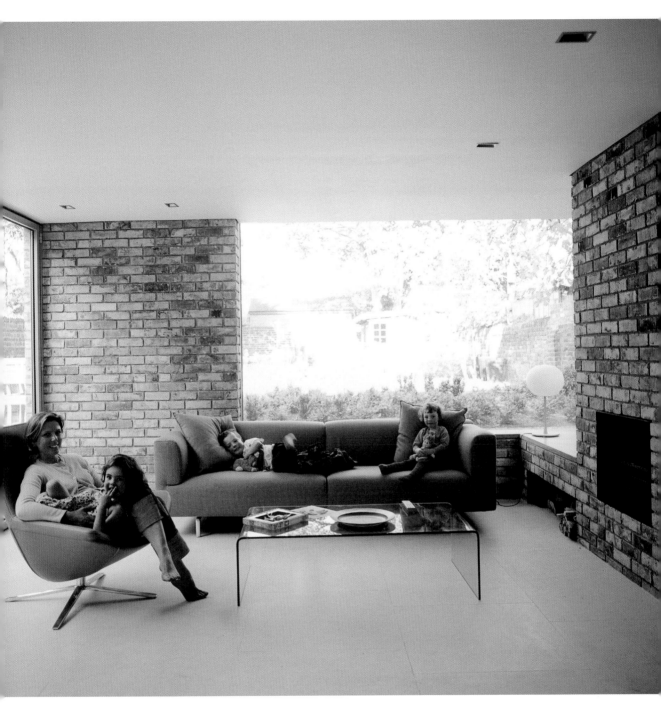

Above **Second-hand London stock bricks give a pleasing patina. The corner window seat is designed to take full advantage of the garden view.**

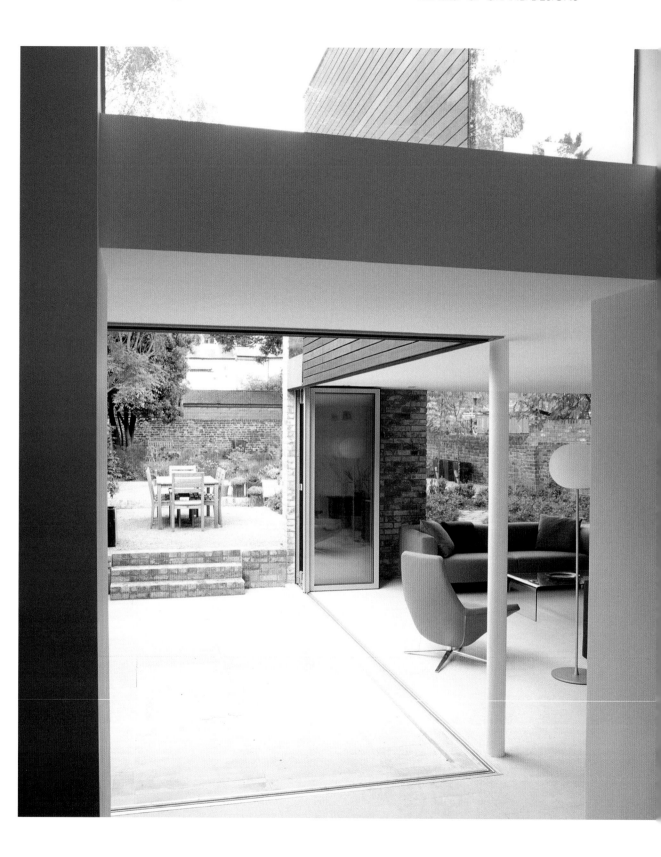

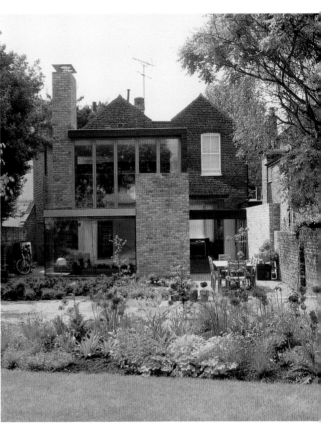

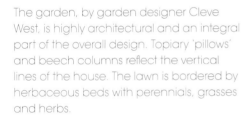

The garden, by garden designer Cleve West, is highly architectural and an integral part of the overall design. Topiary 'pillows' and beech columns reflect the vertical lines of the house. The lawn is bordered by herbaceous beds with perennials, grasses and herbs.

Left **A wall of glass doors folds and slides to connect the living room to an intimate courtyard space.**
Above right **The garden is an integral part of the overall design.**

The third wall, built from second-hand London stock bricks, turns a corner to make a low, wide window seat: a place to sit and admire the garden view.

And the Wrights were determined to have a garden that was worth looking at. They commissioned the garden designer Cleve West to design a sculptural space to complement David Mikhail's design – if their children wanted to run riot outside, they could go to the local park. The area closest to the house is highly architectural,

with gravel underfoot and strong vertical elements – topiary 'pillows' and beech columns – that reflect the lines of the house. To the rear, there is an area of lawn bordered by herbaceous beds with perennials, grasses and herbs.

From the front, this is the archetypal suburban London house. From the rear, it is something very rare indeed: a contemporary family house where the home embraces the garden, and the garden enhances the house.

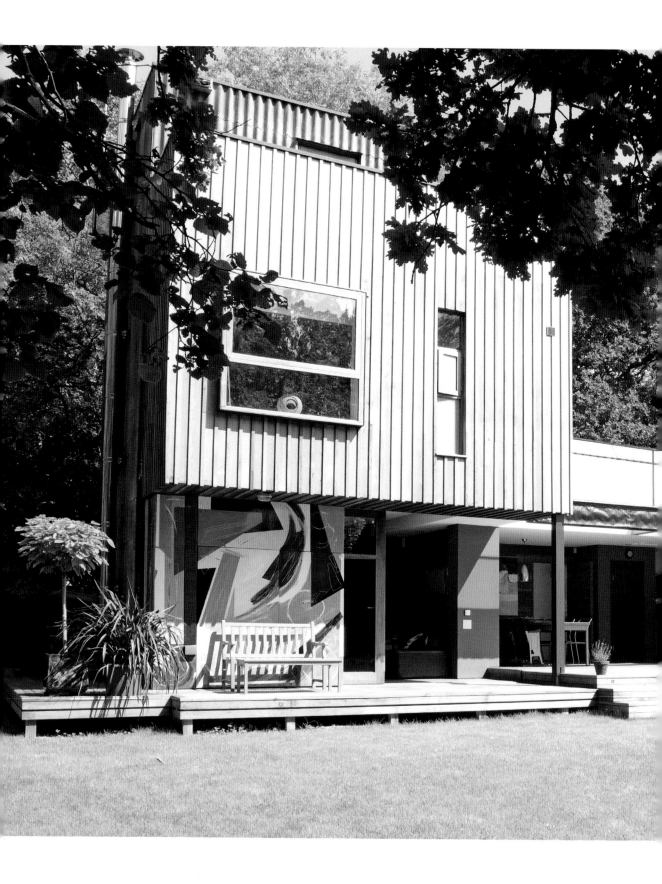

03
HAIRY HOUSES

These are not homes that are literally hairy (well, some are, and green too). They are sometimes scatty and loose-edged. They represent a view that deliberately rails against the neat red line on the planning drawings and which fights the bludgeoning obsession in design for order. Better to allow for a little disorder here and there and more autobiography in our homes; it better represents who we are.

HEDGEHOG HOUSING COOPERATIVE

It's tough enough for one family to build their own home. So what happens when 10 different households embark on the task of designing and building a community of 10 homes?

Below **Houses are both characterful and contextual.**

The Hedgehog Housing self-build project was dreamt up – and funded – by Brighton Borough Council and the South London Family Housing Association as a strategy for housing people in severe housing need. The households weren't expected to stump up cash, but they were expected to build the homes themselves, putting in a minimum of 30 hours a week.

Leaving a group of total amateurs building their own – and each other's – homes could sounds like a recipe for disaster. Fortunately help was at hand in the form of architectural practice Architype, specialists in collaborative design, sustainability and, crucially, self-build projects. Their work builds on the work of the architect Walter Segal who spent the Sixties and Seventies pioneering an approach to construction that would allow anybody – regardless of experience, expertise or skills – to build their own home. His formula? Build lightweight timber frames, and use standard modules or panels where possible in order to avoid wet trades.

The design by Architype and the Hedgehog Housing Cooperative follows his lead, with modifications to meet environmental aspirations and respond to the characteristics of the site. Warmcel insulation and extensive south-facing glazing keep energy bills to a minimum. Built on a ridge above a valley in Brighton's South Downs, the houses have grass roofs to minimise their impact on the view and balconies to take full advantage of the south-facing sea views. Cladding, verandahs and decking are made of British larch and Douglas fir.

The result is characterful, contextual, cheap to run and, most impressive of all, home to a functional community. The group dynamic was a total gamble: the only selection criteria were that

Above **Resident Debbie Seacombe with daughter Rosa on the verandah of their new home.**
Left **Resident Donna Olden in the communal vegetable garden.**

participants had to be on the Council's waiting list and willing to build their own house. Perhaps that's why it's worked. Inevitably there have been differences of opinion. But by and large they have been met with equanimity. There's an understanding that this is a community forged by expedience and that, whilst friendship is a bonus, 'rubbing along' is good enough.

THE STRAW HOUSE

▼

This house, by Sarah Wigglesworth and Jeremy Till, has become one of the most talked-about, exemplary and exploratory buildings put up in Britain in the last decade. It has provided an effective platform for the pair as architects and intellectuals, largely on account of the innovative and sustainable approach to materials and construction.

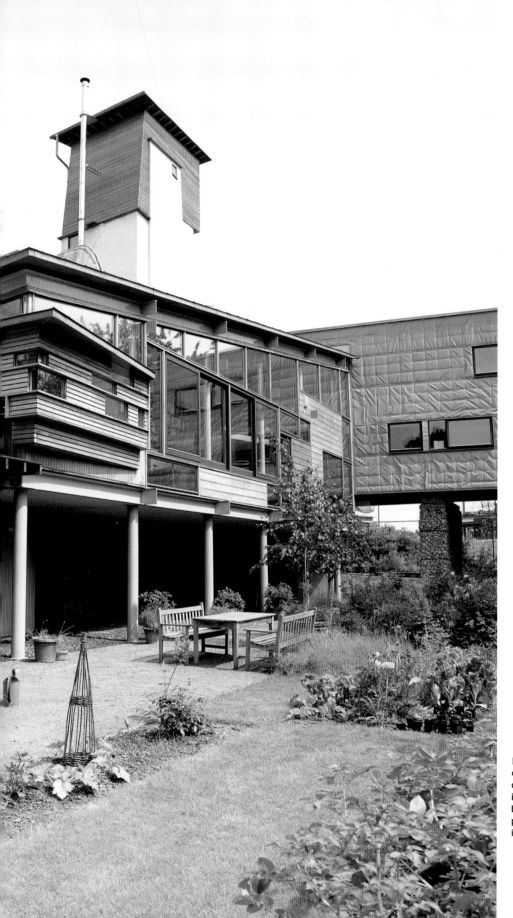

Left **The rules of visual conformity are thrown away. The composition is deliberately jumbled, bursting with detail and packed full of prodding, investigative ideas.**

We filmed it for the first series of *Grand Designs*, little knowing what a stir it would cause in architectural circles. It spearheaded a new wave of 'hairy' and highly enjoyable sustainable architecture and its influence has spread far and wide, having had articles about it published in more than 20 countries. The architecture critic Deyan Sudjic describes it as Wigglesworth and Till's 'architectural manifesto'. Fittingly, its apparent jumble of ideas has also been described as 'a living architectural sketch-pad' like Alvar Aalto's summerhouse at Muuratsalo in Finland or Frank Gehry's first house for himself. Architectural historian Giles Worsley said that Jeremy and Sarah's house reminded him of a pure medieval manor house, a public hall with a minstrels' gallery.

Above **The bathroom overlooks a small courtyard.**
Right **Architects and owners Jeremy Till and Sarah Wigglesworth. The Straw House was the first domestic building to use gabion walls.**
Far right **By day the dining room is used as a meeting room/ conference room. A sliding wall allows it to become part of the house as a formal dining room.**

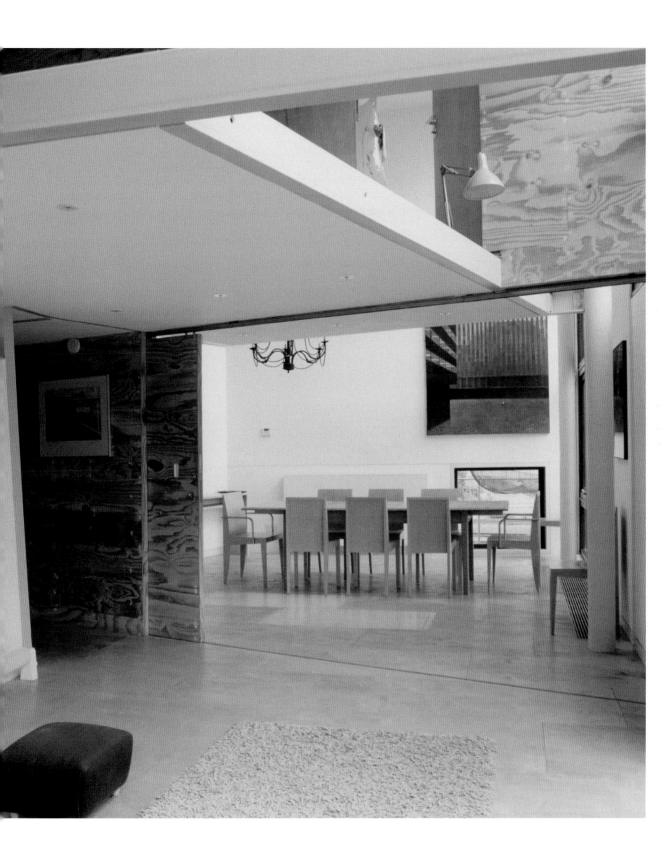

Right **The top-floor lookout reading room peeking above the grass roof.**
Below **The garden provides a welcome retreat from the frenetic urban surroundings and supplies the household with vegetables.**

And Samantha Hardingham, who best captures the ambiguities inherent in the project, wrote that it is 'part farmhouse, part allotment, part Modernist villa, part castle, part bunker'.

The most intriguing word in that sentence is 'villa', a type of house that evolved in the classical world, was revived by Palladio and later advanced through any number of iterations from the Parisian Hotel to George Washington's home to the smaller English Palladian country house and the suburban detached home of the early twentieth century. The villa suggests

a mathematically organised building (or arrangement of buildings) to provide maximum comfort for its owners, laid out along Vitruvian lines of orientation and the civilised arrangement of rooms. Sarah and Jeremy's house is, by contrast, laid out along railway lines – the Great Northern track which runs adjacent to one wing of their home, the quilted office block for Sarah's architectural practice.

But many of the core ideas of the villa are there in The Straw House. The enclosed courtyard offers privacy and retreat, albeit formed from the perimeter of the old

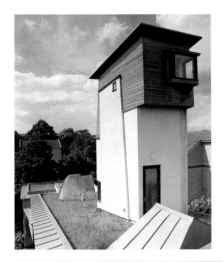

A five-storey tower of books rises through the roof culminating in a top-floor lookout reading room. The tower acts as a thermal flue, catching the wind and allowing natural ventilation to cool the house in the summer. The roof of the house is planted with wild strawberries, grasses and flowers.

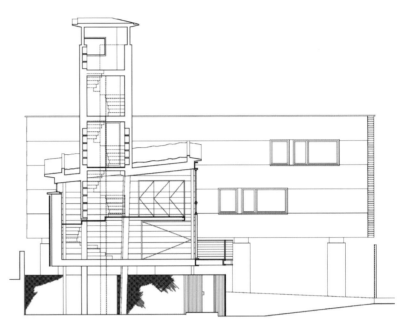

industrial site and the deliberately jumbled arrangement of buildings. Buildings are arranged in wings, each with its particular function: sleeping, living, working, like a model Palladian farm villa, but since when did Palladio organise his houses with an entire wing for sleeping? Classical order is perforated by anarchy, the rules of visual conformity are thrown away and the buildings wear both their function and their hairy, straw and duvet, green credentials on their sleeves. Not that those sleeves are crudely stitched. Jeremy and Sarah are sophisticates (Jeremy was a Professor at Sheffield University whilst Sarah's practice is considered to be among the most progressive and enquiring in Britain) and their home bursts with detail, symphonically articulated, full of prodding, investigative ideas.

Many other architects would have attempted a more contextual fit. Something to reflect the mix of old and new surrounding houses plus the infrastructure-scape of railways and overhead power cables. But that would have given the world something in much better taste that was much more forgettable. Instead, The Straw House is one of those wild and influential projects in architecture that, just occasionally, re-direct our thinking. Not surprisingly, in 2010, Sarah produced a book about the project which has been seized on by architects and students with the same enthusiasm with which they embraced the building. The book inevitably follows the same eclectic lines as the house. It delves into the messiness of building, Renaissance ethics, contextual design and feminist materiality and is as exploratory, open, incidental, argumentative, polemical and enjoyable as the building itself. Both celebrate the magical tension between us, our built environment and our notions of how that environment should be.

CRUCK-FRAMED WOODLAND HOUSE

The most sublime outdoor peeing experience I have ever had was in a purpose-built rustic woodland latrine built by Ben Law.

Imagine an upturned stout wooden box, 3 foot square and 3 foot high. At the front is a step and in the centre of the top surface – which is bum-polished smooth – is a large hole. The entire affair sits over a hidden pit in the middle of a chestnut forest somewhere in Sussex. For modesty's sake there's a 5-foot-high hurdle wall around the latrine, built from woven chestnut laths split from small branches. Above, suspended on poles at the corners of the walls, is a ceiling hurdle panel, installed for protection from bird droppings, the odd shower and, presumably, sunburn to the privates. As you sit and look around the entire forest reveals itself to you in a new way, viewed through a man-made frame

from a man-made viewing platform. You entirely forget the purpose of your visit – you commune with nature.

Ben Law built his house from the woodland that he owns, in the same spirit; with a respect for place and a love of the magic that can descend when you spend your time living alongside the natural world. For many of us, the countryside is a threat or inconvenience. For Ben it is a resource and a source of wonder and delight. His home has a frame of round poles, each coppiced. Now, seven years after they were cropped, the sweet chestnut tree poles – or coppice stools as they are called – have regrown to the height they were when Ben felled them. His house – in embodied carbon terms at least – is invisible.

Coppicing is a form of natural magic. It defies belief, given that when you chop down a fir tree or spruce, that's it – the tree doesn't regrow there and neither does anything else for a while. But in a coppiced woodland, as the stump quickly

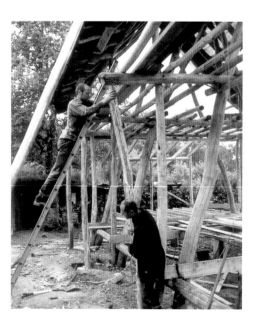

Left **Ben built his house, with a team of volunteers, in just six months. They are shown here erecting the sweet chestnut cruck frame.** Above right **Walls are clad in oak and chestnut boards whilst the roof is finished with sweet chestnut shingles.** Right **The house has weathered over time, blending in with its woodland surroundings.**

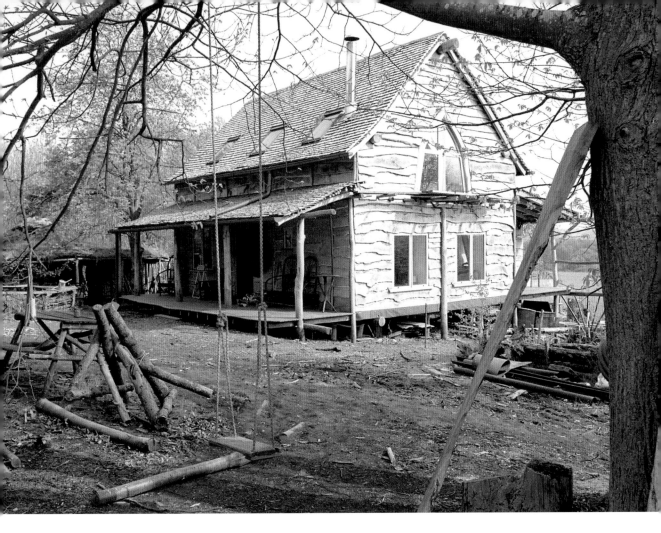

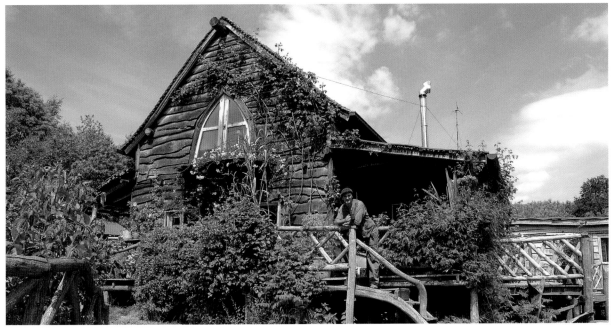

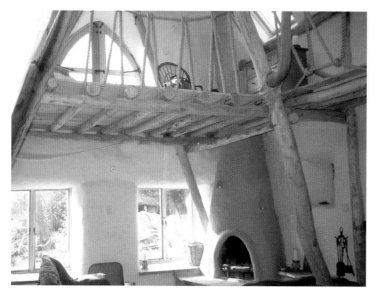

Above left **The fire is set into a huge cob chimney. Wood for fuel is, of course, free.**
Above right **Ben Law outside his woodland retreat.**
Right **The soaring cruck frame rises majestically into the roof.**

regrows, so do vetches and violets in the new-found warmth and light of the clearing. Certain species of tree, notably willow, hazel, ash and sweet chestnut, will tolerate being cut right down to the ground once the tree has lost its leaves and shut down for the winter. Next spring a new crop of fast-growing and straight poles will spring from the stump that in five or 10 or 20 years can once more be harvested. Because of the developed root system, the growth can be prodigious. A tree can put on several metres a year and the poles, after 10 years, can really 'girth up'. If you could coppice human beings we could all live forever.

As the poles grow into a bush, nightingales, turtle doves and dormice are attracted. Later, flycatchers will dart around the tall airy poles of a well-managed copse. Some species are even totally dependant on coppicing for their survival, like the pearl-bordered fritillary, a now-threatened species of butterfly.

You may find the idea of living in the woods and depending on the land around you for food, water, power, warmth and solace terrifying. You might wonder what you'd do without a freezer or an iPod or

a hot bath. But Ben has all of these things. He runs a small fridge/freezer from power stored in a bank of old submarine batteries and generated by two small wind turbines and an array of second-hand photovoltaic cells that had previously graced the roof of the *Big Brother* house (first series). He can power the house (all on 12 volts) enough to provide all the music and entertainment he and his young family need. His wood-fuelled Rayburn stove heats the kitchen and the water (collected from the roof) to provide hot baths. And the old athwater is run off to water the vegetable garden while the wood for fuel is, of course, free.

We have revisited Ben twice in the television series. The first time, having replaced his bender and caravan for this fairytale home in the woods, he had found love and married and started a new family. That was heartening. The second time, he had added a workshop and training centre to his home – built of course in the same inimitable and delicate style. Ben's life is expanding and developing in the woods in a way that reminds us of the most fundamental role of architecture: to allow human beings to flourish.

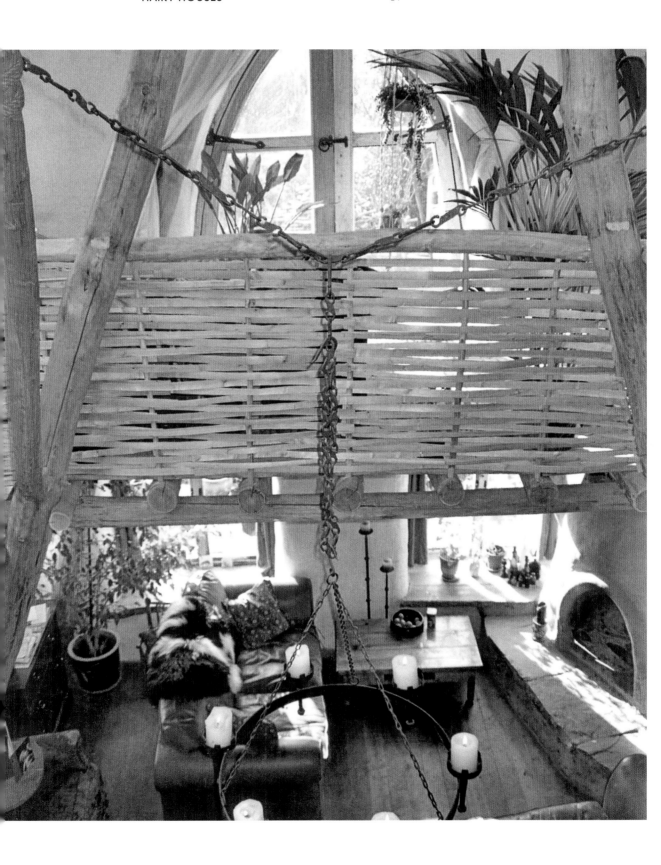

HAND-BUILT HEXAGON HOUSE

▼

The oak-framed house built by Kelly and Masoko Neville in the Cambridgeshire fens looks like a half-timbered medieval spaceship, the kind of thing a fourteenth-century carpenter might expect Martians to use when visiting the fens.

Its hexagonal shape draws its inspiration partly from natural structures such as leaf cells and honeycomb, and partly from Japanese tea houses and temples that Kelly and Masoko had visited together. Ben Platts-Mills, Kelly's friend and a gifted furniture-maker, carved the hobbit-like central staircase that forms the structural spine of the house; wherever possible, components are natural and/or locally sourced. Walls are clay or lime plaster over straw bale insulation; floors are terracotta; wall tiles and even the bath are made by artist friends. Timber abounds.

The garden is fed by rainwater gathered from the roof and 'grey' and 'brown' water that gets filtered and cleaned by the reed-bed sewage system. An underground microbiotic digester feeds on what are euphemistically known as the 'solids' in the waste and the accumulating sludge from this can also be used as fertiliser. This isn't fork-to-fork gardening: it's pan-to-pan.

Not only have Kelly and Masoko created a closed-loop cycle of food cultivation, they have a wind turbine to generate electricity and they grow their own fuel in the form of coppice willow that Kelly cultivates, harvests and then burns in a low-tech furnace to provide hot water and underfloor heating in their

Left **Kelly and Masoko Neville built their home as part of a quest to live in harmony with nature and be less dependent on the world.**
Above right **Hexagon House looks surprisingly at home amidst the Cambridgeshire fens.**
Right **The central staircase was carved from the trunk of an ancient oak tree.**

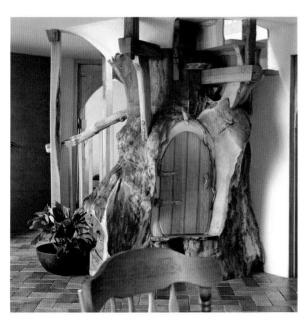

super-insulated house. Any carbon dioxide generated in combustion is effectively reabsorbed as the fast-growing timber sprouts again from the well-rooted coppice stump. The ash is recycled as a high-potash fertiliser which is good for apple trees.

Kelly and Masoko describe what they do as a form of permaculture, a movement that started in Australia in 1978. Initially concerned with redesigning agriculture using ecological principles, it has morphed into a general quest for a self-sustaining lifestyle that's a mix of ecological construction and organic gardening, and which avoids chemical fertilisers and harmful products in the home. As Masoko puts it, 'We want to live in harmony with nature. We just want to be a little less dependent on the world.'

THE GROUNDHOUSE EARTHSHIP

The Groundhouse in Brittany belongs to a tradition of sustainable earthships kicked off in the 1970s by the architect Michael Reynolds who specialised in futuristic semi-underground adobe dwellings in the New Mexico desert.

Like Reynolds, Daren Howarth and Adrianna Nortje set out to build a house that was off-grid and constructed from recycled materials; a passionate reflection of their reluctance to over-depend on petrol, oil and plastics or products that need a lot of fossil fuel energy to produce.

The house itself is carbon neutral and a capturer and generator of energy. It faces south, allowing the living space to utilise every available ray of sun. With a little help from wood-burning stoves it maintains a temperature of between 18.7°C in winter and 22°C in summer. It also processes its own waste and, through providing the wherewithal to live modestly and independently, it reduces waste in the first place.

For a building that relies on the heavy thermal inertia of the ground, is ecologically sensitive and treads lightly on the planet, it's somewhat shocking to think that it is built with steel reinforcement, vulcanised processed rubber and huge quantities of embodied energy in its walls. But that's because said walls are built from old tyres. Tyres are among the most problematic and energy-intensive products we consume. And consume we do: every year in the UK we throw away 486,000 tons of them – of which only a tiny fraction are recycled or reused. So to use them in construction to help build super-strong earth walls is a compelling idea.

Just as compelling is the idea of staying in one place, and exploring your dependency on it, by tending it, growing food, chopping fuel and exploiting the energy that the sun can provide for free. The earthship and its garden represent a synthesis of home and lifestyle, of house and garden, mankind and our planet – and a salutary reminder of our ability to organise, invent, create and transform inhospitable corners of the universe into places that lift the soul.

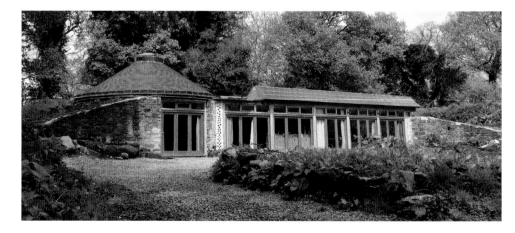

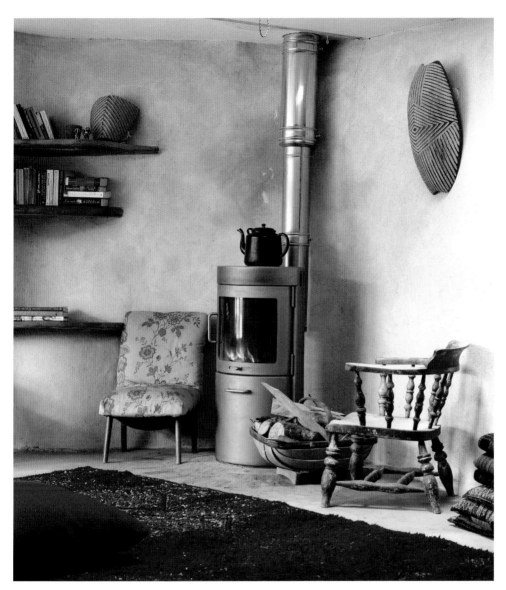

Far left **The earthship and its grounds represent a synthesis of home and garden.**
Left **Wood-burning stoves help the house to maintain a temperature of between 18.7°C in winter and 22°C in summer.**
Below **Daren Howarth and Adrianna Nortje relax in a house that was built not only to respect the planet but to nourish the soul.**

Discarded tyres are used in the construction of the super-strong earth walls to the rear of the house. South-facing glazing allows the living area to take advantage of every available ray of sun.

UPCYCLED BUNGALOW

▼

Buildings reflect place, time and people. When designed and built to order, houses reflect in the most highly tuned, the most eloquent of ways, the strains and traits of their owners' characters. The most audacious of them reflect the most audacious patrons. Likewise, the most modest reflect the natural shyness of their creators.

But what about the role of architecture to reflect the energy of a place and speak of its time? And what about its role to act as a crucible for ambition and offer its inhabitants undreamed-of environments which go way beyond their initial ideas? Any good architect will take a brief from a client, knead its contents and let them prove before baking them to perfection in their CAD oven. Only then will the clients' original vision be both fully formed and fully explored. It's like watching a Michelin-starred chef taking the raw materials of an egg pudding only to return with an out-of-this-world soufflé.

Given these lofty aims of design, it's not surprising that when a client brings a natural modesty and love for the existing, a certain tension is going to result.

Right **The existing bungalow, now clad in burnt larch, is distinct from, yet clearly related to, its bold new extension.**

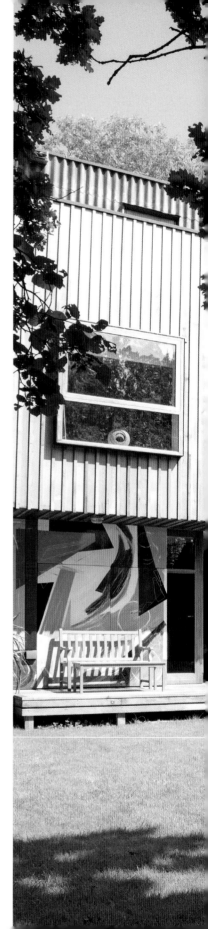

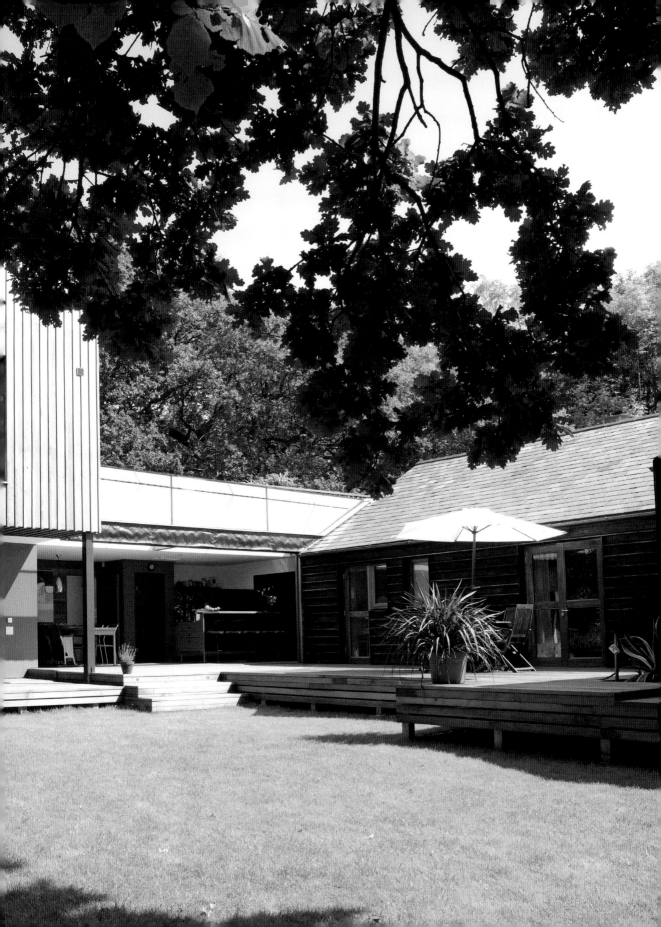

This project, the result of a collaboration between client and designer (artist Lisa Traxler and Lincoln Miles, who were partners when they built but who have now married), treads that fine line between statement building and modest conversion; between energy and calm. The building has many of the top-ten trappings of modern architecture: a glass roof; spaces that consecutively compress and release you; a giant sliding door that lets the outside in and inside out; occasional ambiguity of spaces. But each one is rewritten to Lisa's brief. She wanted to retain the 1970s bungalow on the site – in which they had lived for three years. She wanted a larger studio to replace the leaky garage she had previously used to paint in. Any extension to the building should be almost completely hidden from the road. The new home should feel bright, in contact with the surrounding forest but fundamentally modest.

So the sliding glass wall is a sculptural arrangement of windows set into a walnut frame. The glass roof is used highly intelligently to wrap internal walls but also create separation between old and new buildings and exterior and interior claddings. Lincoln meanwhile had to rein in his own 'greed for space' as he puts it, and learn to work within Lisa's restraints. What emerged is one of the finest homes I have ever visited.

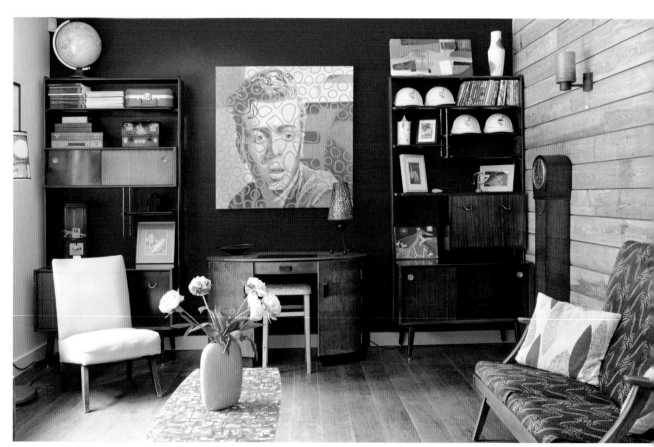

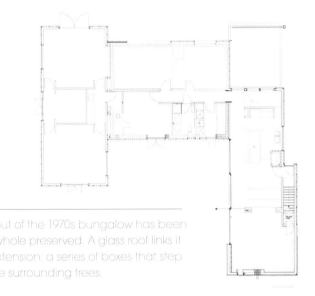

The layout of the 1970s bungalow has been on the whole preserved. A glass roof links it to the extension: a series of boxes that step up to the surrounding trees.

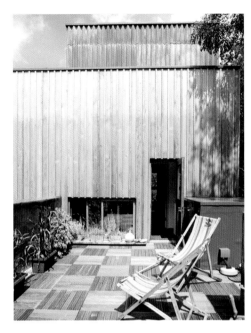

Above left **Lincoln Miles, standing, with Lisa Traxler to his right, and her daughter Ellie.**
Left **The house feels like a stitched and repaired garment, gloriously assembled with some new fabric, a comfortable lining and some vintage trimmings.**
Above right **Larch and concrete corrugated agricultural cladding reflects Lincoln's interest in experimenting with materials.**

It is not entirely a new build. It is not an excoriating statement of white render and trendy glass walls. It is enormously considered and the building, above all, feels like a stitched and repaired garment, gloriously assembled from something out of the back of the wardrobe with some vivid new fabric, a comfortable lining and some vintage trimmings. The bungalow was clad in burnt larch (the burning forms a charred, resinous protective coating) and slates which sparkle in the rain like mussel shells from the beach that sits just the other side of the woods. Its layout was on the whole preserved. It is now joined, thanks to the glass roof, to the new extension, a series of boxes that step up and into the canopy of the surrounding trees, like children's building blocks.

No series of *Grand Designs* would be complete without an experimental project, preferably in the hands of a pair of artists. This one was made all the more fascinating by Lincoln's inquisitiveness for experimenting with materials, whether agricultural, vernacular or high tech. The larch and concrete agricultural

corrugated cladding were two such experiments. As was Lisa's attempt to patinate the latter with a mixture of cow-dung and live yoghurt. Three years on, the panels are still resolutely grey. But no matter, because the mottle of moss and algal camouflage that Lisa anticipated might have thrown this building too far into anonymity. The building is better for being slightly more assertive and allows Lincoln a few glorious moments to relish its architectural crispness.

Recycling a building is clearly a less wasteful and more resourceful way to save carbon and materials. Upcycling that building and reinventing it as part of something else is even more creative. It revivifies a place. And it allows the fabric of the old structure to be re-insulated and adopted into the energy performance strategy of the project. But perhaps, above all, it strengthens the narrative of a project and helps all the new additions feel more connected to where they are.

As a result this house feels more rooted, more delightful and far more autobiographical than most.

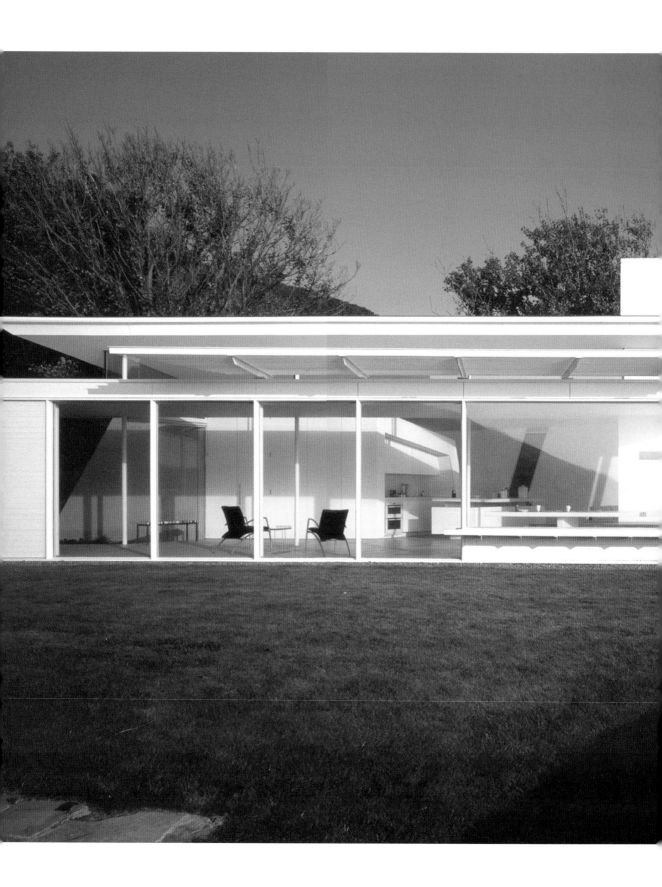

04
THE SMOOTH AND POLISHED

Just as the tree is to the veneered and polished china cabinet, so the rough-at-the-edges hairy homes of this millenium are to the precision cabinet-making houses here. These projects celebrate straight-edged craftsmanship judged by the laser as much as the eye. But they are just as contextual and just as finely tuned to their setting as the buildings that precede them.

THE WOODEN BOX

▼

Some Grand Designers are driven by a Big Idea. An uncompromising vision about the way they want to live. Others, like John and Terri Westlake, are reluctant visionaries.

They were wedded, not to an architectural ideal, but to a particular plot of land; a patch of open country on the Northamptonshire/Cambridgeshire border that Terri spotted whilst out driving on a fateful rainy day. She was struck by the views, and hatched a plan to build an extension to the ramshackle nineteenth-century cottage that occupied the site.

But their architects, Andrew Budgen and Nathan Lonsdale of Spacelab, had other ideas. Namely, to raze the cottage to the ground and build a brave new box; a perfect cuboid clad in cedar (or, in the event, clad in rather less costly tongue-and-groove pine), and with full-height south-facing glazed façades. Having lived in a gloomy, light-starved Northamptonshire cottage, the Westlakes were easily seduced by talk of an open-plan double-height living room, light, bright, airy interiors and – best of all – sweeping panoramic views.

But it takes a certain dogged commitment to live in such purist perfection. The Westlakes quickly came to the conclusion that open-plan living doesn't necessarily lend itself to children, and all the clutter and chaos and noise that they inevitably bring. They went back to Spacelab to commission an (appropriately purist) extension attached to the main house by a double-storey glazed link.

And although they may have had their fill of cramped cottagey quarters, they realised that light and spacious minimalism can have its downside too. Whilst they loved the place in summer, the winter months started to feel a bit bleak. Hence – to the architects' horror – they took matters into their own hands, turning

A glazed link building links the original house to the smaller extension, protecting the purity of the two box-like forms.

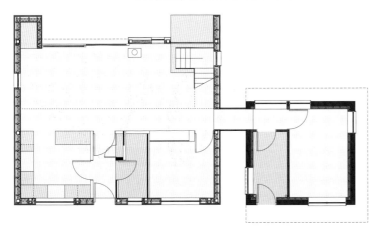

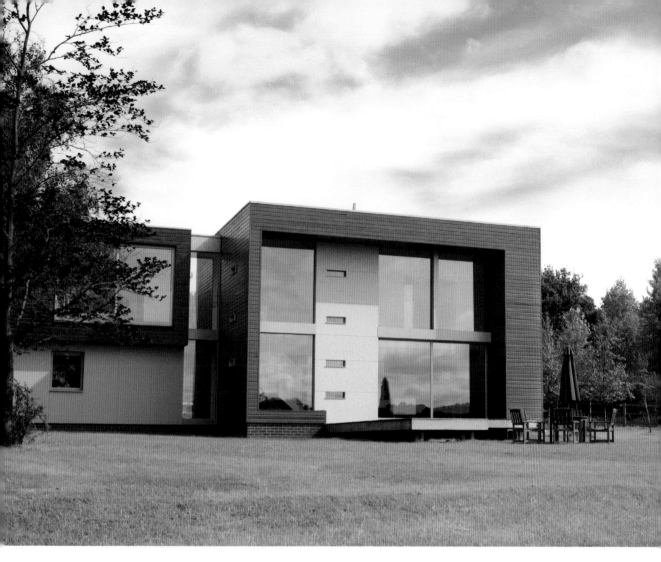

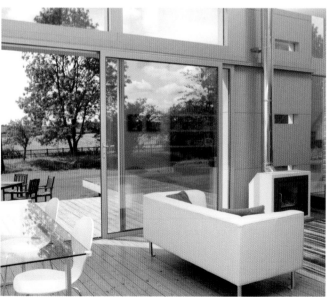

the office in the main house into a cosy, slouchy living-room-cum-snug designed for curling up on the sofa and watching TV.

So there you have it. A compromised masterpiece. Or, to paraphrase Simon Cowell, a welcome instance of a couple running with somebody else's classic hit, and making it their own.

Far right **John and Terri Westlake with their children.**
Above **The original cuboid is joined by a smaller, more enclosed, extension.**
Left **The double-height open-plan living room enjoys panoramic views.**

SUNNYBANK PASSIVHAUS

There's nothing architects hate more than a client who changes their mind once a project has started on site. So it must have come as something of a surprise to Jim Lucas and Jennifer Mole when their architects, Venner Lucas, came up with a new suggestion for the design of their home in the Scottish borders, four months into the year-long construction programme.

Venner Lucas proposed that the house, called Sunnybank after the 1970s bungalow that previously occupied the site, should be built to the Passivhaus standard. In other words, they would minimise energy consumption by super-insulating the house, making it airtight and then using a heat exchanger to introduce fresh air to replace outgoing stale air.

It wasn't quite as dramatic a *volte face* as it might sound. The design already included a heat-recovery ventilation system with ground source pre-heated air. More importantly, it followed the basic principles of passive low-energy design, working with the contours and orientation of the hillside site to minimise energy use. Main living spaces were stacked towards the front of the house with a two-storey south-facing glazed façade to take full advantage of solar gain. Storage and service spaces were lined along the northern side of the building, tucked into the slope of the hill.

Nevertheless, the decision to switch to Passivhaus required some significant changes. Plans for a biomass-powered underfloor heating system were ditched, whilst the building fabric was made more efficient by way of triple-glazed windows with insulated frames and thicker insulation on the walls, floor and roof. To make the building more airtight, they introduced a service void between the

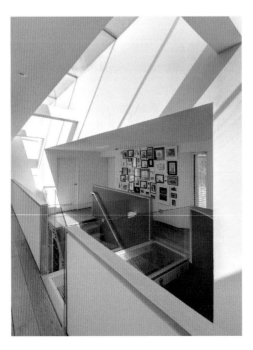

Left **A full-length skylight and glass bridge bring light deep into the interior.**
Right **The house is tucked into the slope of the hill.**
Above right **The south-facing glazed façade takes full advantage of solar gain.**

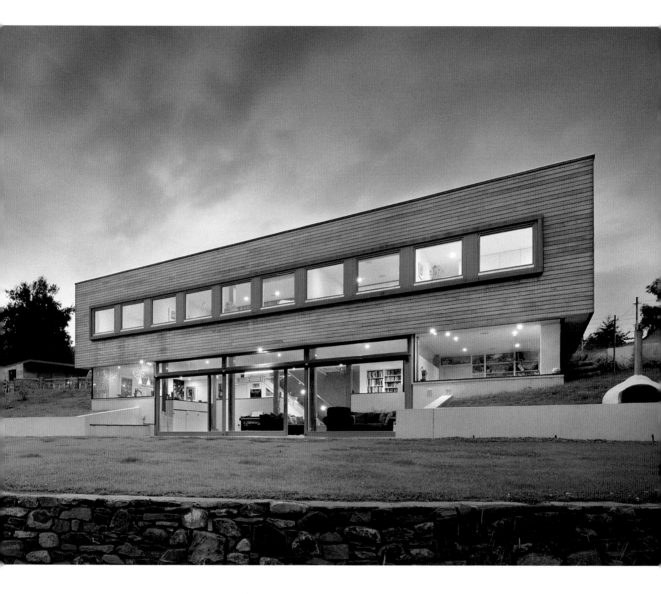

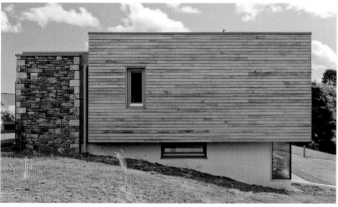

shell of the building and the plasterboard finishes hence doing away with the need to poke holes through the walls.

Not that you'd ever know. Despite the last-minute changes, the finished house shows no sign of ad hoc decision-making or compromise, and gives no particular clue as to its impressive environmental credentials. With its clear plan and super-clean design, Sunnybank is the antithesis of the hairy eco-home: a strong, polished house, with the bonus of extremely low energy bills.

TWO TIMBER ECO HOUSES

This is not one, but two, houses constructed on an almost land-locked site in south London, by a man of wood, Australian cabinet-maker Bill Bradley, who brought his love of finesse to these buildings and constructed them – with his own firm's labour – as lovingly as if they were pieces of furniture.

As a result doors, windows, shutters and built-in furniture operate and fit into this building with all the precision and poise of a dovetail-jointed drawer in a Hepplewhite credenza.

Bill's own house for himself and his singer wife Sarah (funded partly by the sale of the second, adjacent house) is one of those eco-homes that follows the lightweight route: it is a super-insulated timber frame, with a small thermal mass, that sits on lightweight mini-piles screwed into the ground. It's a compelling construction method that absolutely minimises the use of concrete (there is no slab and no strip foundations) and which is relatively cheap on stable ground, as well as being environmentally friendly.

Right **The living room opens onto a central glazed courtyard that brings natural light deep into the plan.** Far right **Bill Bradley and his family in the courtyard of his house.**

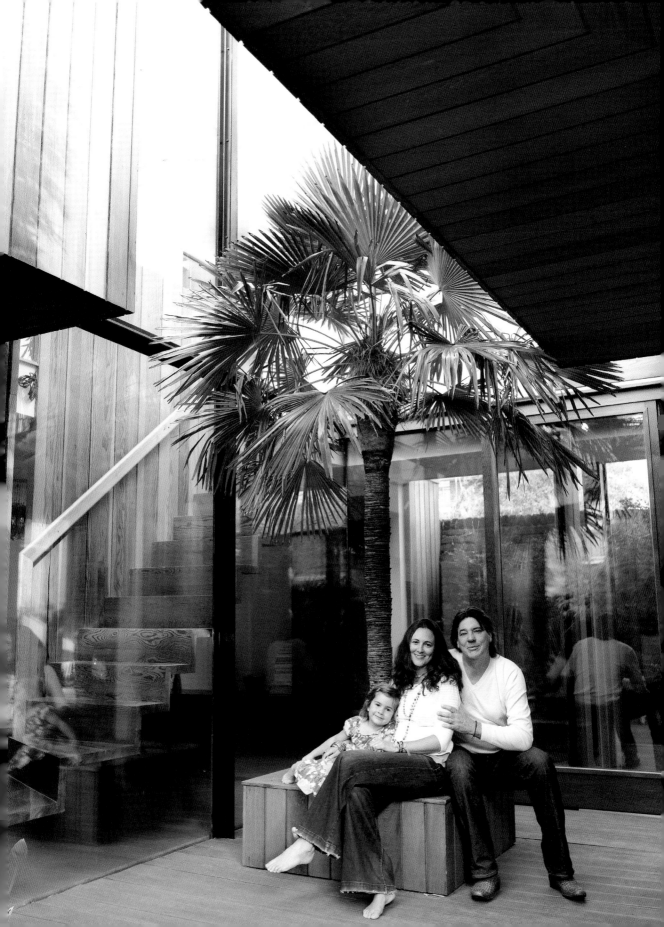

This project is not one, but two, houses constructed on an almost landlocked site. The project was funded, in part, by the sale of the second house.

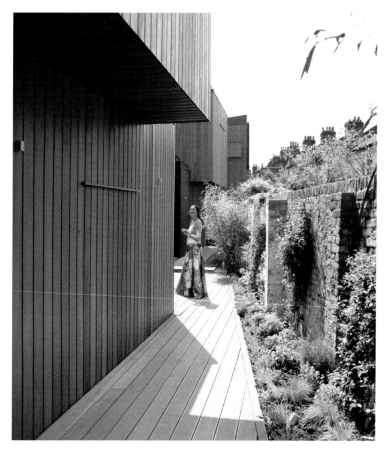

However, the lack of thermal mass that accompanies the absence of heavy materials open the buildings up to potential overheating problems. Bill may one day decide to retrofit one of the new innovative phase-change lining boards being developed for lightweight timber buildings.

Meanwhile, what the modest house lacks in thermal mass, it gains in gravitas. The design, by Hampson Williams, turns a crushing planning condition (that the building cannot overlook the surrounding neighbours' houses) into a triumph of ingenuity. There are skylights, light boxes that project out of the building with only their side walls and roofs glazed. There are shutters, large glazed areas at ground floor level and windows with views that just graze the sides of the buildings. The masterpiece is the centrepiece of each of the houses: a mini internal courtyard, glazed to full height, so that the buildings can look in on themselves and suck light from the very centre of their plan. This is a design, that if not a template,

is a wellspring of inspiration for anyone wanting to build on a difficult, urban, overlooked site.

It is also ingeniously ventilated, with shutters and openings that draw fresh air up and through the building from the cooling gardens below. As with so many of the projects we follow, the design is not a one-solution-to-fit-all. It is a building driven by philosophy as well as engineering that is tailored to its site and which deals with the weaknesses of its building system (and there are always weaknesses) intelligently. And Bill was always a man of wood. Why would he build in anything else?

Why also, as a maker of things, would he not also insist on a kitchen of his own design and making, a staircase made entirely of timber, and furniture everywhere that is bespoke and full of the invention and originality that he and Sarah bring to the pieces he makes? I've always thought that the best architecture is that which continues to engage you as you get to know it and which improves the more you explore it. Bill understands this instinctively and, with Hampson Williams, has procured two homes which are pieces of detailed craftsmanship yet powerful objects as well.

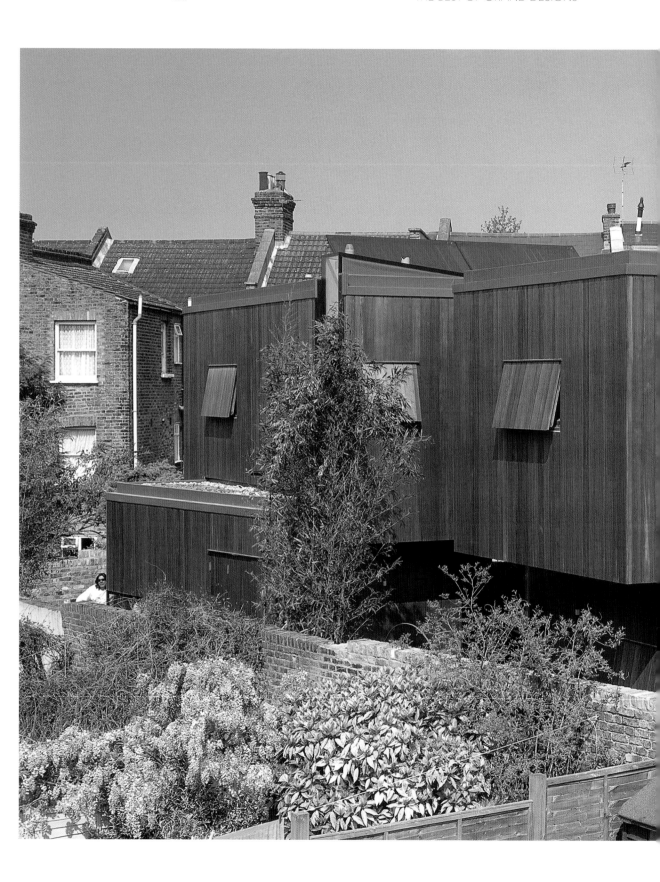

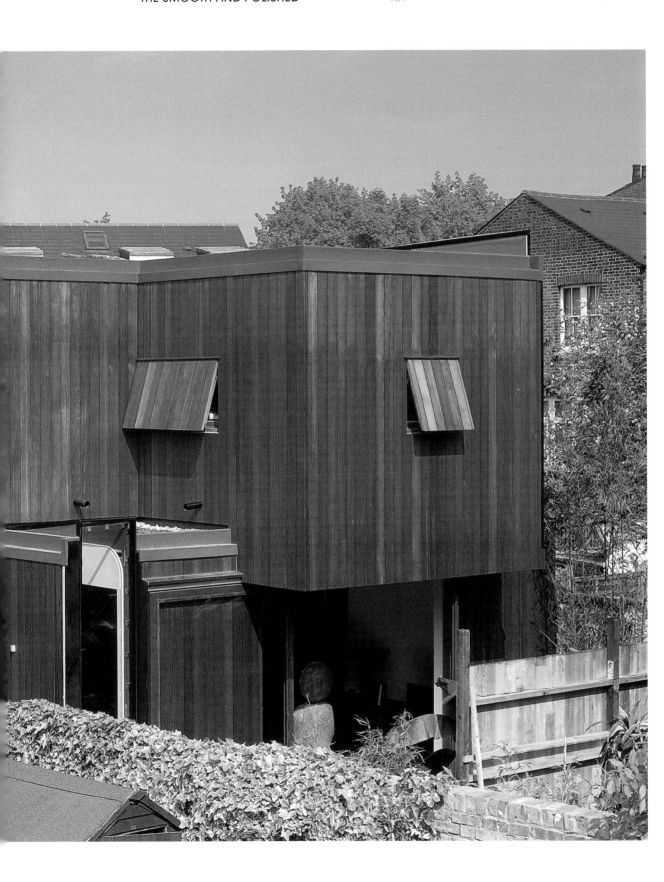

LIME KILN HOUSE

▼

Big: that's the adjective to describe this project. Big ambition, big scale, big vision, big people, big furniture, big landscape.

On seeing the television programme you might have thought that the house that Richard and Pru Irvine built on the site of an old cement quarry in Midlothian was a mite over-indulgent; that despite its weather-coat and cap of shingles and cladding, its giant white façade stuck out like a sore bare belly.

But let me tell you that everything on this project worked. The structure is straightforward – two split-level boxes enclosed between a gigantic retaining wall built into the hillside and a partly glazed double-height south-facing curtain wall. Its attitude to sustainability is straightforward and pragmatic: the 60-inch-thick walls are stuffed with old newspapers. Anything too tricksy or expensive was automatically ruled out – leading the Irvines to an economical but effective choice. For all its size the house

uses one-third less oil than the adjoining cottage which the Irvines lived in during the build and is now a holiday let.

The internal layout is simple and in fact modest: there was no gym or cinema room or equivalent indulgence but there was plenty of investment in craftsmanship. The entire building is in proportion. Yes, the scale is large but it needs to be in this part of the world where the setting is open and the views distant.

The Irvines briefed their Edinburgh architects Icosis to design a building in a style that was 'long, low and international', but somehow ended up with something a little bit more shaggy and a little bit less sleek. Something altogether more suited to the rugged beauty of the landscape. It's assertive, but it is also sensitive and subtle, sitting comfortably on its site.

There are many projects where 'landscaping' means putting in a garden. Here, it means teasing a new meaning out of the site and setting, knitting this building into the hill, and weaving a relationship between the new architecture and the two huge lime kilns that keep watch over the Irvines' house.

Above right **Two enormous lime kilns keep watch over the house.**
Below far right **The Irvine family enjoy their new home.**
Below right **An outdoor terrace offers a sheltered space to enjoy the open view.**

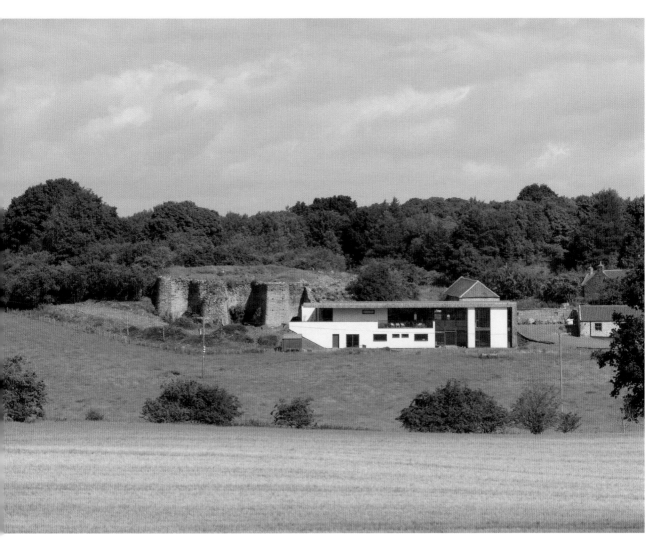

The entrance hall is on the upper floor, and leads to a bedroom at one end of the house and the kitchen/dining room and drawing room at the other. The family bedrooms occupy the lower floor, enclosed by a solid retaining wall built into the hillside.

KENT MODULAR HOUSE

▼

This striking Kent house made from prefabricated timber panels can be glibly described as three portakabins glammed up with some cedar cladding. It can also – more poetically – be described as a deceptive building that plays with its own materiality by reflecting and refracting views of the woodland around it; a building that is a master of disguise. And with time, as the untreated timber cladding ages to match the tree trunks around it, that disguise will be complete.

Mimi da Costa and her husband Andre had spent 16 years dreaming about building their own house before they found their dream site, complete with apple orchard, wildflower meadows, woodland and stream. They had clear ideas as to how they wanted the interior spaces to work. They knew, for example, that they wanted the staircase to be part of – as opposed to apart from – the life of the house. The result is a circular stair encased by a latticework of mementos and books – a living tower that serves as an autobiography of family life. Four desks built around the base of the stair allow the couple and their two sons to work at the same time.

They had fewer fixed ideas about the external appearance but, working with the eminent architect Nick Eldridge of Eldridge Smerin, they set about designing a house that complements – and takes full advantage of – the landscape. Views out are luxurious, uninterrupted and vast, aided by the fact that almost 50 per cent of the façades are glass. Not any old glass, but triple-glazed heated IQ glass, a Belgian product that

Above right **Façades are a combination of untreated timber cladding and triple-glazed heated IQ glass.** Below far right **The staircase is a part of, rather than apart from, the life of the house** Below right **The pool locks the sun's heat into the water in summer and releases it in cooler months.**

The circular staircase that rises through the house is encased in a latticework of mementoes and books – a living tower that serves as an autobiography of family life.

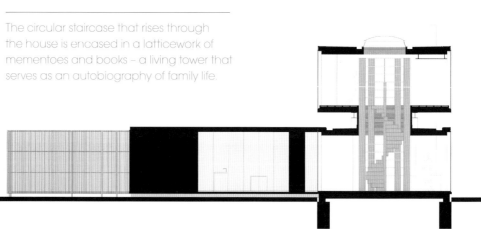

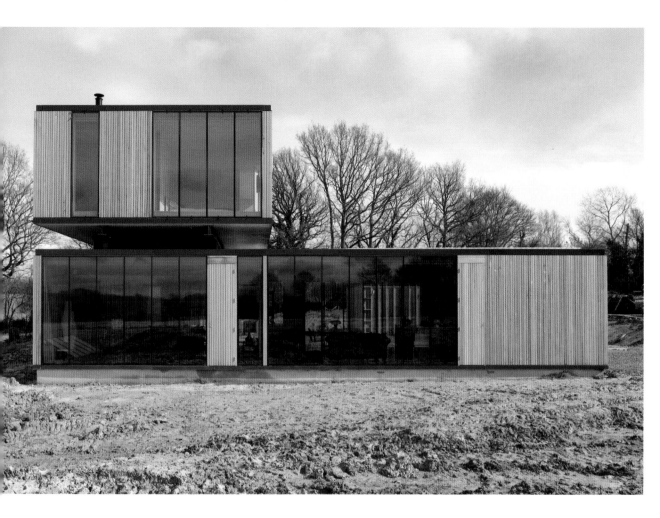

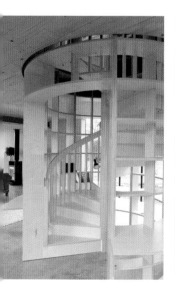

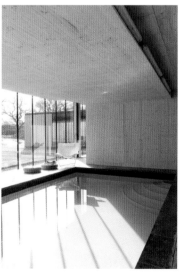

is remarkably efficient as an insulating window and remarkably effective as a radiator too. So much so that heating the house costs around half of what it would conventionally cost to heat with electricity or gas.

The house is airtight and ventilated with a heat recovery system. The indoor swimming pool is a giant thermal battery, locking the sun's heat into the water in summer (directly through the windows and indirectly from solar panels) to release it in cooler months via the ventilation system. This is an intelligent, well-managed and beautiful house.

SMALL HOUSE

What do you do when you can't afford a house in the place you want to live? For Australian architect Domenic Alvaro, the solution was simple. Find a site and build a house yourself. And if the land is too expensive? Just don't buy very much.

Domenic and his partner Sue Bassett are committed urbanites who had set their hearts on finding a home in Surry Hills, an inner-city suburb of Sydney, Australia. Their budget didn't run to a house, but it did run to a corner site wedged between an industrial building and a terrace of housing. The only hitch was that, at 7 metres long and 6 metres wide, their little patch of Surry Hills was roughly the size of a typical suburban garage.

Inspired by Japanese architects, who pride themselves on squeezing the most possible uses into the smallest possible space, they came up with a

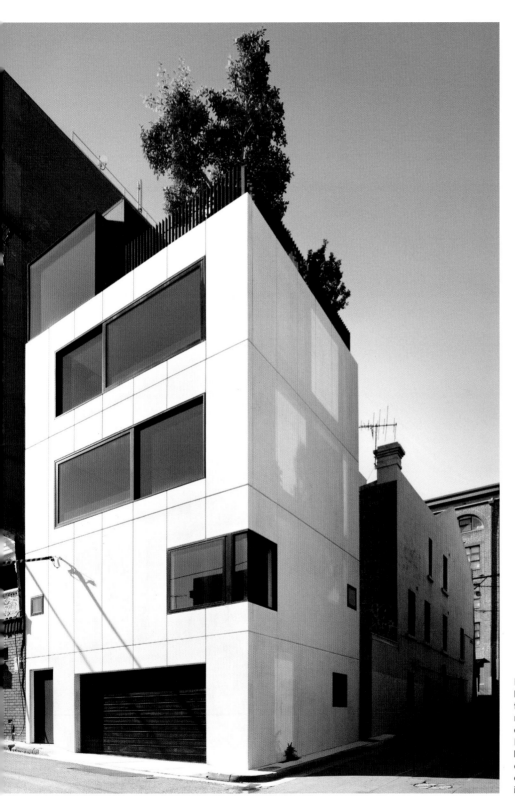

Far left **At 7 metres long and 6 metres wide, the corner site was roughly the size of a suburban garage.** Left **The house was built from prefabricated concrete panels moulded off site and assembled in four days.**

Right **Simple interiors
and minimal furnishings
make the most of
compact rooms.**
Below **Sliding glass
doors link the study
to a rooftop garden.**

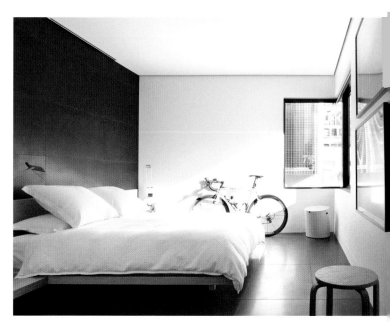

design for a five-storey house – hence shoehorning 220 metres of living space onto a 42 square metre site. The ground floor is given over to parking, bicycles, utility and storage space. In spite of the tiny footprint, three bedrooms, two bathrooms and living, kitchen and dining space have been squeezed into the three floors above. The fifth floor is a 'working' roof garden: a study with sliding glass doors opens onto a lush rooftop garden complete with herbs, flowers and a large fig tree.

For Domenic, a principal at the Sydney studio of global architectural practice Woods Bagot, the project – known as Small House – is not only a personal odyssey but a professional mission statement; a potential solution to the urgent needs for cities to evolve more efficient ways of accommodating population growth.

Built from prefabricated concrete that can be moulded off site and assembled on site in four days, it addresses the problem of needing to build at speed on constrained sites. Perhaps more importantly, it encourages a different attitude to urban space by demonstrating that creative and ingenious design can magic much-needed living space out of even the tiniest patch of land.

Above **Spaces are small but perfectly formed.**

CLONAKILTY CLIFFTOP FARMHOUSE

At first sight, Niall McLaughlin's extension to this house in Clonakilty, County Cork, looks angular, brusque and aggressively at odds with its clifftop setting. It's bolted onto a traditional farmhouse, built in that soft, thick-walled Irish west-coast vernacular, yet it's uncompromisingly futuristic. It looks like someone shoved a shard of glass through a beautifully smocked Irish linen bodice.

But you have to take a closer look, because Niall tends not to make mistakes. Each piece of work he produces resonates to its own frequency, with its own charm. I think the particular Irish magic of this design is revealed when you view the house from the hill above, from a place where passers-by might catch a glimpse. Looking down, the shape of this building suddenly makes sense: it repeats the extended finger-like shapes of the rocks below, on a similar scale, in a similarly robust way. Its angularity is a formalised version of those rocks; an architectural version that human beings can live in rather than be dashed against.

And just as the shape is a crystallised and geometrical version of the shoreline, so the materials of the extension/conservatory crystallise the geology of what lies below. The stone fingers were formed when – five hundred million years ago?

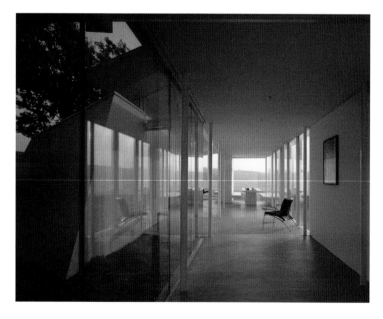

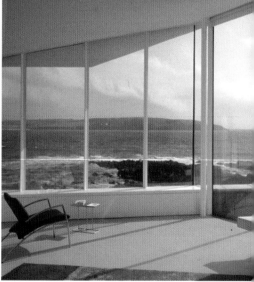

Grand Designs Award | 2006 | Ireland | Architect **Niall McLaughlin**

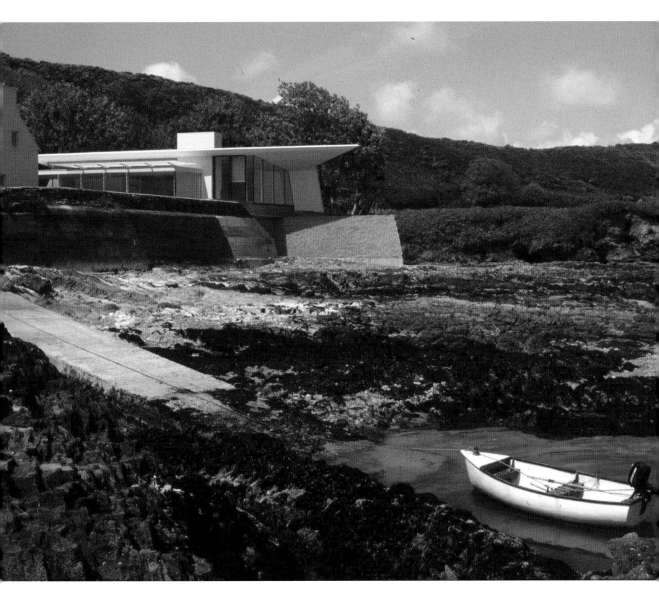

Far left **A glazed passageway frames the dining table, and a view across the bay.**
Left **The living space stretches out towards the water.**
Above **The old cottage houses the master bedroom, whilst the new extension houses kitchen, dining and living space.**

But Niall's concrete and glass are made of the same materials: ancient silica and clays and limestone. You could imagine a mythical giant breaking open one of the long gnarled rocks below and discovering inside the perfectly triangular sparkling quartz shape that has now materialised here.

Viewed in this light, the new building makes perfect sense. It revitalises the old farmhouse by redefining its relationship with the natural world. The old building used slate, rubblestone and split stone floors – raw materials in their unprocessed states. The new building transforms those raw materials, offering concrete and curtain-wall glazing as sacrifices to the Celtic Gods of Land and Sea. You have to look at landscape, farmhouse and new-build together to appreciate the relationship between them. The rocks are the mother stone which have yielded the diamond-in-the-rough which is the house. Niall's new build is a polished, faceted gem.

05
COSY
HOMES

There will always be, at the tables of *Grand Designs*, a special reserved place for the small, perfectly formed, exemplary family home. With few frills but great grace and energy, these buildings encapsulate all the qualities of big-ticket look-at-me architecture and scale them right down to normal size.

CONTEMPORARY NORDIC LONGHOUSE

▼

Tony and Jo Moffat, both musicians with the Scottish Opera, had long held a dream of a home in the countryside, but in commuting distance of Glasgow. They found their site – a steeply sloping spot above a tiny seaside village on the Rossneath Peninsula. The house was essentially a means of capturing, framing and enjoying the view – water, wildlife, distant beaches, misty hilltops and an endless ever-changing sky.

Working with the architect Andy McAvoy of Base Architecture they came up with a design that is largely open plan so that all the major spaces can enjoy the stunning views. Whilst the house is multi-levelled in order to negotiate – and take advantage of – the steeply sloping site, large picture windows mean that every level shares the same magnificent view – down the Clyde Estuary and towards the Isle of Arran.

But as well as celebrating the view, the house had to offer protection from the unforgiving coastal climate – not only physically but psychologically as well. It had to be seriously sturdy, but cosy too: a challenge in a building that is predominantly open plan.

The solution was a building type that was inspired by traditional Scandinavian architecture and local oak-framed barns, but that also borrowed from tough modern construction techniques: a green oak medieval cruck frame set into a concrete and aggregate base. It is a fearless combination of new and old technologies: a Nordic longhouse with a modern skin.

Whilst the exterior of the house is crisply modern, a white concrete base sheltered by an over-sailing zinc roof that echoes the colours of the ice-cold sea, the interior is altogether more tactile and romantic.

The inverted V-shape of the green oak cruck frames is suggestive of an upturned Viking longship or boathouse. Rarely used in construction today, these great curved timbers have an almost primal character that speaks of the past, of timelessness, of man's fundamental need for shelter.

This magnificent timber frame makes Tony and Jo's home feel – well, like a home – but it also acts as the ultimate picture frame, drawing the eye towards the view that was the building's *raison d'être*.

Right **Tony and Jo Moffat with their children.**
Above right **The zinc roof echoes the colours of the ice-cold sea.**
Below right **A white concrete base is topped with a timber-clad upper floor and sheltered by an over-sailing roof.**
Below far right **The inverted V-shape of the green oak cruck frame is suggestive of an upturned Viking longship or boathouse.**

Series 4 | 2004 | Scotland | Architect **Andy McAvoy, Base Architecture**

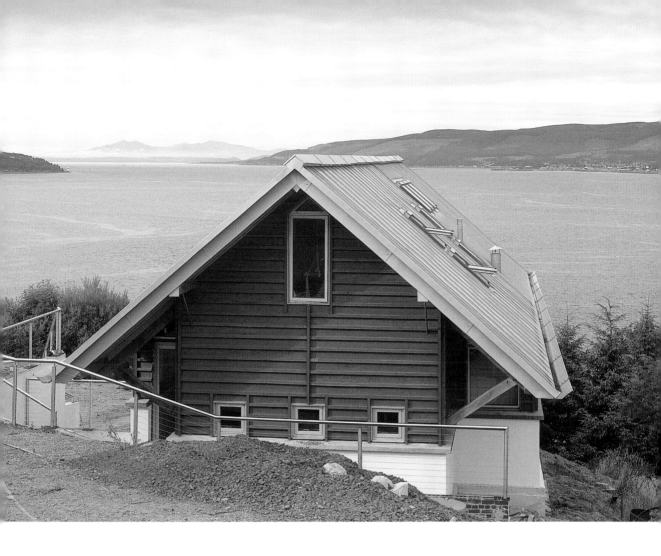

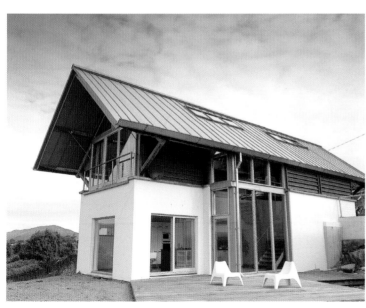

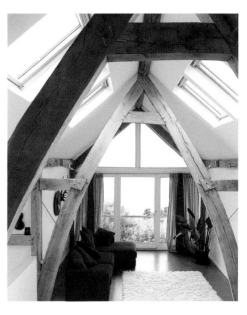

ARCHITECTURALLY EFFICIENT POWERHOUSE

▼

One of my perennial favourites, this delightful wooden box in the foothills of the Campsie Fells in Scotland is one of the handful we have filmed that can truly be called exemplary family homes.

Another is the house by Jerry Tate for Lucie Fairweather on pages 120–23 which, like the Leisjer house here, accomodates the average family whilst attending to them with the full range of architectural delight and practicality. It is this mix of comfort and joy that is nearly always missing from modern developer-built housing, and yet both these projects were relatively low budget and modestly scaled.

So what are the key components that a modern home can deliver, at very little cost, that we can all respond to? The architect Chris Platt of KAP Architects in Glasgow does not see this as any kind of standard template home but one which is highly sensitised to its site. The half-buried concrete basement, or lower ground floor, was a response to the steep slope of the site. The arrangement of windows was a

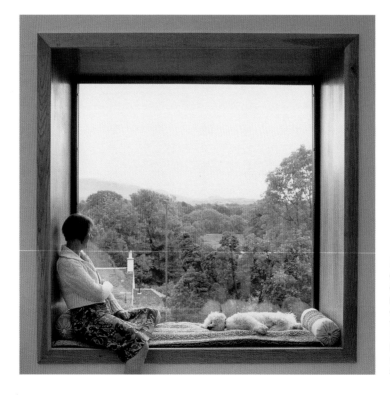

Left **Windows are organised to block out the surrounding properties and engage directly with the natural world.** Right **The half-buried lower ground floor responds to the steep slope of the site.**

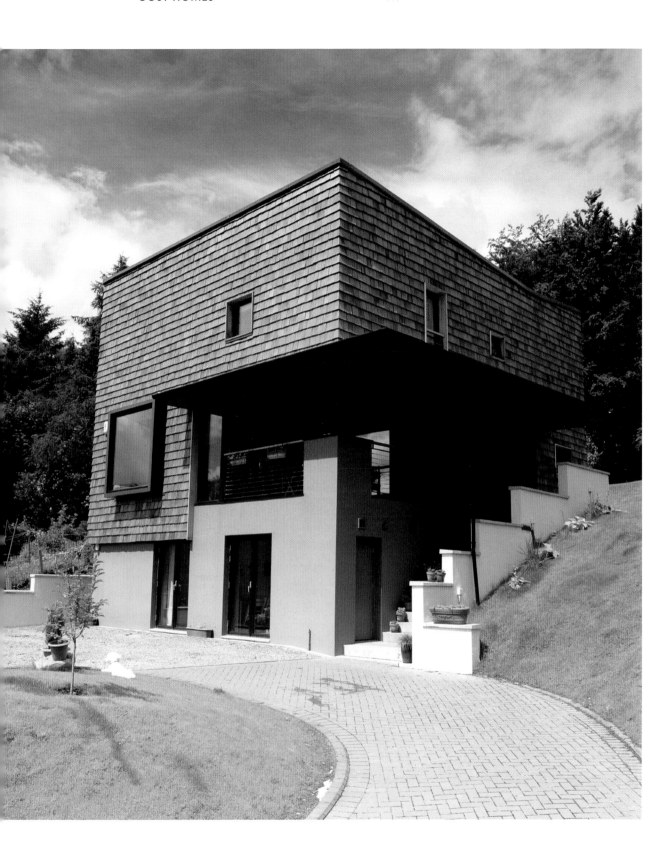

The simplicity of the cube-shaped form made the house economical to build. Despite being both semi-open section and semi-open plan the house stays warm all year round thanks to the super-insulated timber-framed construction of the top two floors.

direct response to the fact that across the valley rose the splendid ridge of the Campsie Fells, but in between and below the house ran the main road. Either side, there were existing houses. So the windows were organised to project and recede, to lead the eye up here or through a narrow slot there so that all you engage with is the natural world.

But in the building's simplicity of form (a cube shape is cheap to build) and its skin of rustic shingles which would quietly fit in just about anywhere in Britain, there is a repeatability that has appealed to other potential self-builders: Chris has been asked to reproduce the building exactly in another location, while a landowner in Africa wanted a dozen of them, adapted for his site. There's proof in the pudding.

Theo and Elaine Leisjer were the clients. Theo works in sustainable development, and, having worked around the world, wanted a comfortable home in which they could bring up their two sons. By comfortable he meant draught-free, warm, cheap to run and flexible. The carefully crafted views are the bonus here, one of which is provided by the full-width skylight that runs across the full-height atrium at the front of the building, affording a view into infinity from the sofa, night and day. The super-insulated timber-framed

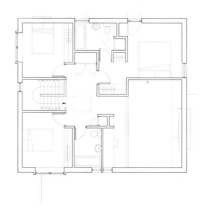

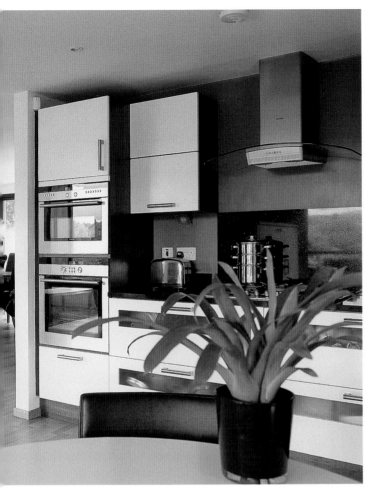

construction of the top two floors was precise enough to ensure excellent airtightness so that heat-recovering mechanical ventilation could be incorporated. But that was it. Other than the wood-burner, Chris planned no further complicated heating system, believing that cooking and people would provide all the heat necessary, even in Scotland in the winter. Theo didn't believe him and installed a gas boiler as back-up. A year later he received a gas bill for 21p.

Moreover, Theo and Elaine recently confided in me that in all the time they have lived in this house, none of them has fallen ill. The ventilation system, changing the air in the building many times more frequently than that required by building regulations, kept the internal environment free of the usual dust and mould that permeate poorly ventilated homes. If systems like this are vacuumed occasionally and the filters properly changed, they can transform indoor air quality. The Leisjer family health record seems to confirm that.

And as to their spiritual health, just what are the architectural delights this building crams in? Other than the giant roof light there's the open-plan and open-section design; the projecting bay windows that orientate magnificent views; the sense of compression and release in the circulation space; a Juliet balcony with hidden study space. And a whole host of carefully resolved details that are a pleasure to behold and contemplate. Making this not just a power-efficient house, but an architecturally efficient powerhouse.

Above **The kitchen opens onto the living and dining space.**
Right **The first floor living room enjoys a covered outdoor terrace. The wood-burning stove provides sufficient heating for the house.**

ASSERTIVE SUBURBAN HOME

▼

Grand Designs projects often reflect the taste of the time and current thinking in architecture. The German term for this is *zeitgeist* (literally, time-taste) but you might prefer the more lyrical view of the Tudor traveller and polemicist John Leland who described this essence as 'building in tyme of mind'.

Occasionally we project forward into the future of the mind, as architects design and deliver projects that influence the future work of others. Jeremy Till and Sarah Wigglesworth did this with their Straw House home (see pages 72–7) as did Jerry Tate for his client Lucie Fairweather in Woodbridge. Jerry worked for the great Nicholas Grimshaw and this shows. His ability to think round problems and deliver all the high architectural ideas of expensive buildings in this affordable package are evident. As a result Lucie's home, built for her and her two children, reinterprets the 1960s chalet bungalows that surround it with gusto and no little cheek, crossing British suburban domesticity with Scandinavian pointy aspiration.

This house, then, is a new template for the suburban home and not just for its assertive form. The layout is a model of how to set out a three- or four-bedroom family home. The hallway compresses you slightly but the eye is led straight forward to a living space of enormous expansion. It includes the kitchen in its embrace, leads to the garden through sliding doors and shoots up through a double-height

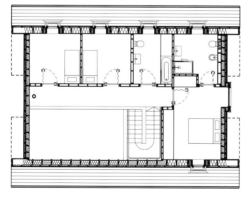

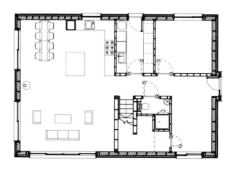

The layout is a model of how to plan a compact, but architecturally exuberant, family house. From the entrance hall the eye is drawn to a generous living space. As with the house by Chris Platt on the preceding pages, the house is both semi-open section and semi-open plan.

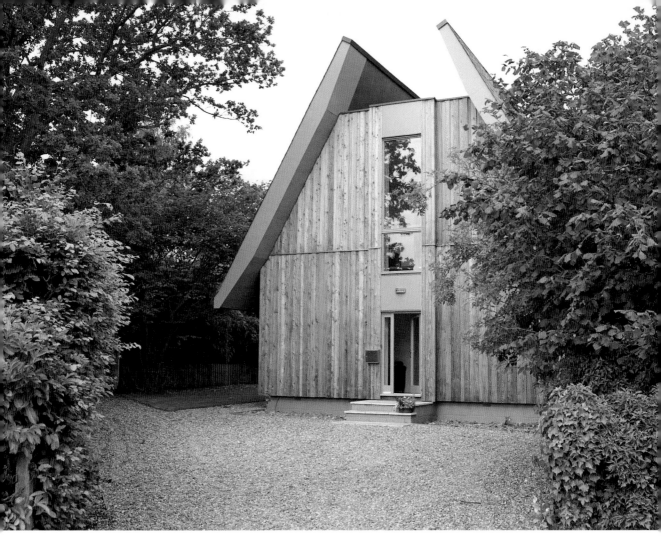

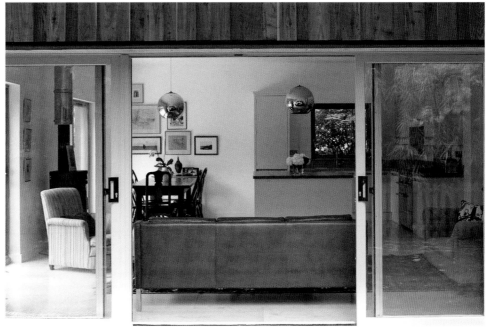

Above **British suburban domesticity meets Scandinavian pointy aspiration: a cheeky reinterpretation of the surrounding chalet bungalows.**

Right **Sliding doors connect the living room with the garden.**

space to the slope of one pitch of the roof. There is a snug for television or children's play; a functional utility room; the staircase resembles that of an art gallery, clad and painted white as the walls, like a processionary sculpture (but cheaply built with plasterboard and studwork of course).

These ideas, of compression and release, of the semi-open-plan layout and semi-open section, of balconies and small private rooms, are not new. They've been explored in buildings for millennia. The trick is fitting them all in to an affordable box and making them work effortlessly. Chris Platt of KAP Architects managed to squeeze all of them into the modest house built for the Leisjers on the preceding pages, which also qualifies that building as an exemplar alongside this one.

This is a hugely successful piece of architecture but it is a smaller, slightly less

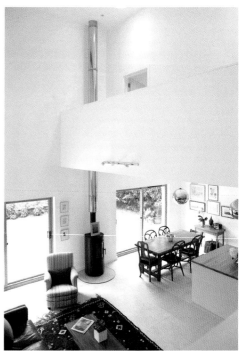

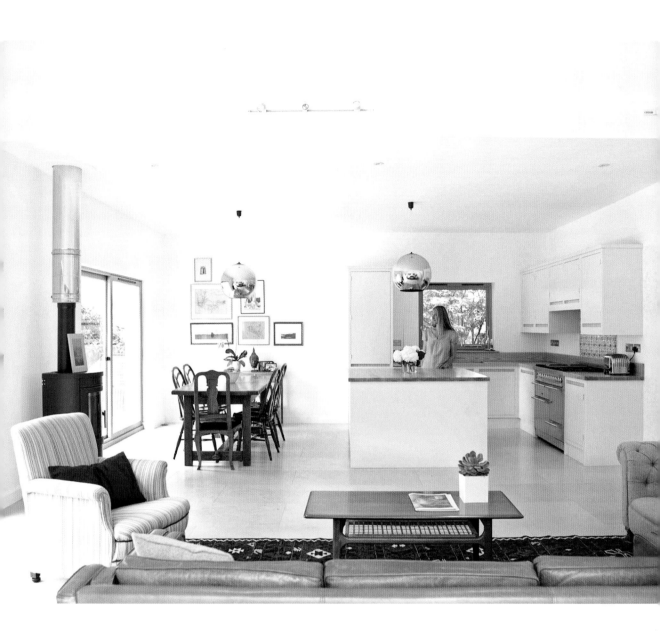

Far left **The staircase resembles that of an art gallery, painted white like a processionary sculpture.**
Left **The living room embraces the full height and width of the house.**
Above **Lucie Fairweather in her new home.**

green and less ambitious project than originally planned, and the course of that evolution is tinged with great sadness. The house was originally planned between Jerry, Lucie and Lucie's husband, Nat – all old friends. Nat was a gifted environmental analyst and the driving force behind the idea for this home as an exemplar of, not just domestic architecture, but of green construction. He fell ill as they were planning to break the ground on site

and died shortly afterwards, leaving his young family to pick up the pieces of the project and deliver a slightly scaled-down but nevertheless beautiful version of his dream. As Lucie put it when the project was finished, Nat seemed to be in the building, in her choice of tiling, furnishing and every other detail. The building remembers him.

In every way, John Leland would certainly have approved.

UNDERSTATED HILLSIDE HOUSE

▼

Some Grand Designers spend years – even decades – dreaming, planning and searching for their dream site. Others fall in love with a building and buy it on a whim. For interior designer Kathryn Tyler, it was more a case of seizing an opportunity and running with it.

Having discovered, by chance, that her parents' house in Falmouth was legally two separate plots with a right of way down a neighbour's plot, she spotted an opportunity to get onto the property ladder and hatched a plan to design and build her own house.

Working with a friend, architecture student Ian Tyrrell, she came up with a design inspired by Los Angeles Case Study houses and mid-century Scandinavian architecture, specifically Alvar Aalto and Sverre Fehn. Eco-design specialist Robin van der Bij advised on sustainable elements including thermal insulation, rainwater recycling and a heat-recovery ventilation system.

The building makes the most of its tight hillside site, shoehorning living and work space into the open-plan white-painted-brick ground floor, and bedrooms and bathrooms into a lightweight timber-

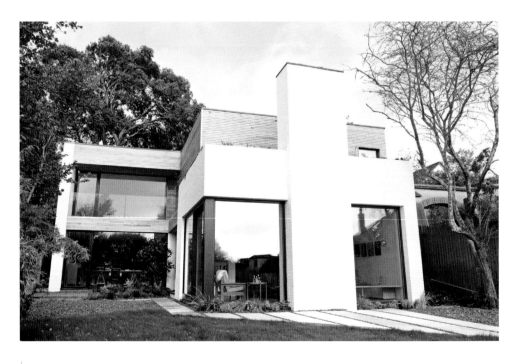

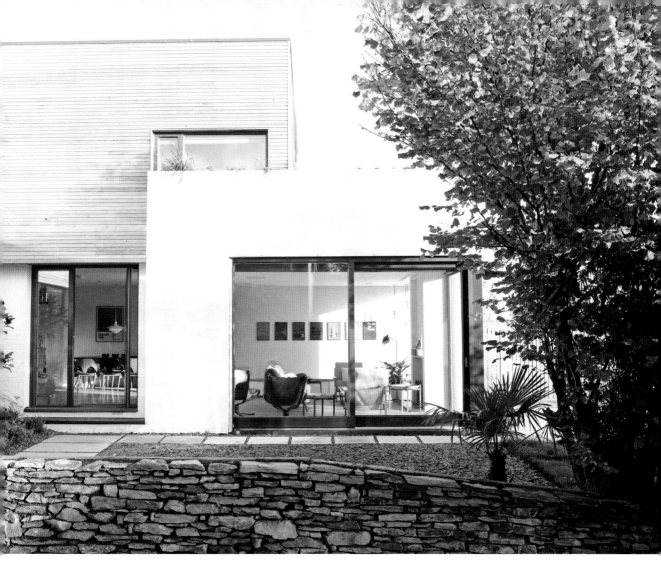

Left **A lightweight timber-frame upper floor sits atop a white-painted brick ground floor.**
Above **The design is inspired by Los Angeles Case Study houses and mid-century Scandinavian architecture.**
Right **Furnishings are a judicious mix of scavenged Fifties furniture and staples from Ikea.**

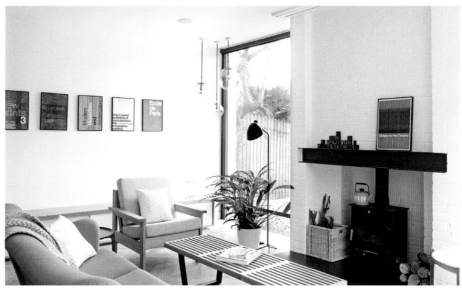

The plan is simple and compact. Living, dining and work space are shoehorned into the ground floor. The upper floor has bedrooms and bathrooms as well as a small roof terrace.

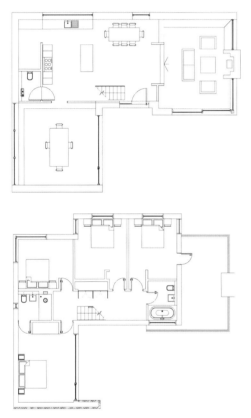

frame upper floor. A small roof terrace, complete with outdoor fireplace, provides a sheltered suntrap.

In a bid to keep costs down, both planning and finishes are understated and simple. It's pared down, but it's also homely and relaxed, with an emphasis on tactility, patina and warmth as opposed to highly polished minimalist glamour. The brick façades are finished in white paint, a decision that cut costs by allowing the use of imperfect building stock.

As a young interior designer at the start of her freelance career, Kathryn viewed the interior as a canvas to showcase her collector's eye and design flair.

Right **Pared down finishes include white- painted concrete and parquet floors.**
Above far right **The emphasis is on tactility, patina and warmth.**
Below far right **Kathryn Tyler perches on the staircase-cum-kitchen-storage unit.**

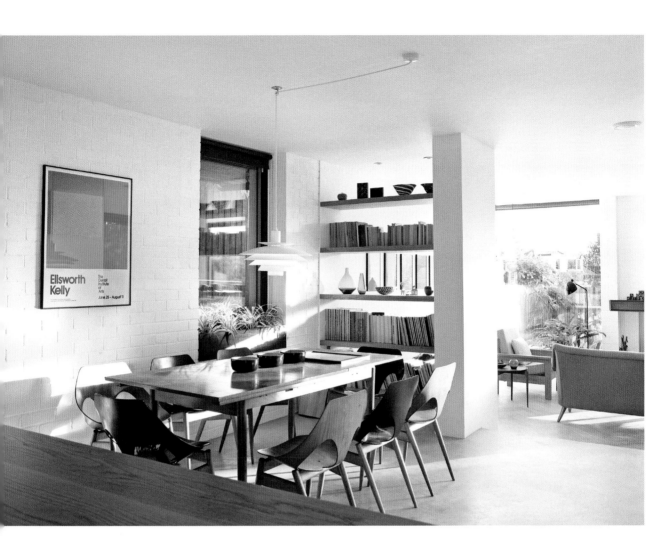

Bathrooms are finished in small white tiles and waxed cork floors whilst in the larger spaces white-painted, poured concrete and parquet floors provide the perfect foil to a judicious mix of vintage Fifties furniture scavenged from junk shops and eBay, and carefully selected – and often customised – staples from Ikea. The staircase-cum-kitchen-shelving-unit exemplifies the symbiotic relationship between furnishings and house.

Kathryn has created not just a comfortable home, but a professional calling card: a tangible, highly coherent manifestation of her talent, taste and style.

TY-HEDFAN

▼

Ty-Hedfan belongs to a proud *Grand Designs* tradition of homes built on plots that more conventional souls would avoid like the plague.

The site that architects Sarah Featherstone and Jeremy Young selected to build a weekend bolt-hole for themselves and their son had been on the market for

several years. Nestling in a picturesque hamlet of Pontfaen in the Brecon Beacons, it slopes steeply down to a river bank. And not just any river bank, but a site of special scientific interest – an honour that ruled out the possibility of any development within seven metres of the water's edge.

Where others had dismissed the site as undevelopable, Jeremy and Sarah rose to the challenge with aplomb. Their strategy was to build a house of two parts: a guest wing, which also houses a snug-cum-office, nestles into the hillside whilst the main house cantilevers over the protected river bank, culminating in a light-drenched glazed living room that hovers within the trees.

It's an ingenious solution that plays to the peculiarities of the site, but also reflects Sarah and Jeremy's taste for drama and surprise. From the road, the house is both unassuming and enigmatic, a childlike caricature of a traditional house. Once inside, the small square house appears to have exploded. Its various elements have been dislodged and reset at odd angles creating shifting perspectives and unexpected views. The staircase appears to float, the hallway wall appears to be inside out, its dry stone construction suggestive of an outside wall. The dark façade has given way to a riot of colour.

It's as though the artist who drew the house has been handed a paint set and instructed to let their imagination run free. And so they have. As architects, Sarah and Jeremy were able to experiment and play in a way that isn't always possible when you're working for a client. This project has a breathy showmanship – a bravura – that comes from being answerable to no-one but themselves.

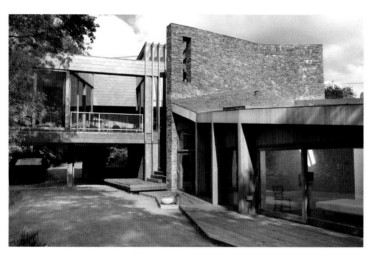

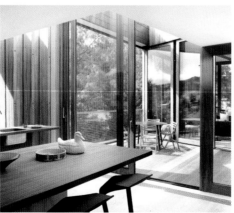

Above **A soaring dry stone wall separates the two parts of the house.**
Right **Kitchen and living area are linked by an open air courtyard.**
Above right **The cantilevered living room hovers above the protected riverbank.**

Grand Designs Award | 2011 | Brecon Beacons | Architects **Sarah Featherstone and Jeremy Young**

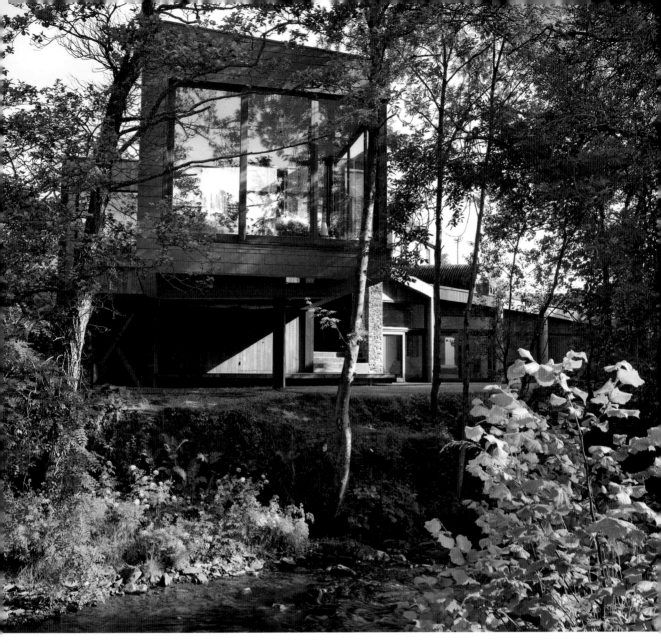

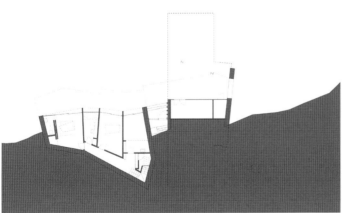

A house of two parts: a guest wing nestles into the hillside whilst the main house cantilevers out over the riverbank. The house gets its name Ty-Hedfan, Welsh for Hovering House, from the light-drenched glazed living room that appears to hover amidst the trees.

DUCKETT HOUSE

▼

Duckett House is altogether more intimate than the other projects by the same architect featured earlier in this book: Watson House on pages 14–15 and Attwood House on pages 28–33. Set within a conservation area in the New Forest National Park, it takes its form from the architectural language of the farmyard; a loose assembly of elements arranged around two sides of a courtyard with a protective masonry rear wall to the north and east, and softer, cedar-clad façades opening up to the views to the south and west.

Right **Deliberately informal, the composition is designed to evoke the haphazard charm of a smallholding that has evolved over time.**

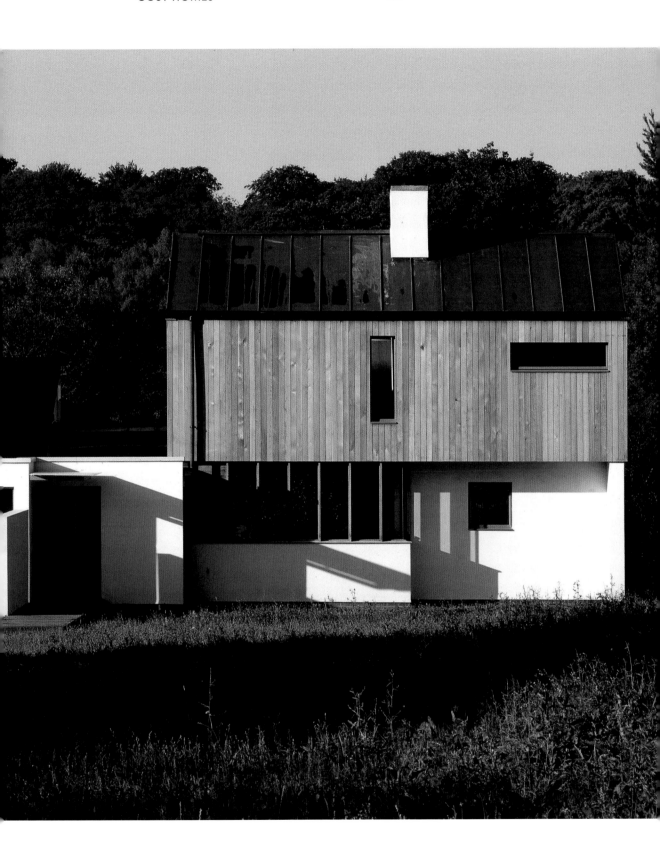

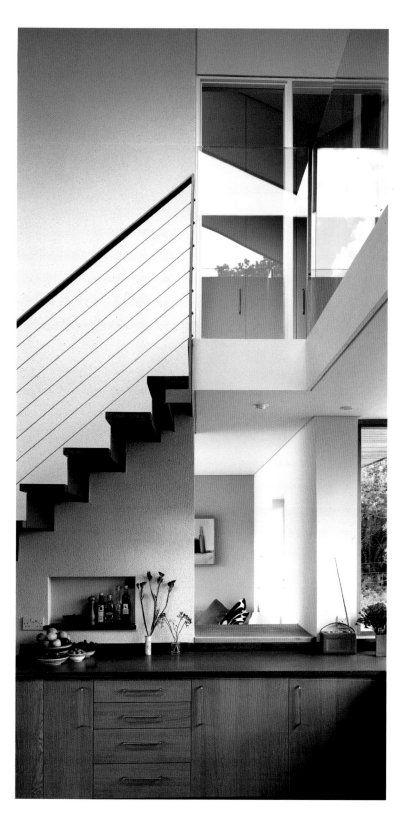

Like Bavent House on pages 224–27, its composition is designed to evoke the haphazard charm of a smallholding that has evolved over time. It is arranged as three distinct but interlocking elements: two simple mono-pitched structures and a third timber box with a pitched roof and glazed gable ends.

This house is not about grand statements, but about celebrating the day-to-day rituals of domestic life. The clients, two engineers with three children, were adamant that cooking and eating should constitute the heart of the house. Hence the kitchen and dining room occupy the only double-height space, a symbolic reflection of the value placed on family mealtimes and entertaining friends. Very much the hub of the house, it is overlooked by a Juliet balcony belonging to the master bedroom and a small gallery that houses a modest library and reading bench, and it opens onto a snug sitting room with an open fire setting a tone of cosy informality and warmth.

Left **The kitchen/ dining room is the only double-height space, a reflection of its symbolic role as the heart of the house.** Above right **The house is designed as an assembly of different forms around two sides of a courtyard.** Right **A snug sitting room with an open fire sets a tone of cosy informality and warmth.**

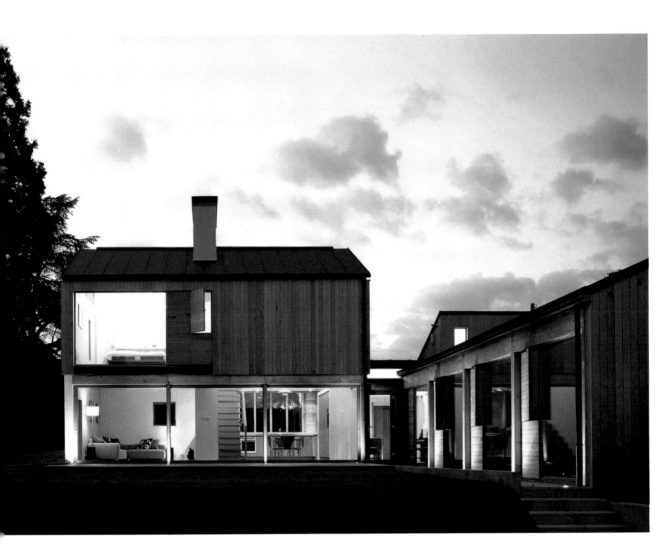

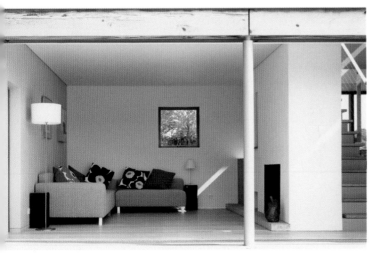

But if this is a house designed for family life and togetherness, it is also about moments of contemplation and retreat. There are unexpected opportunities to enjoy the view: the purpose-designed bed in the master bedroom has a cantilevered foot that acts as a seat with a view across the valley; a low window in the family bathroom gives bathtub views of animals in the fields. And there are magical moments, such as the high slit windows in the children's bedrooms designed to bring in the rays of the rising sun. This is a house that celebrates the simple pleasures that can enrich our daily lives.

DRUMMER'S COTTAGE

▼

What happens when two architects design their own home? Sometimes the freedom goes to their heads. They seize the opportunity to express themselves, to experiment with crazy ideas. Tom and Liz Miller took a rather more level-headed approach, viewing the renovation and extension of Drummer's Cottage in the Suffolk village of Beyton as an opportunity to realise a modest – but highly focused – ambition: to minimise the energy used both in building and inhabiting the house.

It's a highly pragmatic aim, but one that is informed by a broader aesthetic and philosophical stance – they are architects after all. Their work starts from the premise that architecture should celebrate the intrinsic qualities of materials, rather than sanitising them or covering them up.

They cite the English Arts and Crafts architect C F A Voysey as an influence, specifically his belief that plaster should looks as if it was once liquid – aspiring to a live textured finish as opposed to the smooth anonymity of plasterboard or polish. This chimes with the Millers' belief that most modern houses are too finished, too devoid of texture, too smooth.

Hence the brickwork at Drummer's Cottage is painted but not plastered; there are no toxic paints or preservatives in the house and the thermally efficient windows are made from untreated timber and painted with breathable, low-toxicity linseed paint. They positively embrace the fact that the locally sourced larch will weather and change colour over time.

Above **The larch will weather and change colour over time.**
Above left **Exposed timbers in the bedroom.**
Left **Liz Miller at Drummer's Cottage.**

What you see is what you get. Almost. Some of the features that contribute to the cottage's environmental credentials are discreet, even invisible. The larder is housed in the northernmost, coolest corner of the site; the roof insulation is made from recycled newspapers; the foundations are concrete pads on the basis that they use less concrete than a single slab. Even the apparently self-indulgent luxury of underfloor heating beneath the stone floor was selected as the most environmentally friendly choice – the logic being that the impact of direct warmth beneath your feet heightens your awareness of the temperature and makes you less inclined to turn up the heat.

Drummer's Cottage represents a quiet form of evangelism – eco stealth as opposed to eco bling.

VISTA

▼

From a distance, Vista is another one of those black timber shacks that dot the horizontal landscape of the beach at Dungeness, looking like little dobs of charred plutonium waste that have been spat out by the nuclear power station, the only large structure there.

In fact they're little fishing bothies, weekend cottages and seaside villas, scrabbled together from flotsam and jetsam and local timber, built in a local shed vernacular with white windows and lapped weatherboard cladding, blackened with tar or creosote for protection against the salty air.

That's from a distance. Close up, Vista appears odd and abstract, a clean-lined version of the local building type. This can't be a house... it's got to be some weird overground entrance to a subterranean nuclear hideout. It looks as though it was planted there by MI6. Its spookily unnatural appearance is down to the fact that is entirely clad in rubber. Super-matt black

Right **Sliding glass doors allow the house to spill out onto an outdoor deck.**

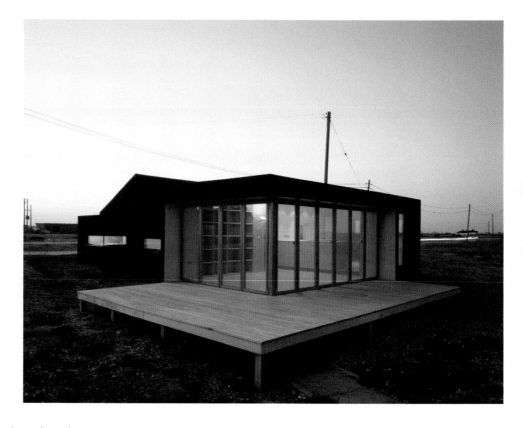

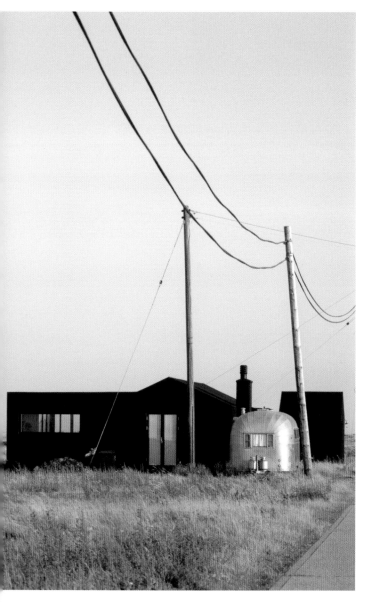

rubber. The kind that makes people get out of their cars and stroke this house. The kind that Batman's costume is made out of and which is obviously designed to be radiation proof.

It's enigmatic, but this type of rubber is also water-tight, breathable and extremely tough. So much so that it's generally used to line roofs or ponds. The genius of this building lies in the architect Simon Conder's delight in using ordinary materials to extraordinary effect. Working to a limited budget, he sought out low-cost off-the-peg materials, then created a design that revels in the intrinsic qualities of products that are usually neglected or hidden from sight.

The perfection of the rubber shell is offset by friendly warmth of the interior. Floors, walls and ceiling are lined in wood, much of it plywood. In the hands of a lesser architect it would appear makeshift, but Simon has a crafted a cosy cocoon - albeit one that can morph into a bus shelter in a matter of seconds. Simon has performed a vanishing wall trick by glazing the sides of a flat-roofed conservatory with sliding timber-framed doors that fold right back. In one swift move the floor merges with the outdoor deck and the womb-like interior merges with the post-apocalyptic landscape and that bracing sea air.

Above left **The owners' Airstream caravan provides a gleaming antidote to the house's matt black cladding.** Far left **The bathtub affords panoramic views of Dungeness' horizontal landscape.** Left **An existing shed, once used to store fishing tackle, has been turned into the entrance hall.**

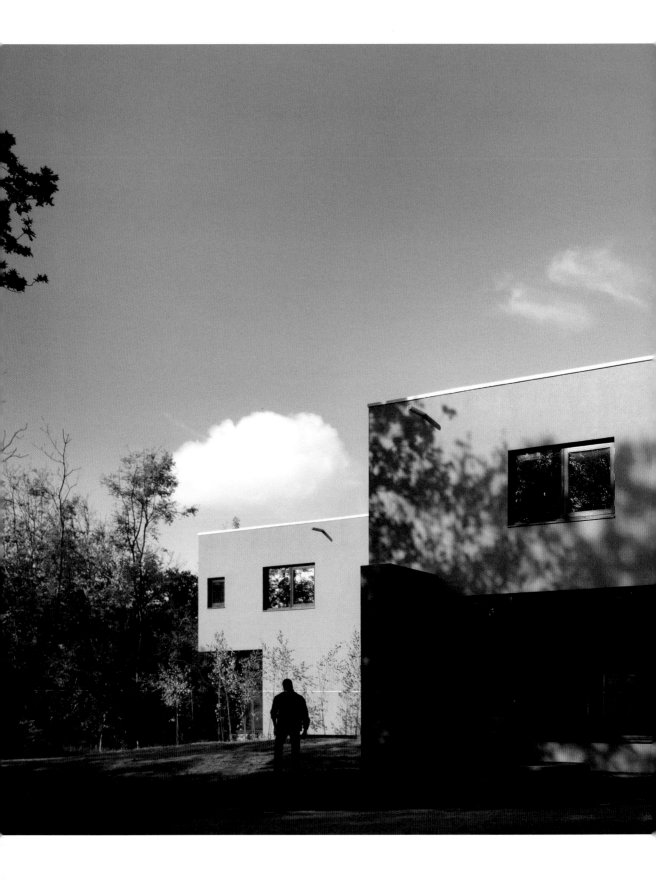

06
SPACE SHIPS

Regardless of the planet's agenda, regardless of our need to think about better ways to share our resources and consume less, there is a die-hard and heroic section of society who want to do MORE, BIGGER, FASTER, BETTER, preferably while making a mid-life crisis statement/epitaph according to the three Corbusian demands of space, light and bifold doors. We salute the occasional makers of BIG because they do it with such chutzpah and self-belief.

WATERLOO VIOLIN FACTORY

Having lived in a loft conversion in New York, Louise and Milko Ostendorf had fallen in love with loft living but were underwhelmed by the 'sanitised' lofts on offer when they moved to London. So they embarked on a mission to convert a former violin factory in London's Waterloo into a spectacular six-bedroom home.

This is a couple that doesn't do things by halves, and there is a certain irony in the fact that their quest for authenticity and utility resulted in what has got to be one of the most extravagant – and most controversial – projects in the history of *Grand Designs.* The ultimate bells and whistles home, it boasts a glass-roofed winter garden, gym, home cinema, heated dumb-waiter and a panelled study complete with a secret exit concealed behind a bookshelf.

And the overall finish and feel of a particularly Metropolitan boutique five-star hotel. Oh, and the kind of cooker you'd expect the aforementioned hotel to have in its kitchen. The kind of cooker that costs £35,000. It was this, more than anything, that sparked outrage and hostility amongst viewers. The idea of spending that sort of money on a domestic cooker is ludicrous or even anathema to most people. It verges on the obscene, doesn't it? It's certainly immoral.

Left **The conversion incorporates original features such as the 1840s entrance doors.** Right **Steel garage doors conceal the entrance to the house.**

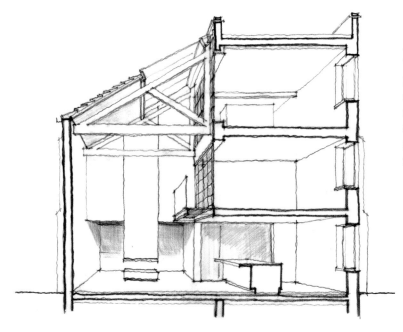

The ground floor contains an open-plan kitchen/dining area with a living room and home cinema at one end. First floor accommodation – bedrooms, bathrooms and a study – are arranged around three sides of the building leaving a void above the full-height dining space.

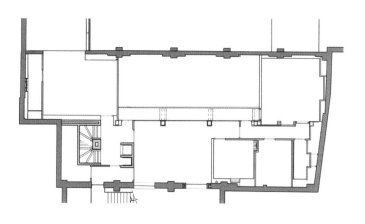

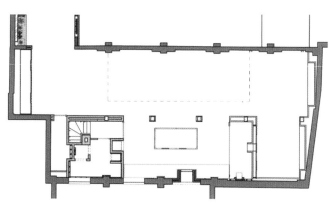

Except, of course, that some people approaching their mid-life crisis find themselves spending far more than that on a boat or big toy car or lifetime gym membership. This house has its own gym, it's as generous and spacious as any Russian oligarch's gin palace and it's within walking distance of every major important cultural destination in London.

So why not invest in proper French craftsmanship (it even didn't work properly for months – just like a new supercar)? Why not spend on a toy that can generously bring joy to its consumers and their dinner guests? Although I suspect it does take most of Sunday to wash down and polish.

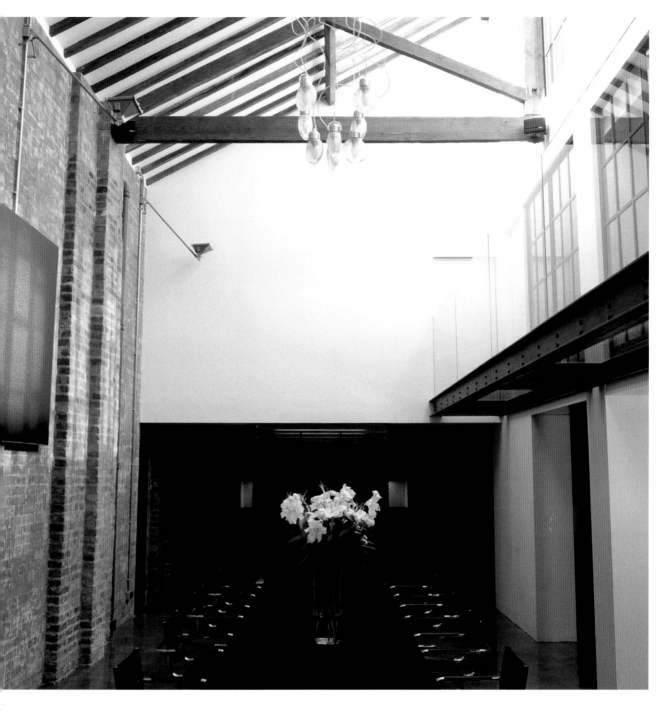

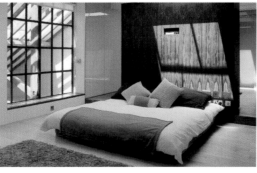

Above **The full-height dining area has a polished concrete floor to complement the original timber trusses and brick walls.**
Far left **Milko and Louise Ostendorf.**
Left **The master bedroom: the walnut bed head contains a projector and screens the en suite bathroom.**

HILL HOUSE

▼

Belfast architect Thomas O'Hare and his wife didn't mean to build a house the size of a car park. Originally, they submitted plans for a much more modest scheme for this hillside site, two miles south of Belfast city centre. But they changed their minds when they heard that the hillside was about to be de-zoned – meaning that nothing could be built on it ever again. This was a once-in-a-lifetime opportunity, and they decided to go for broke.

In its newer, grander, iteration, Hill House is composed of three interconnecting blocks designed over three different levels to take advantage of the steeply sloping site: a crisp, white, volumetric composition amidst verdant tranquil grounds. A grand teak staircase, twice the width of a conventional stair, leads from the entrance level to the main living floor – glass-walled kitchen, living and dining space arranged around a verdant outdoor courtyard. Another half level up, the bedroom block sits lodged into the hillside, its full-height frameless glass giving uninterrupted views across to Belfast.

Thomas is an architect, with plenty of experience of commercial as well as residential design. Where others may have baulked at the prospect of such an ambitious scheme, Thomas was unfazed by its scale and readily able to visualise the complexity of its form. My fear was that he would be too confident; that he would deliver something so slick that it would end up being almost corporate in feel.

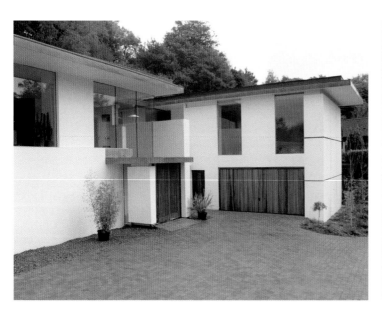

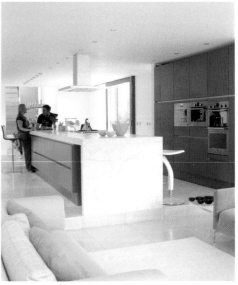

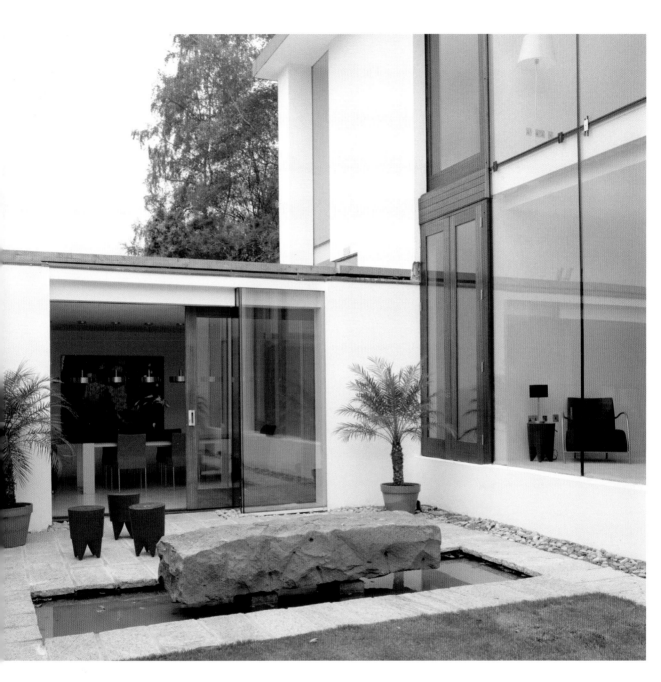

But for all its splendour, Hill House lies firmly in the tradition of domestic architecture. This is a 21st-century answer to the Roman villa, with vast amounts of living space all arranged around a central courtyard. A classical typology executed in an architectural language that is wholly modern. Thomas describes the minimal palette of materials and the use of projecting walls, cantilevered canopies and geometric shapes as a conscious homage to Le Corbusier and Mies van der Rohe: Modernist masters, and the architects of some of the world's most celebrated and memorable twentieth-century homes.

DOME HOUSE

The size of Robert Gaukroger's house is both its major selling point and its weakness. Dome House projects out of the Lakeland hillside at Windermere, the only building in the town that is not black, white, stone or grey, like a fat timber extrusion ready to take on the rest of the place. It demands attention for its scale, which verges on that of a public building. It might be a swimming pool or library. If it were wrought in stone and steel it would be an expensive corporate headquarters. It is impressive and awe inspiring.

Having said that, at half the size it would have possessed greater poise. And it would have been more straightforward to build. The scale of this project was also almost Robert's undoing. He began without enough money to finish it; sold a car, then a boat, then another car; tried to sell some commercial property he had invested in; borrowed more. His work as a building designer was meantime drying up in a recession. He was treading the path that is so familiar to viewers of *Grand Designs*, of the individual fighting the system in pursuit of a very personal vision.

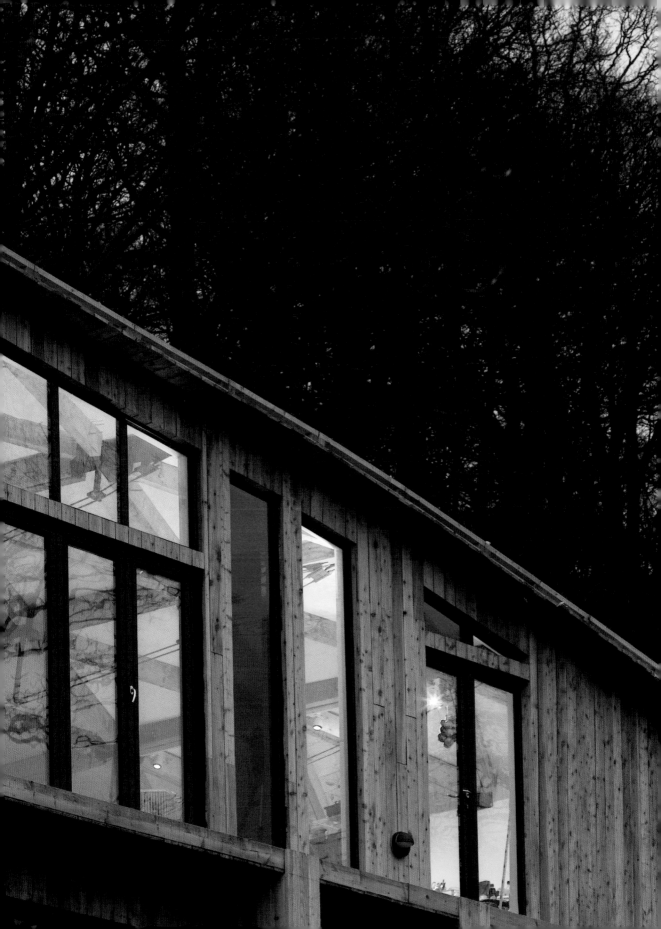

The house is a successful attempt to weld a series of shapes into a mountainside, treading the fine and beautiful line between earth-sheltered anonymity and statement look-at-me architecture. A massive, full-height stone wall divides the building in two and acts as a thermal store.

That wilfulness is expressed in almost every fibre of this building. There are ideas here that Robert could have eliminated or scaled back in order to provide a smaller home, sooner, for his wife Milla and their two children. But every one of those ideas was precious to him and every one deserved fighting for.

The house is divided to accommodate a dozen people or more (mercifully, the Gaukroger's found a change of use to a designer bed and breakfast a godsend); it swallowed up a three- bedroom concrete detached home (as an exploration of recycling a building); there is a Gormenghast mathematical staircase and an impossibly grand first floor saloon; an epic full-height stone wall divides the building in two and contains an experimental array of copper tubes to pump heat into, and out of, the wall, using it as a thermal store (no-one is quite sure whether this is yet working); a joistless, wire truss system, devised by Robert, resolutely holds up most of the roof; there is a first floor courtyard garden; there is stained glass and a swimming pool. And, to the rear, where the house meets the wooded hill, its earth-sheltered, turf-roofed rear appears from some angles to grow into the slope.

Any single one of these ideas might be considered an extravagance in a conventional house. Anyone else would have jettisoned a clutch of them in readiness to absorb the blows of the recession. But Robert fought. When, finally, it seemed there was no chance of completing the building and the family faced homelessness, an angel appeared in the form of an investor, a lady who had seen the programme and taken pity on Robert's plight. It seems he has a knack of sharing his vision with others, since she has backed not only him but his business as well, and procured for him and his family

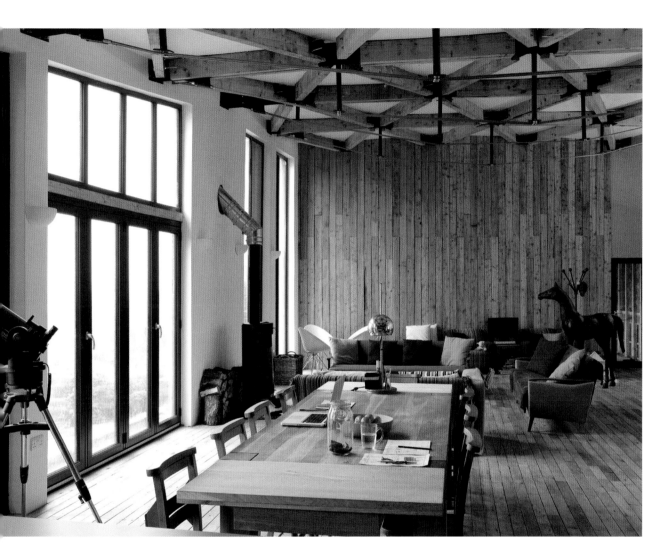

the happy ending that he believed in.

So wilfulness triumphs. Ranged and ordered by determination, the paradoxical nature of this building, its complexity and multiple personalities are not fully resolved and nor will they ever be, but they do hang together. This house is a successful attempt to weld a series of shapes into a mountainside, treading the fine and beautiful line between earth-sheltered, timber anonymity and statement look-at-me architecture. It is also proof of how individual vision can override the conventional niceties of design and produce very good architecture.

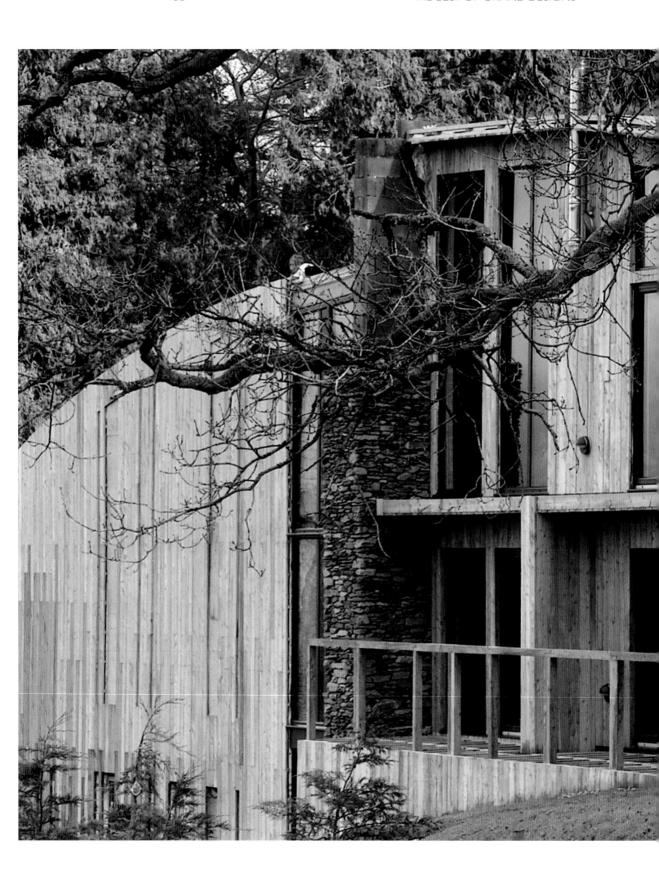

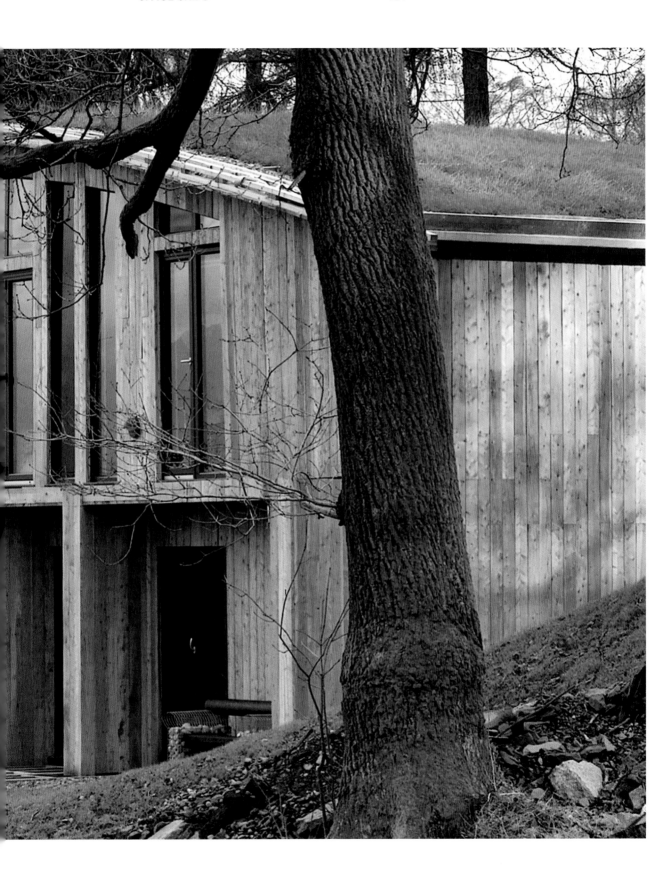

THE WILDERNESS

▼

Once the envy of the western world, the English Country House has suffered a dramatic fall from grace. Today's planning system is stacked against one-off houses on greenfield sites. Those that do get approved tend to be nostalgic exercises in period pastiche. It takes an exceptional – and extremely determined – client to buck the trend.

Sara Low was one of the few intrepid souls to take advantage of PPG 7 (Planning Policy Guidance 7), a short-lived piece of planning law stating that contemporary country houses could potentially be permitted provided they were of exceptional architectural merit.

Having lived in period houses all her life, Sara, a widow with grown-up children and grandchildren, yearned for a home that reflected her passion for modern architecture and art. Undaunted by the dearth of Modernist homes in her native rural Suffolk she commissioned Paulo Marto and Paul Acland of Paul + O Architects to design a Grand Country House for the 21st century – a contemporary home designed for entertaining and family gatherings but also for solitude.

In outward appearance, it has the imposing hauteur of a grand residence; a bold geometric form that surveys its woodland site from an elevated position atop a plinth clad in Suffolk flint. But our attitude to landscape has changed since the glory days of the English Country House. The Wilderness doesn't seek to command its landscape, so much as connect to it. Banks of glass frame the woodland whilst balconies and terraces allow every part of the house to take full advantage of the views. The interior of

Left **A Grand Country House for the 21st century: formal rooms are large enough to entertain in style.** Above right **Wilderness House fuses the confidence of the International Modern movement and a strong connection to its immediate site.** Below right **The bold geometric form exudes an imposing hauteur.**

Grand Designs Award | 2008 | Suffolk | Architect **Paul + O Architects**

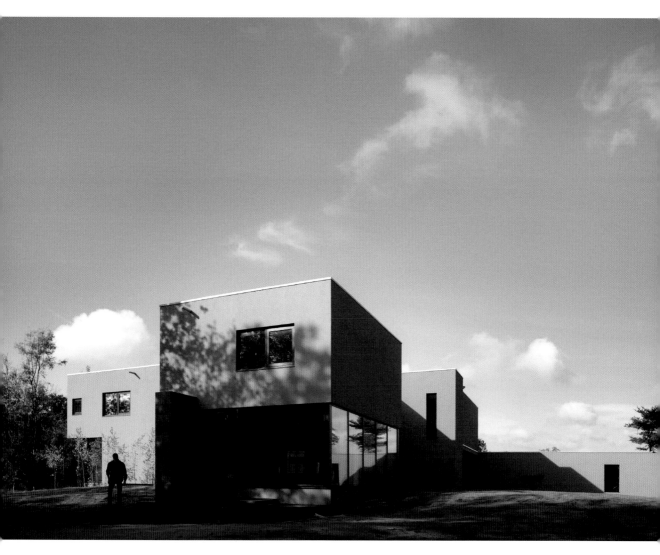

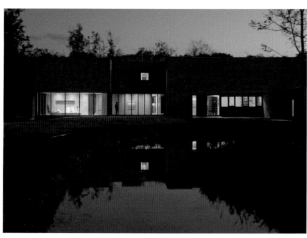

the house is altogether more welcoming: highly crafted spaces that, though often large, are intimate and warm.

This is a house that is cosmopolitan yet very much of its place; a house that fuses the confidence of the international Modern movement with local materials and a strong connection to the immediate site. It is also very much of its time – and the only PPG7 house in Suffolk. Sadly, Sara died at the age of 70, just 10 months after moving in to her new home. In The Wilderness, she leaves a remarkable legacy.

07
GADGET BOXES

Ask a man to choose between upholstery and technology and he will not go for the cushions. Nor will he plump for insulation and draught-proofing, favouring renewable bolt-on technologies instead. Here are the homes of such men, riddled with miles of category 8 cabling, fitted with sensors and clever sliding beds and electrically heated gates.

FUTURISTIC BUNGALOW

The bungalow that Paul and Jo Tarling built for Jo's parents, Jean and Bill, in a once-sprawling private garden in Kent, was the last design by the architect Richard Paxton.

Richard understood domestic architecture both intuitively and through scholarship. With his wife Heidi Locher he designed a series of houses that, though entirely contemporary, explore a paradoxical value established by the Romans and Greeks: a need for privacy matched with a need for contact with the outside world that is consequently played out in an entirely private way.

With this project, there were more practical demands to be met. The Tarlings wanted a low-carbon house that made little demand on the earth's resources. And, since Bill was in a wheelchair, every detail – the position of switches and sockets, door width, ease of mobility – had to be carefully thought through.

Sadly, Richard died unexpectedly whilst still very much at the design stage, leaving the Tarlings with a floorplan, but no fixed ideas as to how the walls and roof were to be built, and no information at all about the more detailed design.

In the event, the walls were made from Ziegel blockwork, clay blocks with a hollow core that provide high levels of insulation, and the barrel-vaulted roof was made from precast concrete. Paul was Richard's services engineer, so the house was constructed like a machine, absorbing, storing and releasing heat and energy according to the time of year and the fiendish technology used to help it. Water tubes in the pre-tensioned curved roof sections now help the building cool. Ground-source heat pump tubes on the foundations bring winter warmth and summer cooling, as does an underground air duct.

Jo's father Bill died before the house was finished, and never got to live in it. Despite being touched by tragedy, this remains an optimistic, joyful house. Richard knew how to make buildings that make you feel relaxed, nurtured and protected. And this building does just that.

Right **Internal and external floor levels are perfectly aligned to give wheelchair users maximum freedom of movement.** Far right **The curved barrel-vaulted roof is made from concrete to provide thermal mass.** Above right **Sliding doors create a 'dissolving wall' between living room and courtyard.**

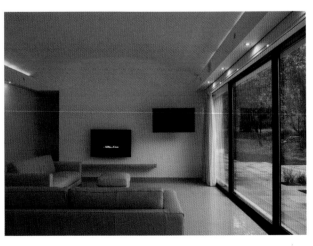

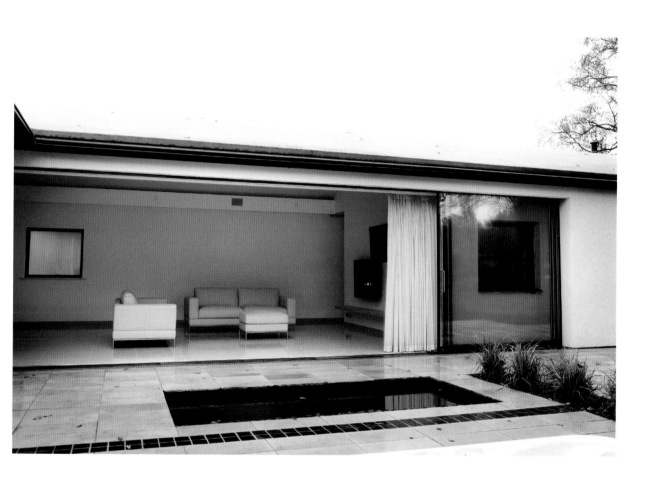

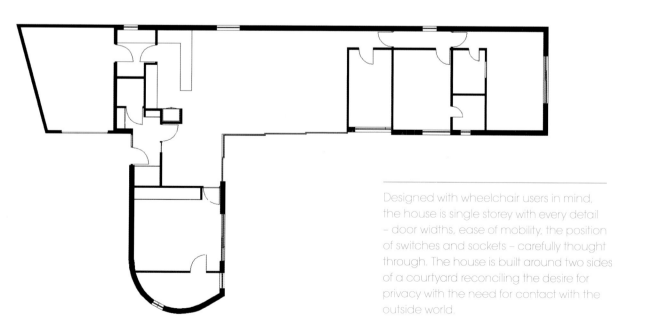

Designed with wheelchair users in mind, the house is single storey with every detail – door widths, ease of mobility, the position of switches and sockets – carefully thought through. The house is built around two sides of a courtyard reconciling the desire for privacy with the need for contact with the outside world.

INDENTED HEAD HOUSE

▼

Ian McDonald and Rob Wilhelm's house on the Bellarine Peninsula, Australia, isn't so much a Grand Design as a Positively Over The Top Design.

Essentially a glass box – albeit a many-faceted multi-layered box with a pair of floating wings on top – the house was primarily built to take advantage of the view, overlooking Port Phillip Bay across to Melbourne. But there are plenty of other distractions. The breakdown of the accommodation reads like a list of selling points for a luxury hotel.

Below **A pair of 'floating' wings' give the roof its distinctive profile.**
Right **The house is essentially a many-faceted multi-layered glass box.**

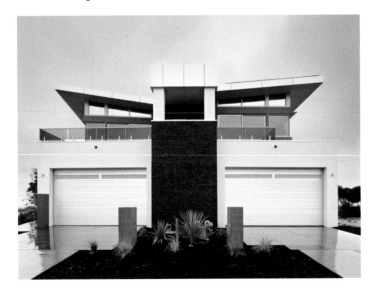

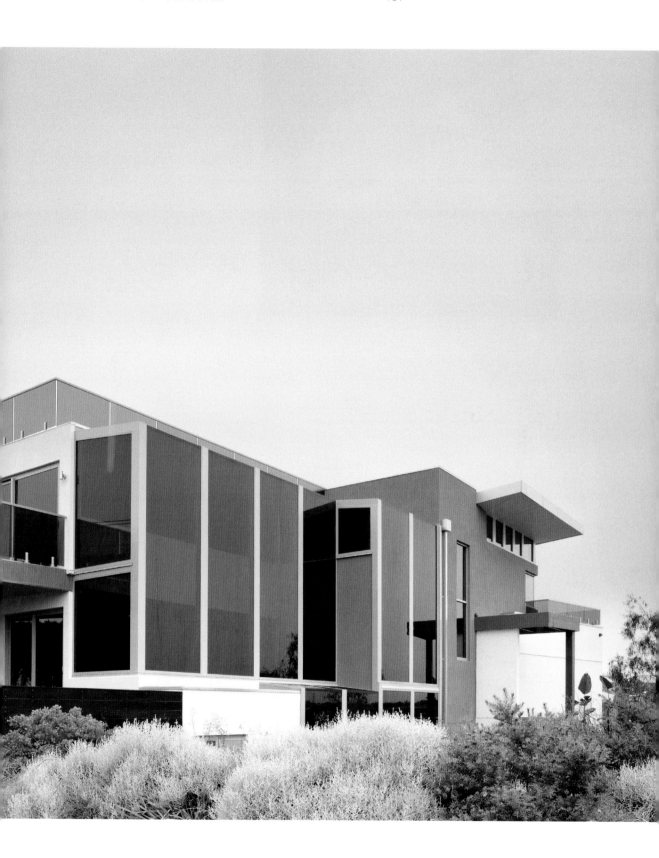

There's a 'lifestyle level' (that's a basement to you and me) including a cinema that seats 15 'in gold class style' and a fully equipped bar with a ready supply of popcorn and cocktails. There's a games area complete with custom-made billiard table. There's a lavish spa area including an eight-seater swim spa (whatever that may be). There's a glass-walled lift with views of the sea. There are 14 – yes 14 – motorised televisions that swing out from the wall at the flick of a switch.

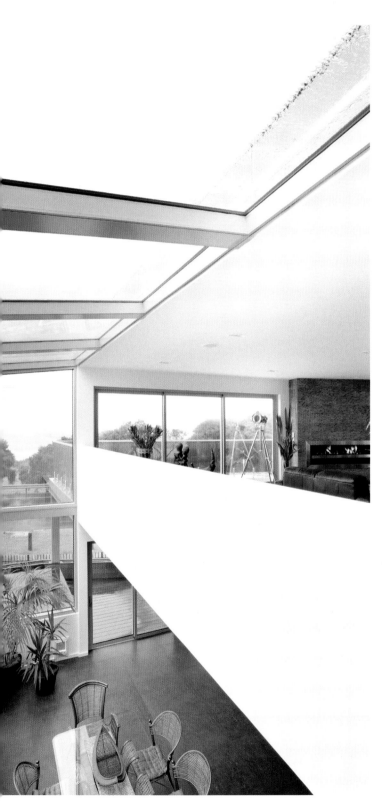

There's a rooftop garden and a glass-panelled pool. There are two kitchens – a formal kitchen that looks great at any time, and a main working kitchen which still looks pretty good, but lets you lock away the mess when you have friends round. Not that you have to go near either of them – a motorised dumbwaiter delivers food and drink to any floor of the house. This is a house for entertaining in style: some might say, for showing off.

To be fair, the private quarters are equally opulent. The master bedroom has an infinity bathtub, a steam room… you get the general idea. It's as though somebody's sat down and drawn up a list of every single gizmo or gadget or fabulous luxury they can imagine, and pulled them together into a design for a fantasy house.

And so they did. Having finished the house Ian and Rob remarked that they'd ended up with everything on their wish list. For me, it's an assembly of great ideas rather than a coherent, over-arching, great design. But I can see that living there could be an awful lot of fun.

Above left **The swim spa – bathroom and spa facilities rival those of a luxury hotel.**
Far left **The 'formal' kitchen area.**
Left **The garden atrium is enclosed by a glass roof and 4.5-metre high glass walls.**

FUTURISTIC DONCASTER HOUSE

The architect Colin Harwood describes Michael Hird and Lindsay Harwood's futuristic glass-and-steel home in Doncaster as a 'James Bond villain house'. And as it started to take shape, the local residents described it as a whole lot of other things: a bunker, a warehouse, even a crematorium.

It certainly has a decidedly un-domestic air, and it's a far far cry from the red brick 1930s semi-detached housing that surrounds it.

Not surprising really, since the inspiration for the design was a 1950s skyscraper, Gio Ponti's Pirelli Building in Milan, the first high-rise building to depart from a conventional orthogonal plan. Like the Pirelli building, Michael and Lindsay's house has a lozenge-shaped plan. Its free-standing, white-painted concrete walls, huge glazed panels and elegant entrance ramp speak of Mediterranean Modernism, not Doncaster Domesticity.

From certain angles this building might not look like a house – more an office or an art gallery, or even some sort of inter-galactic battleship – an incongruous invader sandwiched between a busy main road and a public park. But the occasional transparent wall gives you intriguing glimpses of the beautiful home inside. The ground floor is open plan, with clean lines, plenty of light and space, and a spectacular glass staircase that is encased in walls of glass and supported by nothing but gravity and glue.

It's like Goldfinger's hideaway – a place full of gadgets. Getting in to the building is much like arriving at MI6 – the entry phone security system gets you access to a Hollywood-style underground parking area. All the fittings are state-of-the-art and controlled by the flick of a switch. Even the windows are operated by electric motors – just as well since they weigh a quarter of a ton.

It is striking architecture, and an impressive box of high-tech tricks. But unexpected touches of warmth – cherry wood floors, an outsize open fire – mean that it is also a welcoming family home.

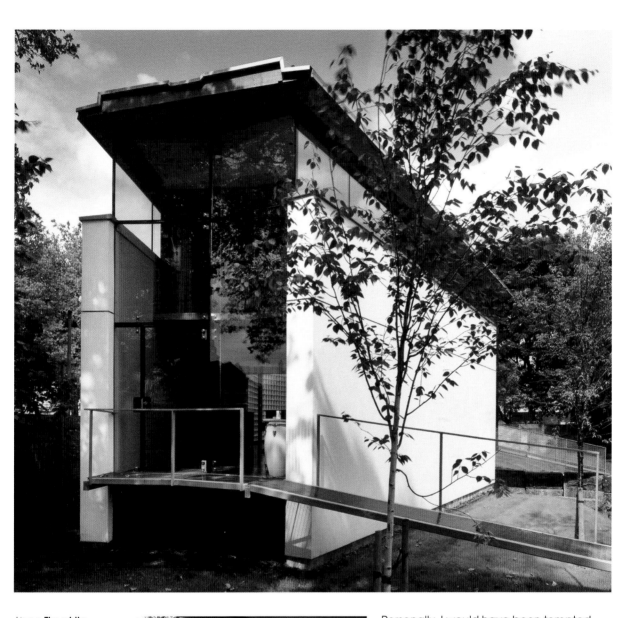

Above **The white concrete walls and entrance ramp give the house a decidedly un-domestic air.**
Left **Cherry wood floors and an outsized open fire give the living room unexpected touches of warmth.**
Right **The staircase is encased in sheer walls of glass supported by nothing but gravity and glue.**

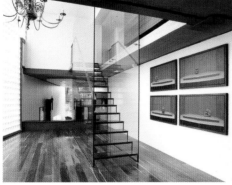

Personally, I would have been tempted to deck the whole thing out in Barbarella orange and velvet. But perhaps that would have tipped it over the fine line between forward-looking architecture and futuristic theme park. It deserves to be taken more seriously.

SURREY THRESHING BARN

▼

Building your own home is a risky business. It puts pressure on finances, relationships, sanity. But it can also be cathartic. Philip and Angela Traill decided to re-evaluate their lifestyle when Philip became seriously ill with a brain tumour after the birth of their second daughter. Their first thought was to exchange the stress of London life for the clean country air of a Surrey village and, specifically, to make a home out of a dilapidated Grade II listed barn on land owned by Philip's parents.

Right **From the outside the barn is still very much an agricultural building, with haphazard windows and outsize doors.**

Working with architect Damien Blower of Stedman Blower, they dreamt up a futuristic fantasy. From the outside the barn is still very much an agricultural building, with haphazard windows and outsize doors punctuating the timber-clad façade. Once inside, it becomes apparent that this ancient building has been invaded by an alien form. A spiral stair punctuates the lofty open-plan living space, seeping upwards to a floating walkway and two space-age bedroom pods.

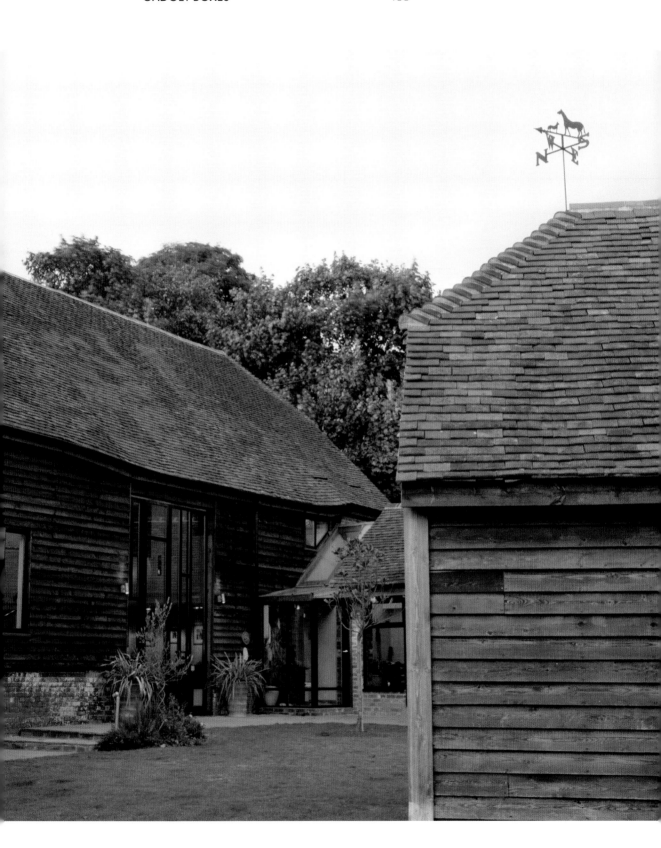

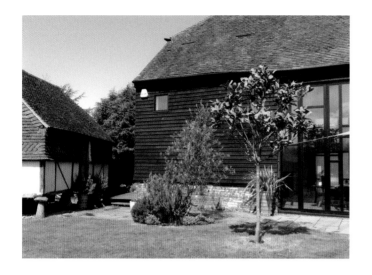

Sunlight floods through huge south-facing windows by day. Turquoise or hot-pink disco light splashes across the walls by night. Techno-geeks, the Traills' sophisticated servicing strategy includes 'mood' lighting throughout the house.

Philip clearly relished the project, and his enthusiasm seems to permeate the house. Sometimes revisiting an old project can be a disappointment, a bit like meeting an old flame for tea, only to discover that she's grown three chins.

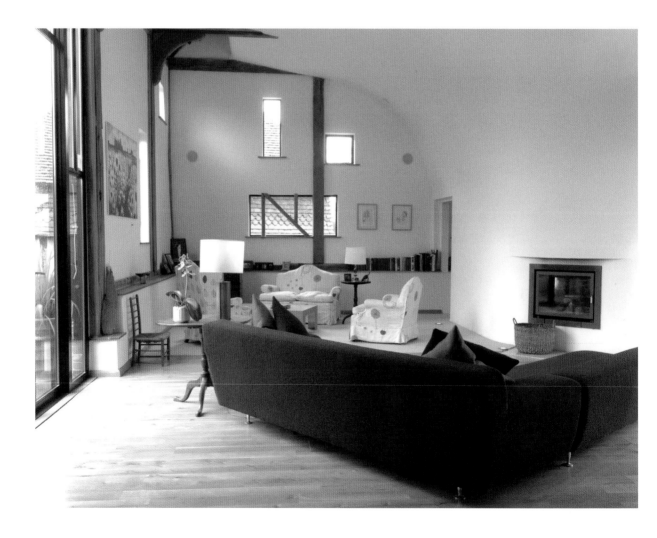

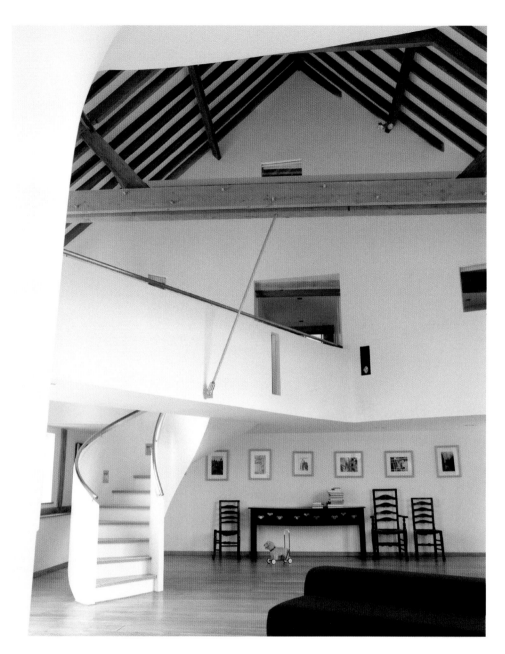

Above left **An original barn-door opening has been glazed to bring light into the main living space.**
Left **The open-plan living area.**
Above right **The main living space is punctuated by a sweeping helical staircase.**

Sometimes things are exactly as you remember them and occasionally I'm truly surprised at the beauty. Going back to the Traills' barn was like that. Beforehand I'd remembered the arrangement of rooms and the details well, yet I'd forgotten how strange and wonderful the building is.

Going back was also poignant. Philip had been ill but was on fine form,

seemingly rejuvenated by the building. After all, that was partly the point of this place: to make a home that was healthy and clean as much as ecological and high-technology. It felt like a building that didn't just make some kind of superficial style statement but which seemed to radiate health and happiness. Houses rarely have that strong aura about them.

PECKHAM
BOX OF TRICKS

▼

Sometimes good architecture's hard to find in the city. Not that it's always scarce but that you just have to look harder to find it.

Urban buildings are often typified by small façades and deep plans – they go back a long way – so that you have to be either a seagull, a mole or a burglar to get any real understanding of the place. So much urban architecture is about fitting in to what already exists and for those steeped in the spirit of urban life this exigency, the need to be flexible and responsive, can draw its energy from the very constraints that limit a project.

I filmed Monty Ravenscroft and his partner Claire Loewe constructing an extraordinary, experimental house on an unpromising site in south London in 2004. Designed by the late, great architect Richard Paxton, but engineered by the polymath Monty, the house effectively had to be hidden from the street and not impede light from reaching the adjoining houses. So out of necessity it became a low, flat-roofed building, cranked in plan like a dog-leg to follow the asymmetrical site, and lit by skylights. In deference to its urban setting, it also employed alternative high-tech construction techniques borrowed from commercial construction.

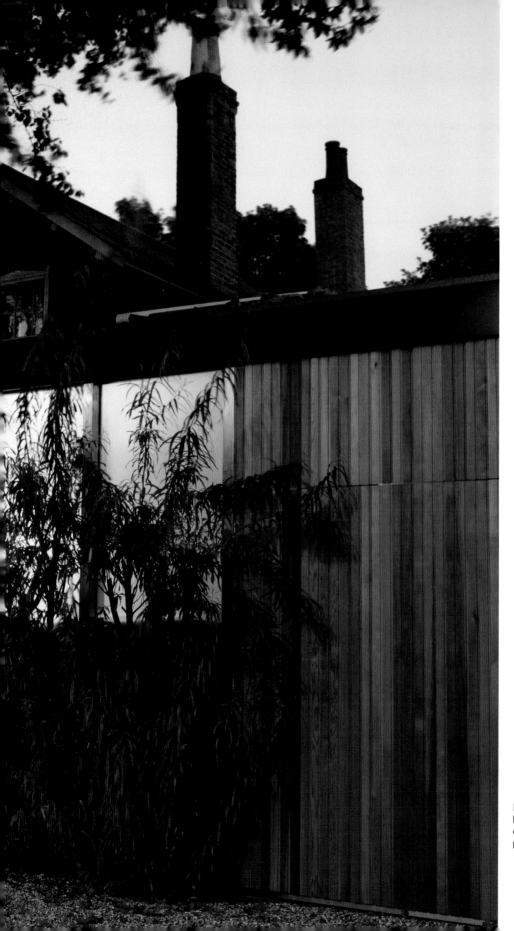

Left **The house had to be hidden behind a screen of willows before the planners were happy.**

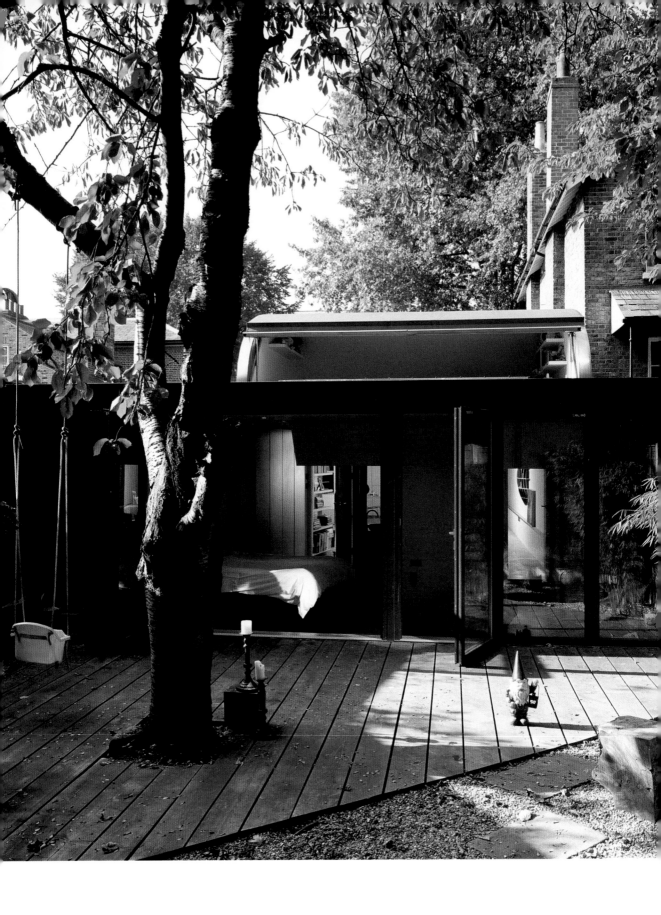

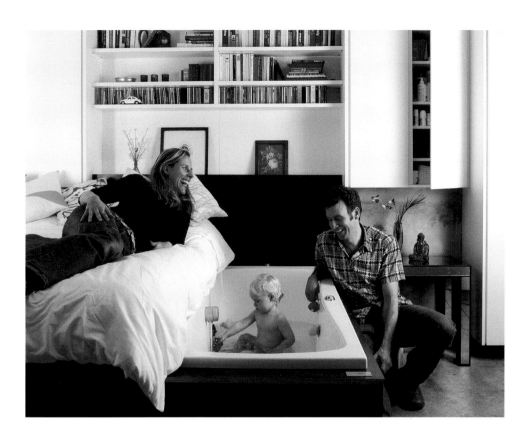

A super-lightweight steel frame and stressed plywood skin made the building a well-insulated mobile home without the wheels; one that was also minutely tailored to the site.

This is the supreme example of the tight-fit urban house, wrought out of an impossibly little site, that had to disappear. That was a planning condition; Monty's place had to be hidden behind a screen of willows before the council were happy,

The finished building is packed with exquisite space-saving details and hidden ideas, shoehorned into impossible spaces. A bed slides to reveal a bath underneath it; ship's fittings and handles fold flush into surfaces; a pigeon-ladder staircase leads to a mini-mezzanine bedroom formed into a bump in the roof. And the coup-de-grace sliding roof over the living space solidly establishes the identity of this building as a box of tricks.

Richard designed buildings that often had no façades to wow you with but which saved their energy for those lucky enough to live in them. He collaborated on several buildings with Monty and their friendship is written into this place, not least into the powerful transformative character of this central atrium. When the glass disappears an extraordinary thing happens. It doesn't feel as though someone has just opened a roof light to let some air in. It feels like someone has just removed the roof light and the entire roof and that you are no longer sitting in a house, but a walled garden or a courtyard, or a cloister. A leaf settles on a table; a bee lazily flies into what had been the sitting room and then disappears out again; the acoustic of what had been an interior now resembles that of an open field and the sky just seems to pour into the space. All in a dense, jumbled street in Peckham.

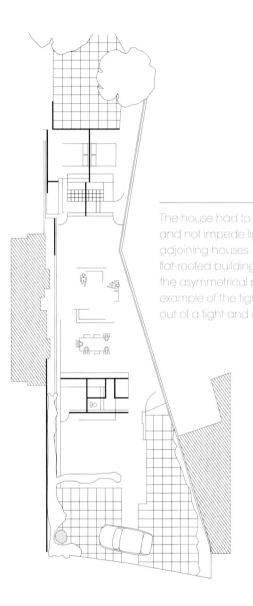

This is not a new architectural idea. The relationship of interior and exterior and the ability to bring the natural world into the most private of spaces was explored by the Romans and Greeks. Richard mined that, evolving the aesthetic potential of a dense urban site by pointing the view upwards. He was also in absolute control of light, understanding how and where it should be reflected off walls or transmitted through glass and translucent materials. In the age of an obsession with space, light and that inside/outside thing, that controlled contact with the outside world, Richard Paxton was a master.

But above all else, what impressed me was how Richard explored the idea of enclosure. For him, walls might not exist to

The house had to be hidden from the street and not impede light from reaching the adjoining houses. Hence it became a low, flat-roofed building, cranked in plan to follow the asymmetrical plot. This is a supreme example of the tight-fit urban house, wrought out of a tight and awkward site.

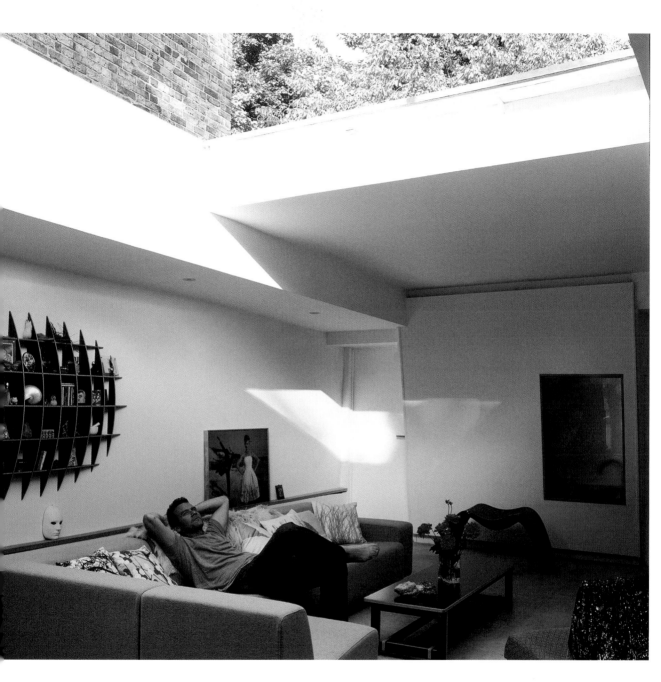

Left **The house is packed with exquisite space-saving details and hidden ideas.**
Above **The sliding roof gives the living room views of the sky.**

support the roof but to provide shelter and comfort. He played with the articulation of shapes in Monty and Claire's home to make you feel relaxed, nurtured and protected, so that when, with a flourish, the roof opens, you don't cower in the wind but feel kissed by a breeze. He understood that great Corbusian truth, that the business of architecture is to create relationships; with a building, with people and with the world at large. In an obituary in the Architects' Journal, Isabel Allen, co-author of this volume, described how Richard's work and life were in a constant state of flux, reflecting 'a restless enthusiasm for transformation and a boundless thirst for architectural experiment'.

THE CROSSWAY HOUSE

It's true that to capture the imagination any great proposal must contain one powerful, simple idea. Communism had collective labour. Nestlé coffee has George Clooney. Richard Hawkes's house, built for himself and his wife Sophie (plus incipient family) has a giant brick arch. Without it he would have simply completed a fascinating set of ecological wooden boxes fitted with some avant-garde sustainable technology. Boys' eco toys.

As it is, the arch is Richard and Sophie's Millau viaduct, their Pantheon, their St Paul's dome, because the extraordinary assertion that any arched or domed object makes is that gravity can be tricked. Richard's design is beguiling because its efficient paraboloid form and its scary thinness stick two fingers up at the laws of the Universe and suggest that big, heavy things like buildings can float like froth. It's one of the great illusions of architecture and now that the roof has a ribbon of grass and flowers stretched across it, that illusion is complete – and pulled off with utter bravado.

Series 9 | 2009 | Kent | Architect Richard Hawkes

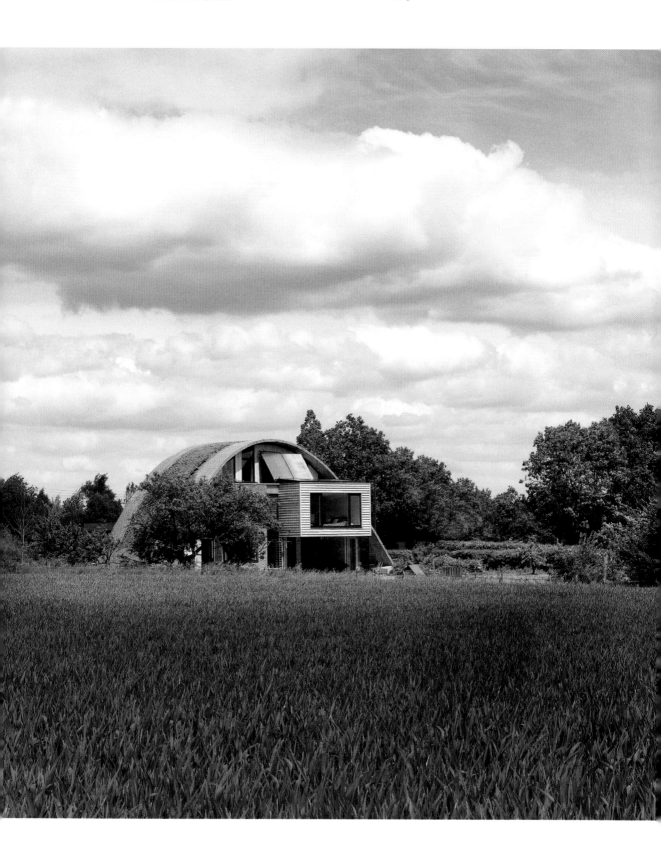

But unlike magic, this trick is even more impressive when you understand how it works. Richard researched a construction method that had originated in medieval Spain. Timbrel vaulting depends on plaster of paris to glue thin terracotta tiles together in order to achieve a rapid progress of construction. The multi-layer vault can be only a few centimetres thick, a wafer skin in effect, and in historical examples achieved its strength from the compound conical effect of constructing a dome where tiles interlock side to side as well as top to bottom around the entire surface. Richard dared to push the technology further, creating just an arch, not a dome, relying on the strong parabolic profile for maximum strength.

It collapsed just once during construction when a builder leaned on a still-damp section, but otherwise remains a marvel of construction: the largest ever single-span timbrel vault in the world, apparently. But the building it embraces is also an elegant home and studio for Richard's architectural practice. And, despite its ecological credentials (it is airtight, super-insulated and hyper-efficient in energy use), there are glamorous spaces and building details under the soaring vault that inspire: not least a return visit to timbrel construction in the form of the arched staircase.

The house was locally grown. The clay tiles all came from a pit down the road. The eco-sand used in the low-carbon concrete slab was ground glass from a local recycler. However, the technology for the building came from further afield and included an in-line mini-woodchip

Previous page **One powerful, simple idea – a giant brick arch. Its thinness gives the impression that big, heavy things like buildings can float like froth.**
Below far left **Inside this avant-garde construction, the house feels entirely serene.**
Below left **The arched staircase under the soaring vault.**
Right **The arch embraces an elegant home and a studio for Richard's architectural practice.**

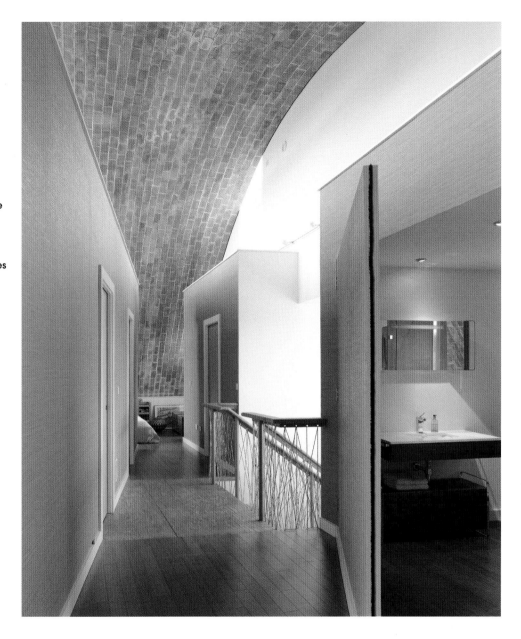

burner in the heat-recovering ventilation system, hybrid photovoltaic/thermal panels that provide both electricity and hot water, and a minuscule thermal store containing phase-change thermal salts. Where would we be without pioneering experimentalists like Richard who treat sustainable construction as a science? Such thinking led to the house being hard-wired with sensors, buried in its walls and floors, that relay information straight into the doctoral theses of several engineering specialists, allowing Richard to monitor the energy consumption and performance of his home. And yet, inside this avant-garde machine for living in, all is quiet for the Hawkes family; the house feels entirely serene.

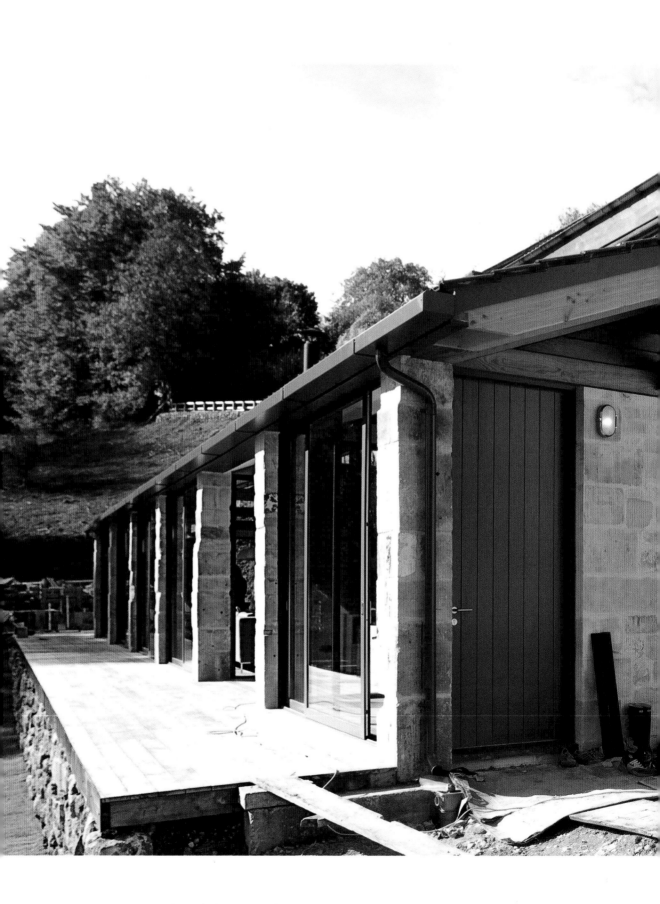

08
WRECKS AND THEIR FLOTSAM

Old buildings help define the character of a place and tell us where we've come from and therefore where we might be going. But there are dozens of ways to interfere with them. In the 21st century people in tweed jackets are re-evaluating the meaning of conservation and Georgian door knobs and deciding there is more than one way to skin a medieval timber frame.

TUSCAN CASTLE

When Howard Smyth and Janne Hoffe-Tilley sold their house in London to restore the Castello di Brancialino, in Tuscany, they embarked on a challenge of a truly epic scale.

Originally a watchtower between Arrezzo and Rimini, Brancialino is at least 1,000 years old, and possibly dates from Roman times. It was once a fairytale medieval hilltop castle, a glorious concoction of courtyards, terraces and towers with views across a lake to the mountains beyond. But history had not treated it well. It had been damaged by successive earthquakes, bombed by the Germans during World War II and abandoned for 60 years. It wasn't just uninhabitable; it was little more than a ruin. The odds – and the interminable machinations of Italian bureaucracy – were stacked against them. But Howard and Janne had vision, passion, and super-human perseverance on their side.

With piles of rubble of up to 8 foot high, the early stages were not so much a building project as an archaeological dig. Armed with a wheelbarrow and a pick they moved and sorted some 1,500 tonnes of stone and general debris. Howard, an amateur archaeologist and curator, collected and catalogued every fragment of history they unearthed including ceramics, ironwork, fragments of a human skull and, most valuable of all, anything that offered clues as to the castle's original design.

Bit by bit, they carried out a painstaking historical reconstruction drawing on photographs, historic records and the clues beneath their feet. They found traces of ancient arches and used them as evidence to gain planning permission to reinstate five large windows in the living room, and had a major breakthrough when a neighbour sheepishly returned some architectural curiosities that her late husband had 'liberated' from the castle – including a column from the Romeo-and-Juliet loggia that linked the castle to its tower.

It's impossible to over-state the magnitude of this project. The arched windows are over two-and-a-half-metres high; the beams are over 30 foot long; the pointing alone took 20 days to complete – and that was with 10 people on the job. Bringing the castle back to life has been a glorious, life-crowning achievement, and an extraordinary labour of love.

Right **A pool nestles within the castle walls.** Far right **Originally a watchtower, the castle enjoys a commanding hilltop position and magnificent views.**

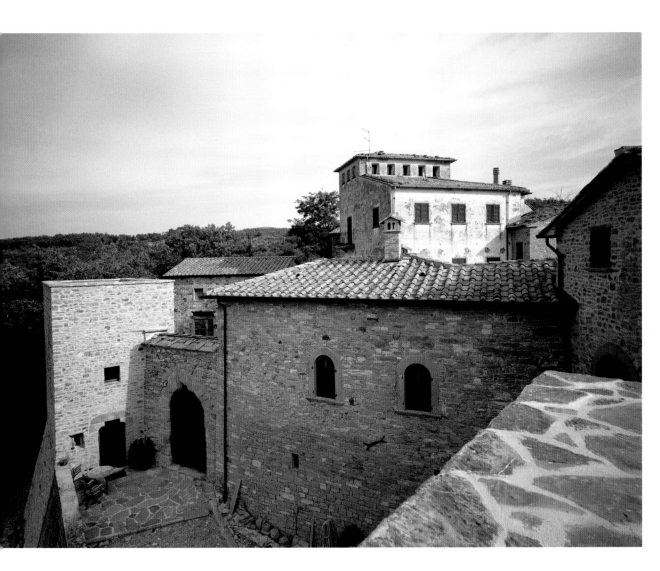

The steeply sloping site and the buildings' historic layout precluded a conventional, practical house plan. Instead, living spaces are interspersed with terraces and built on several levels connected by a network of passageways, bridges and stairs.

THE APPRENTICE STORE

The pursuit of craftsmanship often needs to be single-minded and determined. But it is an irony not lost on many owners of historic homes that in order to save old, poor-quality buildings and conserve them properly, they often require inordinate amounts of craftsmanship, time and money that tests the single-mindedness and determination of any owner.

Ian and Sophie Cooper bought a crumbling stone and timber shed that was trying to slide down a hill just outside Bath, in an area known for its unstable geology. They paid £400,000 for the privilege of ownership only to see much more spent on the stabilisation of the site and ground, on enormous spidery underpinnings, a buried concrete ringbeam, and on a series of tie-bars, hidden wall anchors and restraints all introduced with the express purpose of keeping whatever stood of the old building in the same place.

Ian and Sophie, however, understood the value of the site, looking across a valley of farmland, facing south and yet a five-minute drive into the centre of the city. Their architects, Threefold, knew the importance of taking a conservation approach to as much of the old workshop as possible. Most of the old timber was kept; new work was scarfed in, replacing like with like; repairs were made obvious and new construction and additions were expressed in a very modern language. The building conservators were pleased.

But Threefold also pushed at the extent of that new work, introducing, wherever possible, a modern material or detail, even for some of the repairs and like-for-like replacement. The result is revitalisation of a building in what can be seen as a more progressive and European style of conservation. The British heritage tweed jackets have bristled slightly but the result is a progressive and distinctly Italian-looking interior.

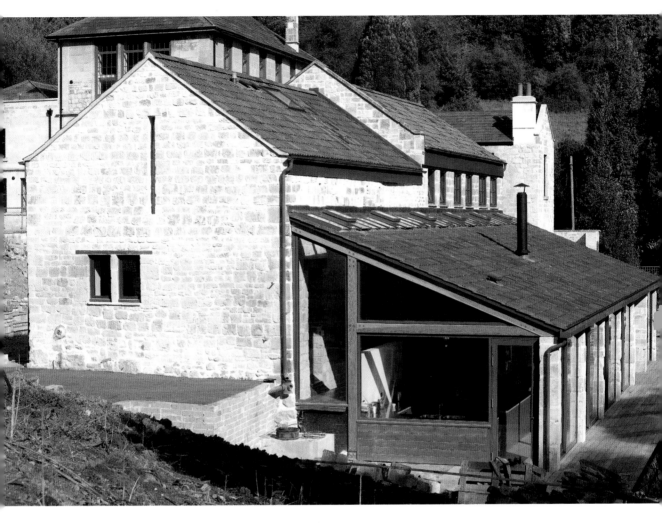

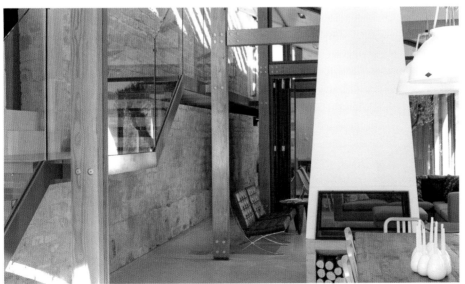

Far left **The Coopers in their winter garden/ entrance hall.**
Above **The full-length glazed façade takes in the panoramic views across the valley.**
Left **A sculptural fireplace and industrial-looking staircase give a precise, contemporary edge.**

It is also imaginative. There's an industrial-looking linking staircase that runs through and around the central spine of the building like a multi-level ribbon escalator. There's a winter garden and double-height entrance hall. There are all the adaptive touches you can get away with when converting an industrial building into a residential one.

But it all required heroic efforts in dealing with the planners and a great deal of will. Parts of this project were exercises in conservation and delicate repair work. They were complemented by some really precise new insertions that weren't too painful to accommodate.

The full-length glazed façade takes full advantage of the view across the valley. The industrial staircase winds through and around the central core of the building whilst the long living floor is punctuated by contemporary touches including a minimalist fireplace and a double-height winter garden/entrance hall.

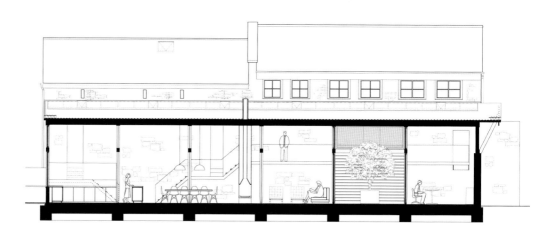

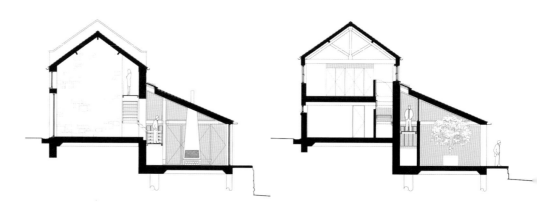

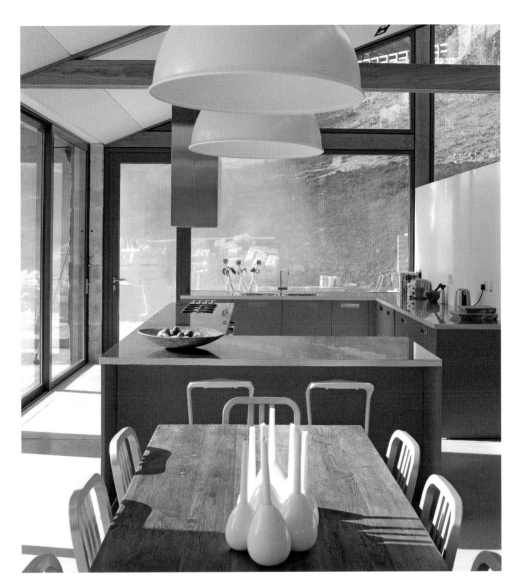

Right **Floor-to-ceiling glazing gives the open-plan living/ kitchen/dining space generous sunlight and magnificent views.**
Below **Bedrooms are in the higher, more enclosed, part of the house.**

Could I live there? Yes I could. I like the mixture of ancient and modern and the new ideas like the staircase. The detailing of the building also appeals to my more obsessive-compulsive side. But I still don't understand why anyone would go to the trouble of commissioning a laser-cut pattern in a stair tread that only mimics some perforated steel bought off the shelf. If only they hadn't all got too architectural about it and just bought some stairtread steel. That would have been proper industrial.

THE CHESTERFIELD WATERWORKS

▼

Believe it or not, the gutsy and hugely ambitious conversion of The Chesterfield Waterworks in rural Derbyshire was essentially a compromise.

A compromise between two seemingly incompatible dreams: Leanne Jones fantasised about living in a Metropolitan loft space whilst her partner Chris Smith hankered after country life.

As you might expect from a utilities building, the architecture of this long-abandoned water treatment works was somewhat utilitarian albeit with a brutal 1930s charm. But its high ceilings, long windows and acres of space offered the potential of open-plan loft-living in a rural location.

Not that you could see much of it. The building was completely overgrown, and the boarded-up windows made it impossible to see inside. It took months to find out who owned the building and track down a key. Once they finally got inside, they found that it was chilly, damp and packed full of gargantuan cast iron tanks. There was no water, electricity or gas. It took a huge leap of faith to envisage it as a welcoming family home.

After a year to agree a price and another two years of legal wrangling, Chris and Leanne finally took possession of their future home. Dispensing with the services of architect, project manager or main contractor they shouldered the bulk of the work themselves. And there was an awful lot of it: it took almost six months just to chip the rotting plaster off the walls.

Wisely they worked with the industrial aesthetic, leaving bolts and pipes in situ and the original brickwork exposed.

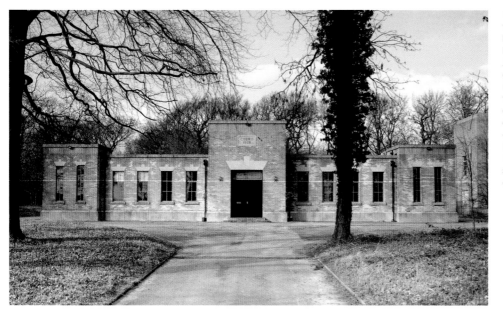

Left **The 1930s former water treatment building has a certain brutal charm.**
Above right **The gargantuan living room boasts reclaimed wooden floors, an outsized dining table and a Mini Cooper converted into a desk.**
Below right **The German kitchen provides a sleek contrast to the exposed brickwork.**

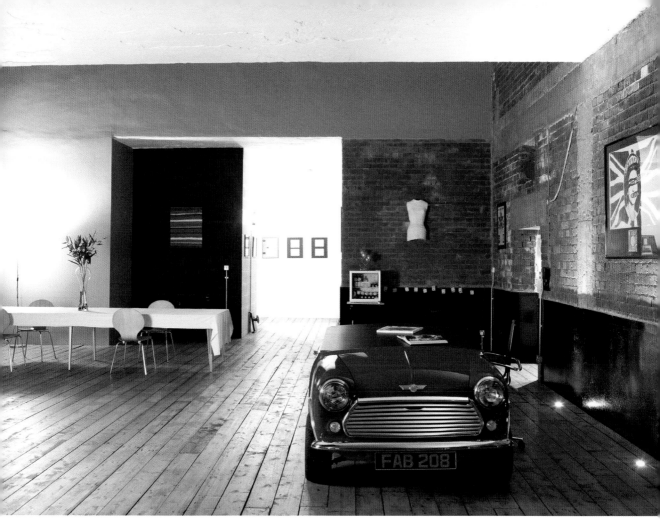

Structural interventions have been kept to a minimum. The bedrooms are enclosed by partition walls, but everything else has been worked within the existing layout. Study, kitchen and bathrooms are in former storerooms. The remainder of the space is one astonishing, gargantuan, living space – big enough for the couple's young son to charge around on his bike, and for the Mini Cooper that the couple converted into a desk to look positively petite. It is the ultimate loft – albeit one surrounded by woodland – and the most uncompromising compromise you could ever hope to see.

HEREFORDSHIRE THRESHING BARN

When Jane and Robert Ellis set out to turn a 400-year-old Herefordshire threshing barn into a new home they knew exactly what they didn't want. They didn't want to disguise the barn or hide its imperfections. They didn't want anything too rustic or twee. And they didn't want the dingy corners and dearth of natural light that are often to be found in barn conversions.

Working with RRA Architects, they came up with a two-pronged strategy. First, they maximised the potential of the openings in the existing structure by arranging spaces according to the availability of natural light. Living space is in the centre of the barn next to the full-height threshing doors that have been freshly fitted out with concertina folding glass. The smaller, more intimate spaces such as bedrooms and snug are in the darker spaces at either end.

Secondly, and more radically, they treated all new-build parts as distinct – and distinctly modern – elements that 'float' within the volume of the barn, separated from the existing structure by bands of clear glass. Hence the first floor, a steel frame which was prefabricated off site, is separated from the existing walls by clear glass perimeter walkways, a strategy that allows light to filter through the building and leaves the full height of the ancient stone walls and their arrow-slit

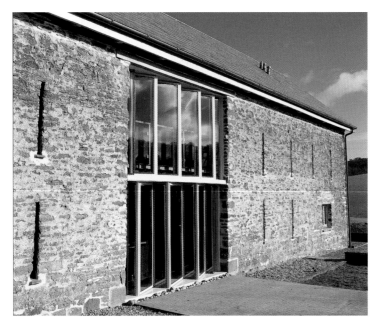

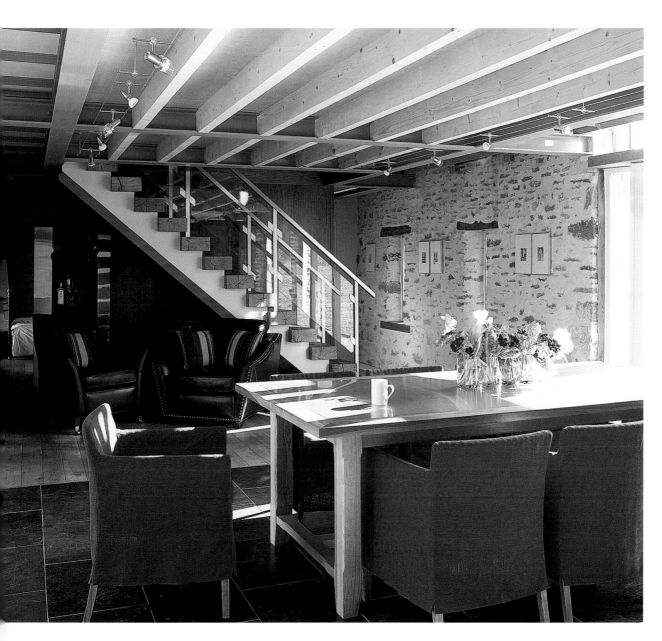

Far left **The conversion was designed to work with the existing openings – arrow-slit windows and full-height threshing doors.**
Left **The original door-openings have been fitted with concertina folded glass.**
Above **Stainless steel sits side by side with ancient stone and oak.**

windows exposed. Bathrooms are housed in prefabricated pods surrounded by free-flowing space. The roof is raised up on clerestory glazing, bringing ventilation and natural light into the upper floor. By night the continuous band of light between walls and roof gives the impression that the roof is hovering above the barn. The result is an intriguing mix of Rural Barn and Manhattan Loft. This project is all about

the contrast between two very different types of construction – the rough-hewn barn rooted to its landscape, and the ultra-modern precision of off-site manufacturing. Everywhere you look in this house the engineering is on show, stainless steel struts and steel framing sit next to centuries-old oak structures. But if it's about contrast, it's also about conversation: old and new sit in a very easy dialogue.

BRAINTREE BARN

▼

Reusing any building is an act of recycling and thus of sharing. The old place is shared between the generations, past and future, thanks to your act. If there is any responsibility in that act it lies in the nature of the changes and interventions you make: so that it consumes less energy in its future incarnation, is repaired to last and is, in as many of its details and character as possible, authentically conserved.

When Ben Coode-Adams and Freddie Robbins took on this monstrous barn they knew the last thing they wanted to do was modernise it into cosiness. Or, for that matter, add trendy pods and a glass link. They felt strongly that they had to keep the majestic full-height monumentality of the ancient timber frame, preserving a view from one end to the other, and that there should be no 'rooms' and certainly no first floor slung across the space. It should remain a barn, but one for living and working in.

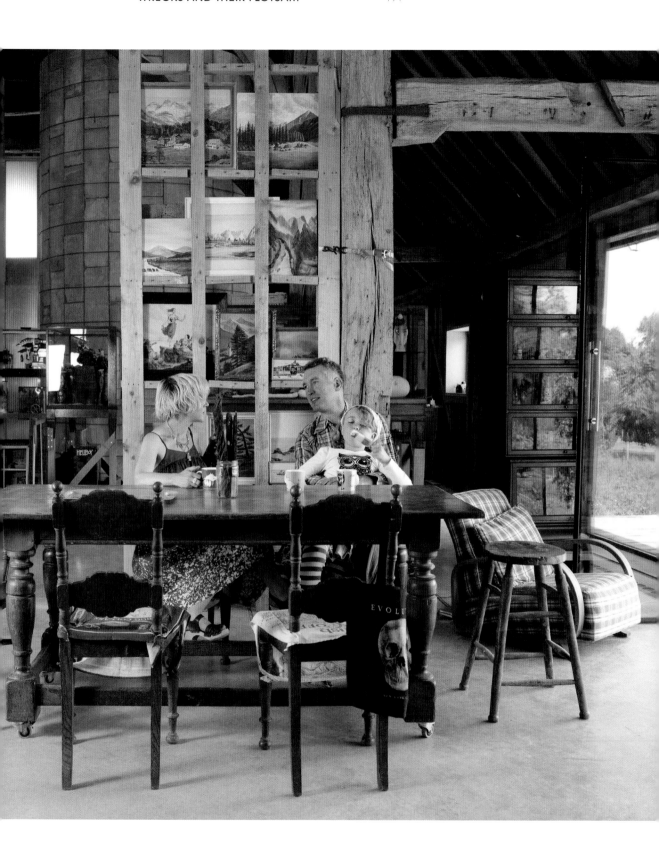

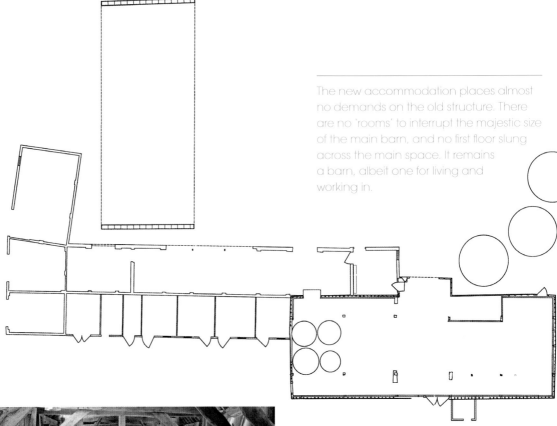

The new accommodation places almost no demands on the old structure. There are no 'rooms' to interrupt the majestic size of the main barn, and no first floor slung across the main space. It remains a barn, albeit one for living and working in.

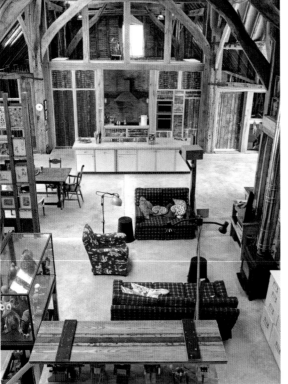

The old concrete floor was reformed with underfloor heating, powered from a woodchip boiler on the farm. Two concrete silos, the agricultural equivalent of pods, were moved down the barn and rebuilt to contain the bathrooms. The skin of the structure was pulled off and a new, timber and plywood insulated wall structure was added outside the oak frame, placed upon it, rather than between the beams and studwork. This placed the conserved and repaired frame on full and detailed view, as it had always been, while forming an enveloping warm wrap around the building.

But given the planning condition that there could be no windows in the roof (the building is mainly roof), where was the light to come from? Their architect, the redoubtable Anthony Hudson, reinventor of agricultural buildings, devised a

brilliant solution with them: a roof skin of patinated, galvanised expanded metal sheet, perforated and undulating, over a complex build-up of polycarbonate sheeting and translucent, insulating Rodeker board. The result is no visible trace of a window outside and a series of enormous shimmering panels of light on the roof pitches inside, that sit as clean and flush on the frame as the polished plywood around them.

This entire project pushes at the boundaries of repair and conservation by replacing every broken or useless component in the building (old tin roof, rotten cladding) with a brilliantly-devised modern alternative (mesh-steel composite roof, plywood mosaic cladding). Ben and Freddie also pushed at the boundaries

of decoration, furnishing the home like a friendly museum (inspired by the Pitt-Rivers Museum in Oxford), to house their vast collection of toys and stuffed animals. They recycled tea chests into french-polished wardrobes and old furniture into a kitchen.

The result is a highly tuned and awe-inspiring building, one that Ben is exalted by every time he sits on the sofa and turns his head upwards. It is also an accommodating live-work space, housing their library of books and studios (both are artists; Freddie teaches at the Royal College of Art). This semi-industrial role serves the agricultural shed well; in fact the accommodation places almost no demands on the old structure. If only all barn conversions were as sensitive, faithful and as epic as this.

Previous page
Determined not to 'tame' their barn into cosiness, Freddie and Ben furnished the interior to look like a 'friendly museum'.
Left **The conserved and repaired timber frame is on full view.**
Below **Tea chests have been recycled as wardrobe doors.**

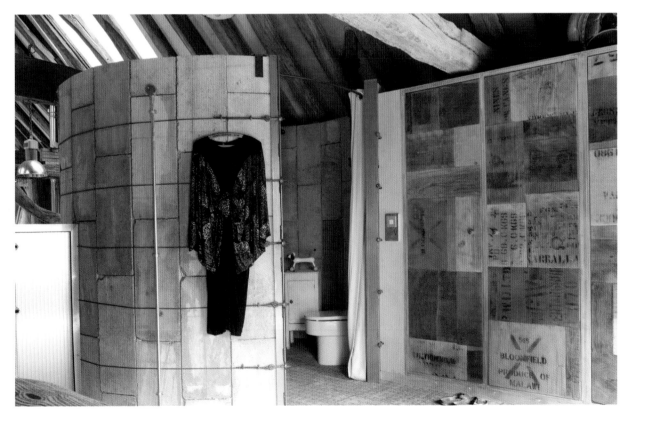

HELLIFIELD PEEL

▼

Hellifield Peel, a medieval defensive tower house near Skipton, was a perilous ruin until Francis and Karen Shaw found it on English Heritage's Buildings At Risk Register, bought it for just £165,000 and applied, in 2004, to rebuild it, reroof it and then live in it.

Not so easy given that it was a Scheduled Ancient Monument and subject to all kinds of stringent conditions; such as an archaeological survey at a cost of £25,000 (that in the end produced one land drain and one plastic plate); or a two-year mandatory consultation process. As Karen says 'We've had quite a few hurdles to jump with English Heritage and the archaeology. Sometimes it felt as though we didn't own our own property.' There again, very few people attempt to work on Scheduled Ancient Monuments. When I asked English Heritage's boss Simon Thurley if he could remember anyone converting a SAM into a home, he couldn't think of another example.

10 years ago Francis and Karen would have been refused permission and told instead to stabilise the ruin, conserve it and leave it more or less as they found it, in aspic. But Keith Emerick, English Heritage's local senior officer wanted to be more pragmatic. As Francis puts it, 'I think it was quite simple. Given another 10 or 20 years this place wasn't going to be here. This was its last chance and English Heritage have been very supportive – providing me with a lot of information, drawings and photographs. So they were very keen to see the building saved.' So the Peel is something of a first in the small arcane world of Ancient Monuments. According to Keith, there was no need to preserve the place as a ruin. It was structurally so dangerous that its lifespan was bound to be very short in any case. Nobody else was mad enough to take the place on. And, importantly, it had only fallen derelict in the 1940s and so, as a ruin, had no association with a major historical event. So why not rebuild, using engravings and early photographs as reference? Why

Below **The medieval tower was a perilous ruin.**
Left **A modern annexe has been built within the new roof.**

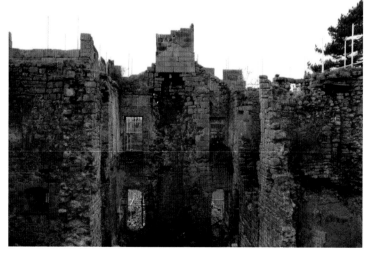

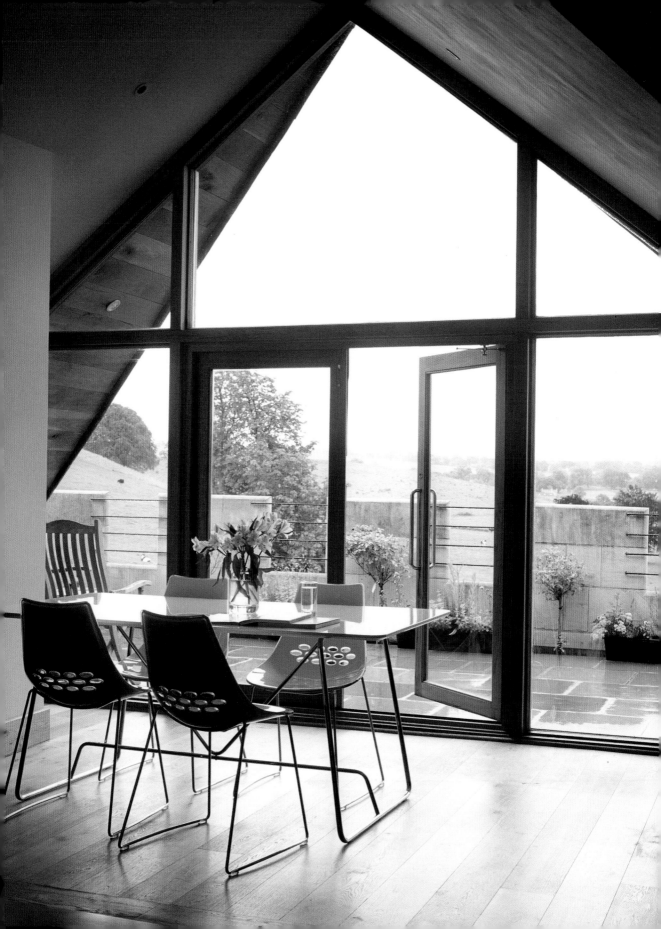

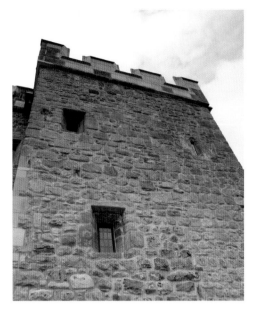

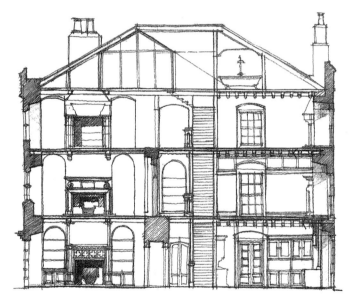

Above **Cross section through Hellifield Peel drawn by Francis Shaw.**

A combination of conservation, restoration and out and out reconstruction, the rebuilt tower is based on an informed guess as to how the building might have looked centuries ago. The aim was to evoke 'the spirit of authenticity', keeping it 'simple, but not too simple'.

not wind the clock back and make some informed guess as to how it might have looked inside and out one, two or three hundred years ago?

The result is a fair success. The finished building is a sensitive mix of traditional conservation techniques, preservation and careful restoration. The interior, however, is pretty conjectural and contains a lot of what can only be referred to as dramatic reconstruction. New carved stone doorways and fireplaces, all designed by Francis, a practising architect, are in a style best described as 'twentieth-century retro-castle' as though designed by the eminent Edwardian architect Edwin Lutyens. Everyone, including Keith Emerick, breathed a sigh of relief at this. We were all dreading a 'twentieth-century Disney-castle'.

'It's about keeping it simple, but not too simple,' says Francis. 'If you go totally against the spirit of authenticity in a place like this, you end up with a plain ceiling, plain walls, no fireplace. You end up with a modern box inside an old building… What we're doing here is approaching not just the repairs but the whole structure and all the new work in a very traditional manner.' The key word here is authenticity, because it crops up as an important concept in a document, 'Conservation Principles', produced by English Heritage during the course of filming this project over four and a half years. That the Principles were published in this time is not coincidence: one of the contributors to the document was Keith Emerick and the Peel served as a something of a testbed for the Principles, which define 'conservation' as the management of change, and 'authenticity' as a guiding consideration. Clearly, interpretations of what is authentic in an ancient building may vary. Francis's opinion sometimes differed from that of Keith. What is

Far left **Hellifield Peel rebuilt and restored.** Left and below **The interiors retain a spirit of authenticity in a style best described as 'twentieth-century retro-castle'.**

important is that in the end, two gifted and informed professionals, one a historic buildings expert and the other the owner, were able to agree what might be appropriate for the Peel (including a modern annexe set into the new roof).

This acceptance of reconstruction, new beams and carved stonework in traditional, rather than contemporary style, isn't commonly allowed in a bog-standard grade II listed house let alone on a Scheduled Ancient Monument. The Peel marks a turning point away from a pure philosophy of 'Conservative Repair' (espoused valiantly and rightly by organisations like the Society for Protection of Ancient Buildings) where new interventions can be read as such, to something altogether more flexible. This glorious reincarnation of a pile of dust into a living building marks a fresh opportunity to look at our built heritage and carefully re-evaluate it.

BASING FARM

Traditionally, aspirational rural dwellings have fallen into a handful of well-worn clichés: rambling farmhouse, rose-covered cottage, Georgian rectory or converted barn. The converted chicken sheds at Basing Farm in Kent represent a new phenomenon: two homes that take their cue not from residential architecture, but from the loose-fit open plan of working agricultural buildings; the rural quivalent of the modern loft.

The architects De Matos Ryan were commissioned to develop a sustainable and environmentally sensitive solution for the conversion of two former chicken sheds to two high-quality contemporary family homes. Since the site lies within a designated Area of Outstanding Natural Beauty it was essential that the solution was appropriate to the rural setting and did not impinge on existing views.

Their solution was to keep the agricultural feel of the buildings, refurbishing the existing timber frames before wrapping them in generous insulation and cladding them in vertical cedar boards. The windows are shielded by automated sliding shutters in the same cedar boarding as the cladding to the façades. When the shutters are closed, the effect is of a uniform window-free timber shed, a classic – albeit unusually pristine – farmyard barn.

When the shutters are open, the houses enjoy a direct relationship with the garden, with full-height double-glazed windows and large sliding cedar-framed doors. Each entrance is marked by a recessed glass slot that brings light and

Grand Designs Award | 2009 | Kent | Architect **De Matos Ryan**

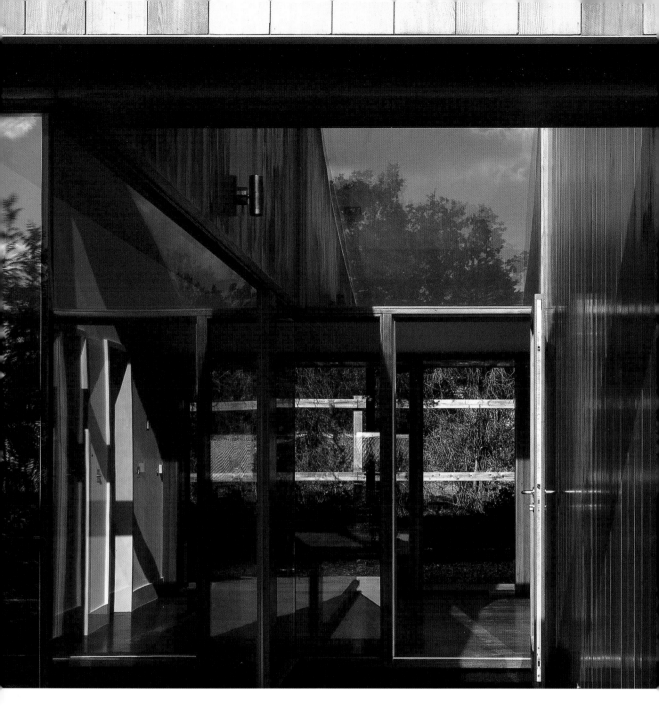

Far left **The exterior reworks the language of agricultural buildings.**
Left **The open-plan interior offers a rural equivalent of the urban loft.**
Above **A recessed glass slot brings light and transparency deep into the house.**

transparency deep into the house. Two sliding glass doors at the corner of the main living space open up so that the corner of the house 'disappears', melting into the terrace and garden.

Rainwater is collected and gathered in concealed gutters behind cedar-boarded fascias supporting the sliding gear for the shutters and doors. Hot water and heating are supplied by a geothermal heat source, distributed by underfloor heating throughout each house.

It is the ideal solution for a new attitude to country life: a desire to connect with the landscape; to enjoy the bright simplicity of flexible open-plan space and to live in a home that is efficient in its use of resources as well as being economical to run.

11 PRINCELET STREET

▼

Like dogs, some buildings match their owners. 11 Princelet Street and its owner Chris Dyson are a perfect fit. Chris is an architect who specialises in working with historic and listed buildings, and a passionate advocate for what remains of Spitalfields' historic architecture.

He and his wife, Sarah, already lived in the area and had long since coveted the eighteenth-century townhouses, originally built for Huguenot silk-weavers, that still occupy a cluster of cobbled streets close to Nicholas Hawksmoor's Christ Church Spitalfields. Number 11 Princelet Street was built in 1720 and originally belonged not to a weaver but to a Huguenot cleric.

In restoring the interior, Chris took his cue from the few existing fragments of the original architecture – the original staircase was still intact, as was some of the panelling – and used his knowledge of eighteenth-century architecture and detailing to fill in the gaps.

While the rest of the Georgian streetscape was largely intact, number 11 had been modified during the nineteenth century, with its three piano nobile windows replaced with factory glazing. Chris restored the façade to its former glory, copying some of the details from Church Vicarage on nearby Fournier Street. It may not be an exact replica of the original but it's certainly a good enough likeness.

Chris wasn't afraid to use poetic licence. Hence the new incarnation of 11 Princelet Street boasts a rooftop workshop, which the original almost certainly never had. They were common in silk-weavers' homes since they allowed craftsmen to take full advantage of every available hour of natural light, but were possibly less useful to a cleric.

Left **Chris Dyson on his roof terrace.**
Above right **The open-plan kitchen is defiantly contemporary.**
Below right **The formal rooms have been restored to their eighteenth-century glory.**

This pick 'n' mix approach works precisely because of Chris's intuitive – and informed – empathy with the building. To the uninitiated eye it's impossible to distinguish between faithful reconstruction, informed guesswork and out-and-out flights of fancy. That said, there are some touches that you couldn't mistake for the original. The open-plan kitchen is clearly a response to contemporary lifestyle. And the hinged panelling – the type used by Huguenot weavers to lock away their precious silks – folds back to reveal modern-day necessities including a TV. Chris has been judicious rather than purist. Which makes it a home as opposed to a museum.

BLETCHLEY MANOR

▼

Nigel Daly and Brian Vowles specialise in rescuing and restoring historic buildings, generally on behalf of wealthy clients. Bletchley Manor, near Market Drayton in Shropshire, presented an opportunity to work their magic on a project of their own.

This was a historic building in dire need of help. The Grade II listed seventeenth-century manor house had suffered multiple indignities. The lane to the side of the house had morphed into a dual carriageway. The entire building was almost demolished in 1830 – it was given a last minute reprieve but not before one end of the house was razed to the ground and replaced with a nineteenth-century extension. The main façade had been covered with a false front in a style best described as suburban mock Tudor whilst the interior had been carved up into a warren of bedsits.

Nigel and Brian's mission was not to carry out a painstaking historical reconstruction, but simply to bring the manor back to life, inject it with dignity, warmth and joie de vivre. Their approach was a heady mix of conventional conservation, warehouse chic and a touch of Country House Cluedo mystique. They stripped the house back to the original oak frame, restoring the interior to its original proportions and revealing the seventeenth-century façade. They carried out a meticulous conservation project on a delightful panelled parlour that, miraculously, had its timber panelling and tiled fireplace more or less intact. But they also knocked two rooms into one to make a magnificent light-drenched drawing room; blithely installed a stainless steel kitchen; designed a super-minimal glass attic staircase – and installed a swinging bookcase leading to a secret staircase just because they could.

Right **The house has been stripped back to its original oak frame.** Above right **A contemporary kitchen/ diner makes the manor fit for modern life.** Below right **The restored seventeenth-century manor and its nineteenth-century extension.**

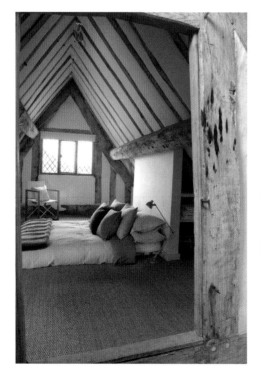

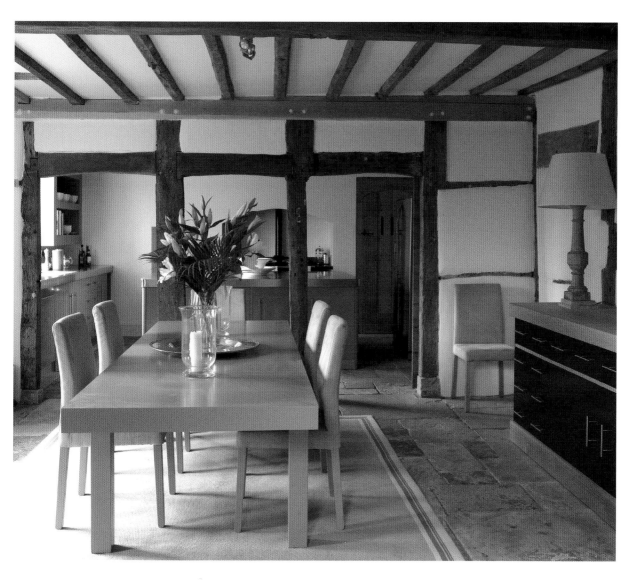

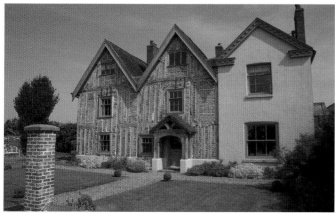

They didn't take themselves too seriously, but they made a very serious point. Like many of our listed buildings, Bletchley wasn't important enough to be preserved as a museum, but was too daunting an undertaking to appeal to the average homebuyer. For our more modest historic buildings, this middle ground, a pragmatic path between slavish commitment to conservation and high-handed disregard for the past, offers perhaps the only chance of survival.

PINIONS BARN

▼

Barn conversions have a bad reputation: net curtains, carriage lamp, a neat front door tacked awkwardly onto the majestic bulk of an ancient barn.

But Pinions Barn was converted by Simon Conder, the architect for two other projects in this book, Vista on pages 136–37 and El Ray on pages 252–53. His work is anything but twee.

At Pinions Barn he was commissioned to convert a couple of Northamptonshire barns into a holiday home for a sociable London family with teenage kids. In many respects, his response was eminently straightforward. The smaller of the two barns has been allocated to the teenagers and their friends whilst the adults get the big barn. The layout works with the existing structure, hence an upper floor hayloft is given over to bedrooms and bathrooms, whilst the main double-height space is a vast living/kitchen/dining area. Existing

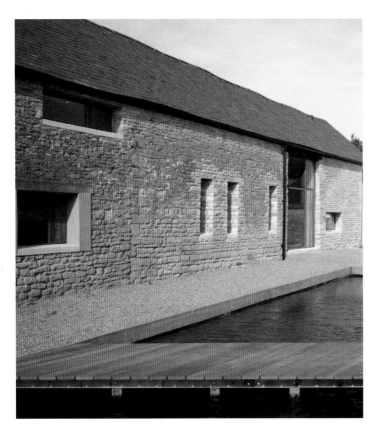

Grand Designs Award | 2006 | Northamptonshire | Architect **Simon Conder**

Right **Birch ply inner walls make space for services and storage and create a warmer, smoother living environment.**
Below left **A steel-framed shed has been demolished to make way for a swimming pool.**
Below right **The single-storey barn houses the children and teenagers.**

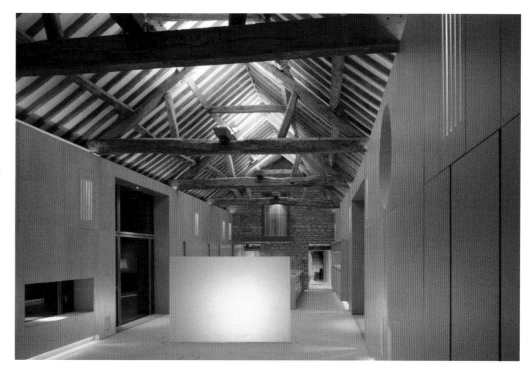

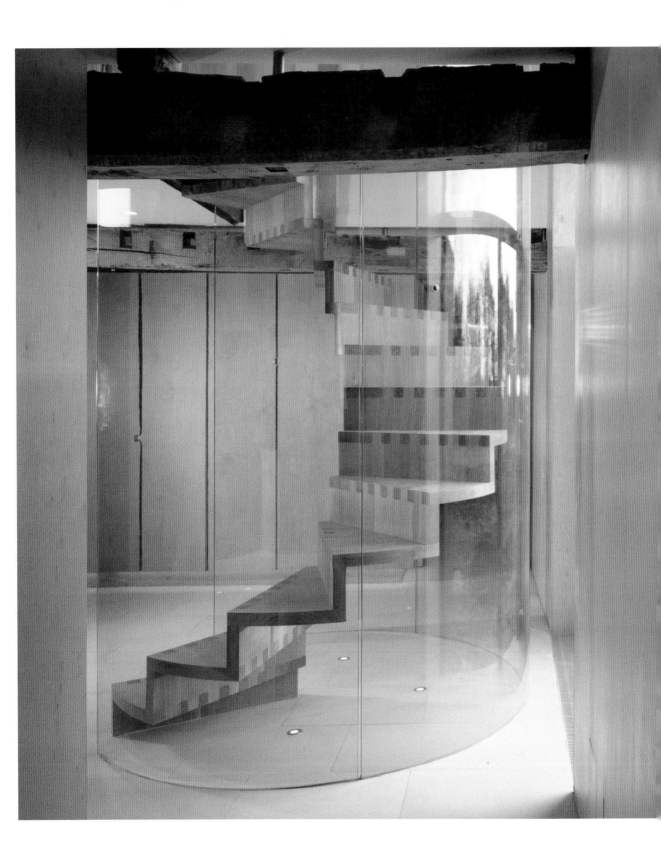

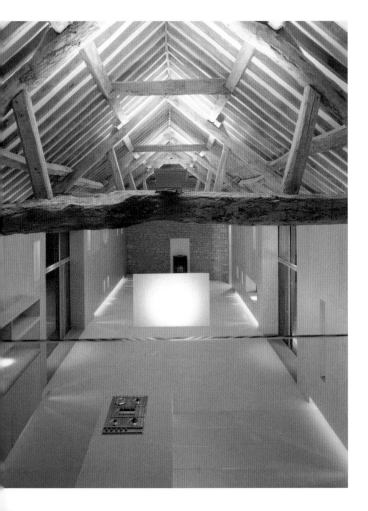

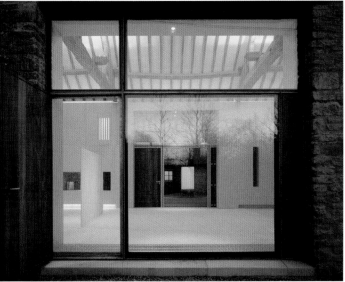

openings have been reused: old barn doorways have become glass walls; a circular hay-hatch has become a porthole window.

The challenge of working with the lumps and bumps of an ancient barn has been solved by lining the two flank walls with birch ply inner walls – a trick that creates void space for storage, pipes and wiring but also creates a smoother, warmer, more contained living environment within the envelope of the rugged stone walls.

But Simon doesn't do straightforward. There are a couple of big surprises. The first is the staircase, a self-supporting spiral of two-inch thick slabs of oak, contained within an elegant cylinder of toughened curved glass. The second is an 18-foot long horizontal strip window in the kitchen designed with the sole purpose of creating an optical illusion. The main Edinburgh to London railway line runs alongside a field next to the house. The window is positioned to frame each train as it hurtles past, giving the momentary impression that the train is running along the window sill.

Two deft, ballsy contemporary moves that match the scale – and guts – of the original architecture. And show that architecture doesn't have to take itself too seriously to be seriously good.

Far left **An elegant glass cylinder contains the self-supporting spiral staircase.**
Above left **The main full-height living/ kitchen/dining space.**
Left **Barn door openings have become glass walls.**

FISH CREEK

You know how it is with impulse shopping. One minute you see a nineteenth-century church for sale. Next thing you know, it's yours. Australian engineer Peter Riedel and his interior designer wife Mary bought an 1870s church for $20,000. Which sounds like a bargain, until you realise that it didn't have a site, and it wasn't actually intact. The church had been carefully dismantled some 13 years beforehand. Peter and Mary had bought a pile of boards.

Right **The rebuilt church: the side extension was not part of the original building but makes for a more practical home.**

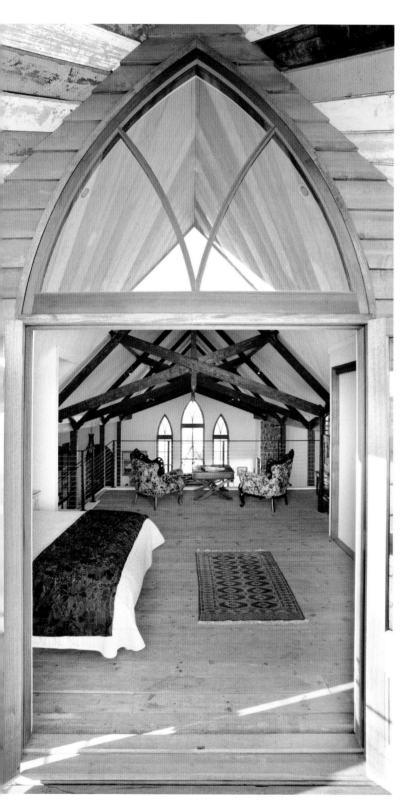

All they had to do was put them back together again on their land on top of a mountain at Fish Creek in Victoria – not too much of a challenge since the company that had removed the church from its original location had taken the trouble to produce an instruction manual noting the exact order in which the church was to be rebuilt. Except that somehow the manual had been mislaid and wasn't included in the sale. Oh, and the timber windows were missing too.

Left **The master bedroom occupies a mezzanine overlooking the main volume of the church.** Below **Preparing to piece together the jigsaw puzzle** Right **The magnificent 4.2-metre high living room.**

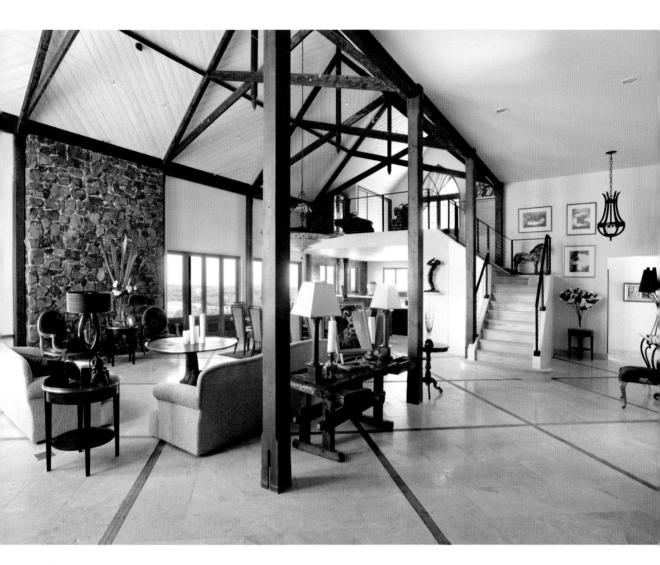

It made for an interesting challenge. Something akin to doing a jigsaw puzzle with the odd bit missing – in three dimensions and on an epic scale. It sounds like a recipe for disaster but, in a way, I suspect that the realisation that they could never make a faithful replica of the original church was the making of Peter and Mary's extraordinary home; that it made them feel more able to adapt and modify the structure to suit their particular tastes and needs.

Hence they have blithely added a side extension to the church, compromising the symmetry of the original design but providing useful living accommodation and, crucially, allowing them to leave the main volume of the church as a magnificent uninterrupted space – a soaring 4.2-metre high living room overlooked by the master bedroom on a mezzanine.

It's not a slavish reconstruction, so much as a loose interpretation of an historic building. But it is a new house with a great back story, a strong character, and a decidedly ecclesiastical feel. It's also the mother of all DIY projects. But most importantly, it's a comfortable and much-loved family house.

KILGALLÁN CONVERTED CHAPEL

Sometimes ruined buildings can have an extraordinary effect. They intrigue, they seduce, they cajole apparently sane individuals to take crazy risks. Such was the case with Kilgallán, a crumbling Church of Ireland chapel surrounded by wild countryside on the west coast of Ireland.

Built in 1836, the chapel stopped being used as a place of worship in 1901 when the bell tower was struck by lightning. When architect Andrew Lohan and his wife Jackie first clapped eyes on the building it had languished unused for almost a century. With two young children and busy careers, restoring a ruin was the last thing on their minds. But love affairs are never rational. And the Lohans fell in love.

And that, I think, is the beauty of this project. Where the average church conversion starts with the desire to build a house, to carve up the available volume into domestic-scale rooms, this one grew out of a passion for the building, a desire to restore and celebrate its intrinsic character.

Hence the smaller spaces – bedrooms and bathrooms – are stacked together in a timber box in the middle of the church, leaving the stone walls, gothic windows, timber roof and the full height of the chapel uncompromised and in full view.

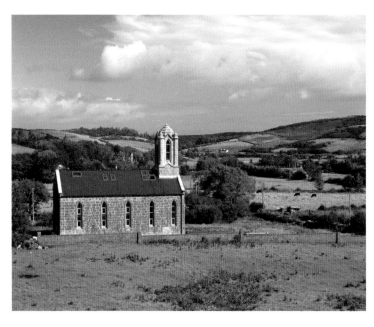

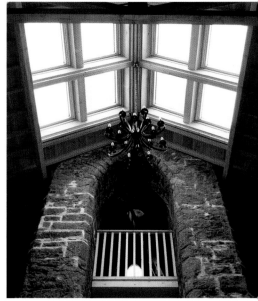

Grand Designs Award | 2006 | Ireland | Architect Andrew Lohan, Brazil Lohan Architects

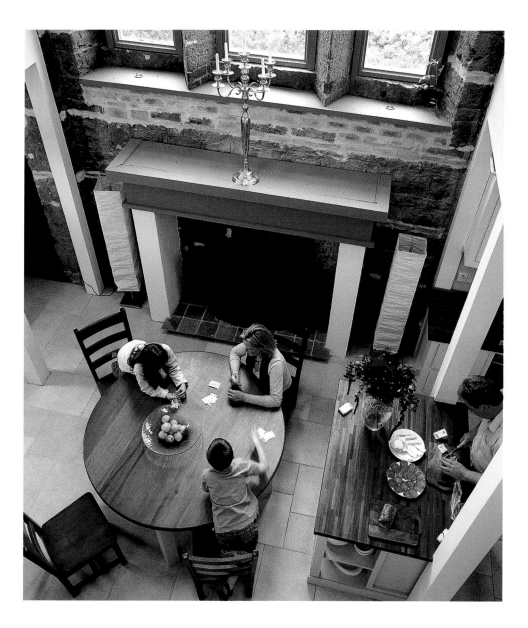

Far left **The chapel is surrounded by wild countryside.**
Left **The renovation is an extraordinary marriage of two very different architectural languages and scales.**
Right **The altar windows preside over the kitchen and dining hall.**

But this isn't simply a case of a house sitting inside a big cocoon. The really clever stuff happens at the two ends of the chapel, where the ecclesiastical architecture and scale meet the language of domestic life. At the entrance end, below the stone bell tower, the living room has views up through glazing in the roof to the stone cupola above. At the opposite end, the three altar windows preside over dining hall and kitchen.

The bedrooms on the upper floor of the box have Juliet balconies overlooking this space and views through the windows towards the rolling Mayo hills.

This is an extraordinary marriage of two different architectural languages and scales. But, as in all the best relationships, it works precisely because neither one is allowed to completely overshadow the other. It's the best example of a church conversion I've seen.

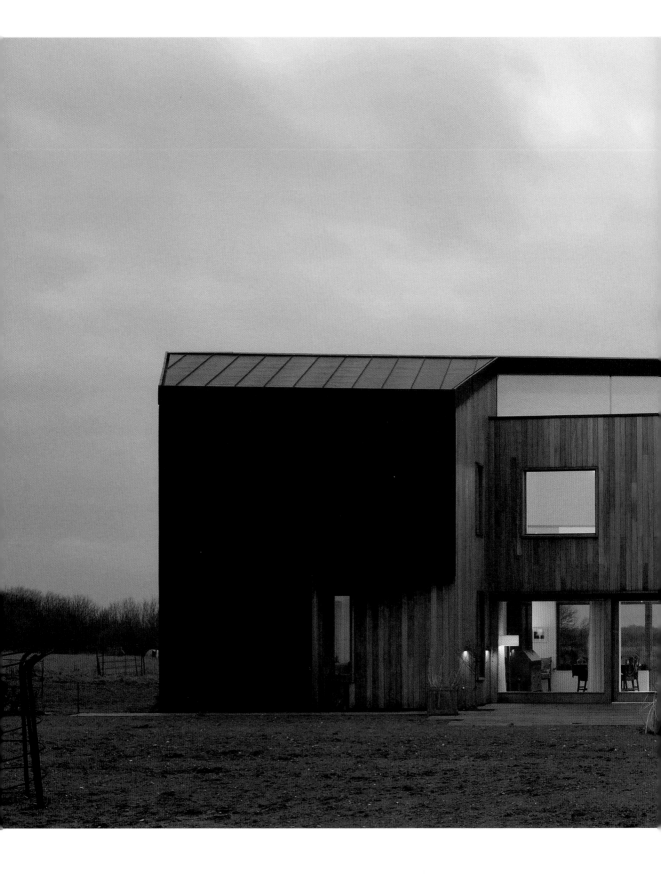

09
DISAPPEARING ACTS

There are some for whom building a modest house is not enough. In this new age of gentle, respectful architecture, it should also, wherever possible, disappear, blend into its surroundings, be camouflaged or be coated in mirrors. The ultimate act of contextuality is for a building to become its surroundings, by turning into a hill, a cliff face or a waterfall.

PROVIDENCE CHAPEL

Providence Chapel in Colerne, Wiltshire, is a house of two parts. The first is a Grade II listed nineteenth-century Baptist chapel which now houses the main living space. The second, a timber-clad extension to the rear of the historic ecclesiastical building, houses bedrooms and bathrooms and is a direct response to the client's request for a building that was 'crisp, modern and spare' whilst being appropriate to the architecture of the chapel.

The architect, Jonathan Tuckey, specialises in working with historic buildings and is an advocate for architecture that collages old and new; that isn't afraid to tell new stories of its own. In other words, he was never going to opt for the faux-historic 'seamless' extension. And he was always going to go for something a little bit richer than the 'neutral' glass-and-steel box.

The extension at Providence Chapel has a very particular story to tell. Rather than attempting to ape the architecture of the original Bath stone chapel, Jonathan's design makes reference to a parallel chapter in chapel architecture – the 'Tin Tabernacle'. Built to serve new communities in previously isolated areas, these were simple places of worship built by early Victorian engineers. They also signified a particular moment in the history of British engineering. The invention of corrugated iron, in 1828, offered a means of putting up temporary buildings cheaply and at top speed.

As it happened, Jonathan didn't use corrugated iron on his own 'Tin Tabernacle'. He thought about it, but eventually

Below **The original nineteenth-century Baptist chapel**
Below right **The timber-clad extension is a direct response to the client's request for a building that was 'crisp, modern and spare'.**

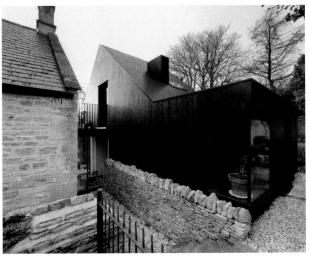

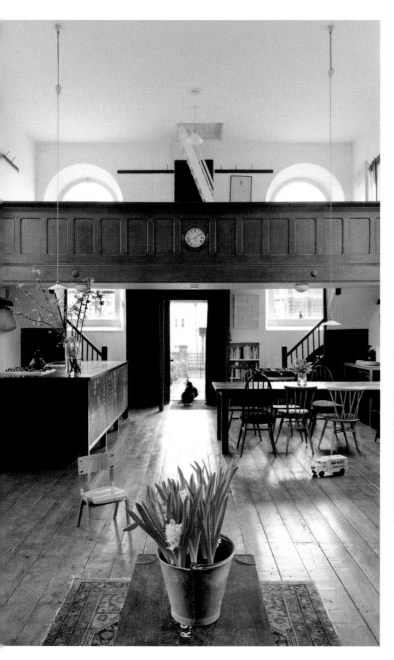

Above and left
**Putting bedrooms
and bathrooms in
the extension meant
that the chapel could
remain as a single
uninterrupted volume
and a spectacular
living space.**

plumped for black-stained western
red cedar giving the house a sharp,
clean silhouette – 'crisp, modern and
spare'. Like the extension to Hunsett
Mill featured on pages 54–7, it reads as
a shadow to its Siamese twin. But it's a
shadow with its own voice, and its own
story to tell. In evoking the spirit of the

'Tin Tabernacle', the extension pays tribute
to an endangered species. Countless
'Tin Tabernacles' have been demolished;
victims of dwindling congregations or
of dust and dry rot. It may be a shadow,
but it is also a spotlight, a quiet tribute to
a building type that is generally ignored
and overlooked.

COTSWOLDS STEALTH HOUSE

▼

Underhill House – or the Cotwolds Stealth House as it's popularly known, built by Helen and Chris Seymour-Smith, was England's first certified Passivhaus.

Passivhauses, incidentally, are not a make or a brand but buildings put up to meet a minimum energy consumption standard. Heat is produced in the home by captured solar radiation and by the human beings who live there (a good idea since each of us produces a healthy kilowatt). Heat is then retained by super-insulating the building, making it airtight and using a heat exchanger to introduce fresh air and take stale air out. They build a lot of them in Germany. Angela Merkel is so confident in their performance and reliability she's adopted the Passivhaus standard as the target, not just for new homes in Germany, but for existing homes as well.

But we don't build very many in England, and Helen and Chris's Passivhaus nearly didn't get built at all. Their plans to build a new home were originally rejected

Left and right **The open-plan living room. Ductwork for the mechanical ventilation and heat-recovery system has been left on show.**

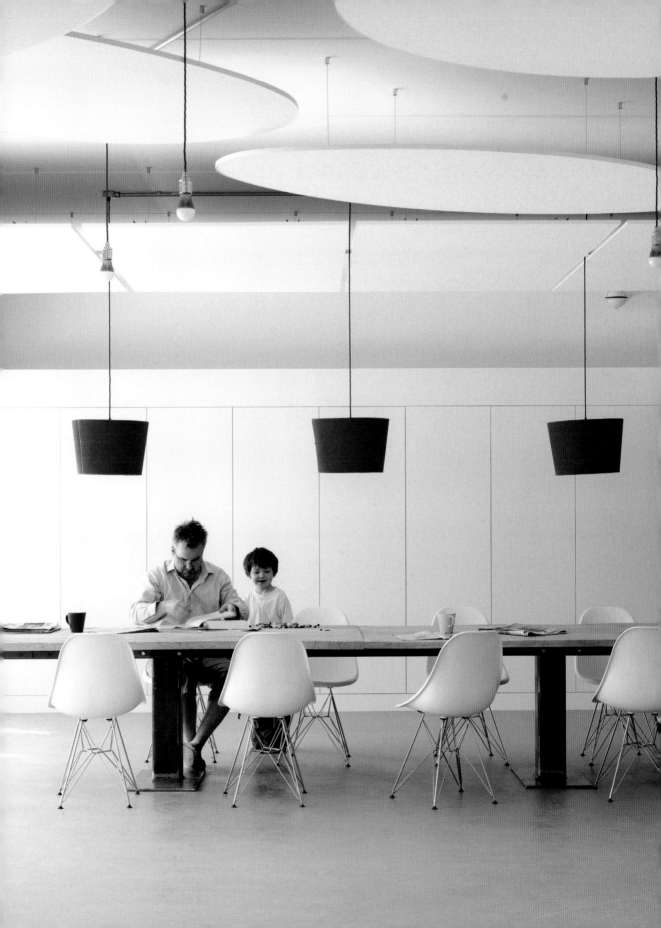

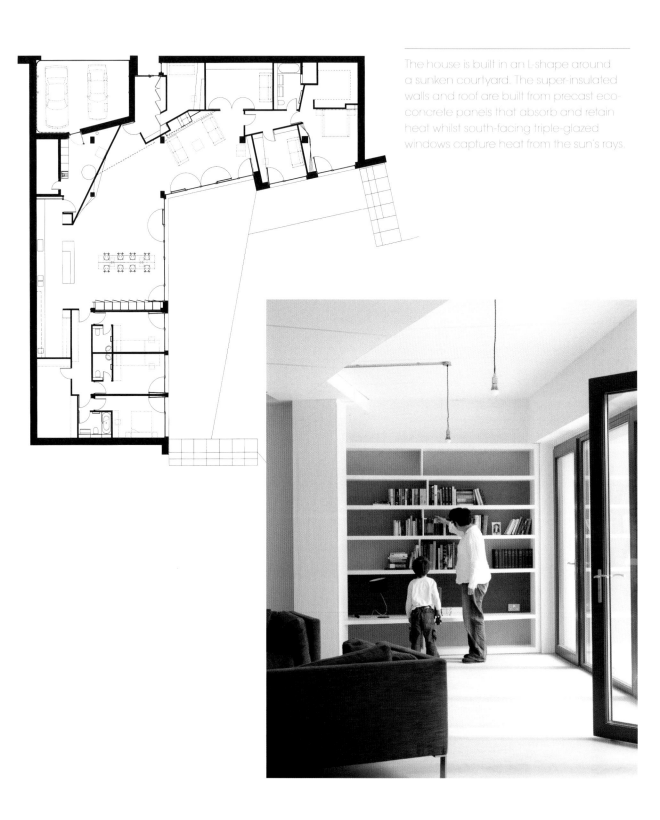

The house is built in an L-shape around a sunken courtyard. The super-insulated walls and roof are built from precast eco-concrete panels that absorb and retain heat whilst south-facing triple-glazed windows capture heat from the sun's rays.

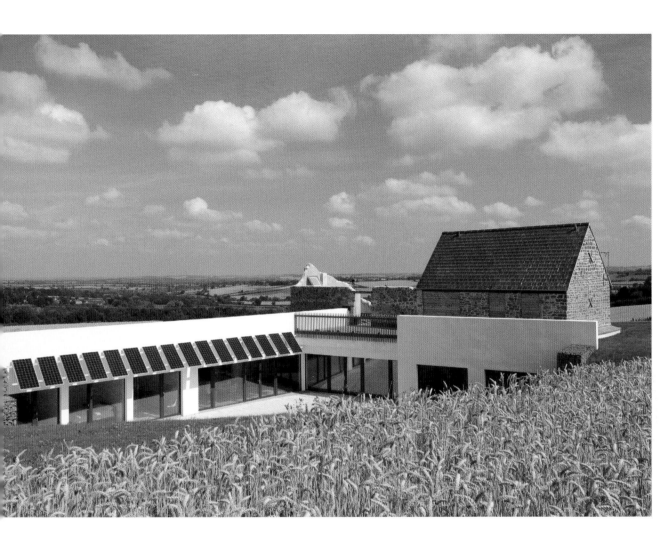

Left **Abundant light and space allow for 'loft living' underground.**
Above **The house hides behind – and partly underneath – an ancient barn which has been rebuilt with solar thermal tiles on the roof.**

by the planners – hardly surprising given that their chosen site was an unspoilt hillside occupied by a picturesque ancient barn. Undeterred, they cited Paragraph 11 of PPS 7, a now-defunct strand of planning law that decreed that – in exceptional circumstances – it could be permissible to build a one-off house on a greenfield site.

To qualify, the house had to be innovative and brilliantly designed. In this instance, the planners also added the proviso that it had to be all but invisible. And so it is, hiding behind – and underneath – the existing barn. Built in an L-shape around a sunken courtyard, its super-insulated walls and roof are built

from precast eco-concrete panels that absorb and retain heat. Its south-facing triple-glazed windows capture heat from the sun's rays. Photovoltaic panels provide electricity and solar thermal tiles, attached to the barn, provide hot water. A mechanical heat-recovery and ventilation system helps to maintain a temperature of around 20°C all year round.

This is a building with an environmental footprint that's so small you can't see it. Passivhaus dwellings achieve a staggering 90 per cent energy saving compared to the average house. Yet there are still only a handful in the UK. We've got a lot of catching up to do.

BAVENT HOUSE

▼

Bavent House, designed by the architect Anthony Hudson for clients Lucy and Richard Turvill, exemplifies a growing tradition of one-off rural houses that draw on the language of agricultural buildings, and that speak of a desire to blend into, rather than dominate, the surrounding farmland.

Like the Braintree Barn on pages 190–95 and Duckett House on pages 130–33, it is reminiscent of a cluster of farm buildings: a collage of uneven rooflines and mismatched planes that mimics the ad hoc jumble of the farmyard and is intentionally picturesque.

But there are other, more subtle, influences at play. Anthony Hudson doesn't do one-liners. His modus operandi is to identify the different elements that give a place its identity, and to weave them into an architectural language that is often startling, but always absolutely of its place. His most celebrated work, Baggy House, on the coast at Croyde Bay in North Devon, was inspired both by the rolling Devon countryside and the hostile jagged cliffs or, more accurately, by the contrast between the two. This is an architect who revels in awkward tensions and juxtapositions, and the challenge of melding them into a single, coherent form.

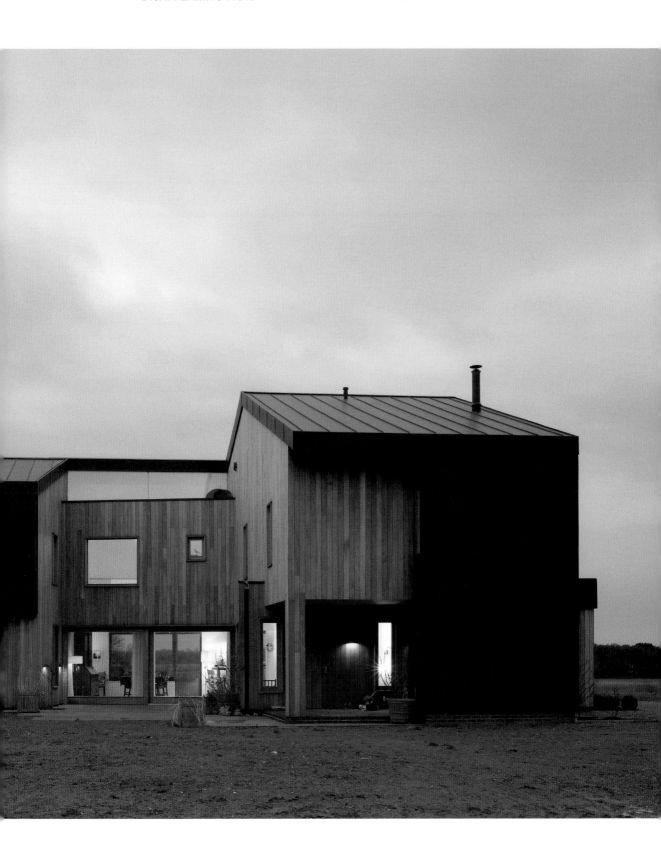

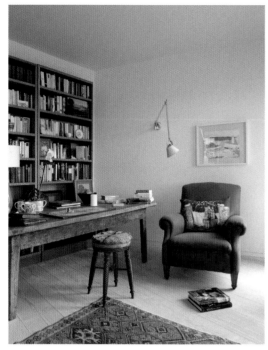

Previous page **Dark zinc cladding, inspired by black-tarred beach huts, gives the house a protective coating. The iroko timber gives the courtyard and entrance spaces a more intimate feel.**

Left **Interiors are pared down and simple.**
Below left **The bathtub offers views across the surrounding farmland.**
Below **The heart of the house is a double-height space overlooked by a first floor bridge.**

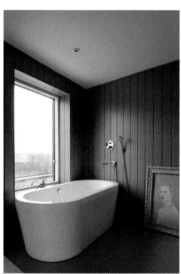

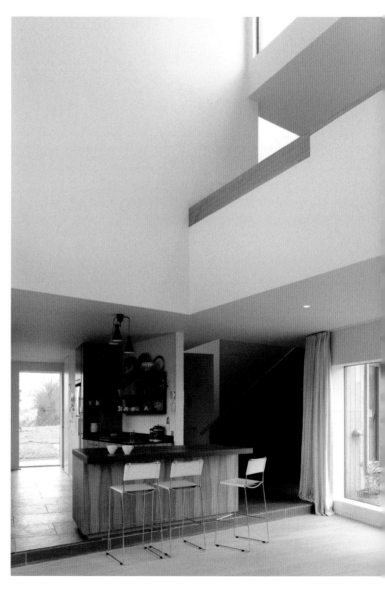

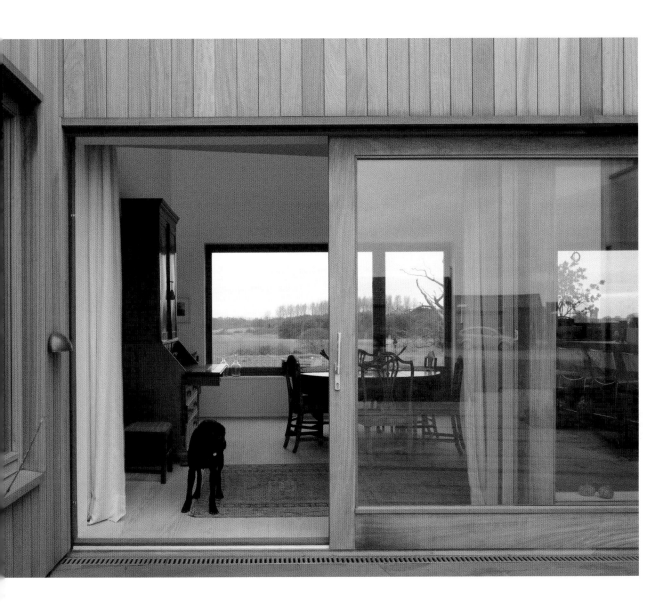

Above **A glass centre lets sun slice through the house and gives through views of the marshes.**

So while Bavent House is a reinterpretation of the vernacular agricultural architecture, it is entirely characteristic of its architect that it is plenty more besides. Its setting is not simply agrarian. The house stands on reed beds, a little inland from the Suffolk coast. The house's orientation and form respond to the fact that, whilst the views to the north are magnificent, those to the south are decidedly dull. But they also play a stylistic game – subtle shifts in geometry mean that the house's shape morphs from beach hut to barn and back again depending on the angle from which it is viewed.

The dark zinc cladding which gives the house its protective skin was inspired by the black-tarred beach huts at nearby Southwold. The Iroko timber cladding, which gives the courtyard and entrance space a warmer, more intimate feel, will weather over time, evolving into a muted camouflage against the surrounding grasses and reeds.

BLACKSHEEP HOUSE

▼

Empty nesters Pete and Christine Hope sold their terraced house in Sheffield and set off to the remote island of Harris in the Scottish Hebrides in search of a new way of life.

They couldn't afford any of the houses they liked, so they bought a ruin; the ramshackle remains of a typical Highlands black house, a low thatched-roof stone dwelling with a hole in the roof to let out smoke from the fire. But even such humble comforts were a distant memory. Three stone walls were all that survived of the original structure. It had ceased to be a house at all. A local crofter was using it as a sheep-pen.

Any misgivings about the modesty of the structure or the enormity of the challenge were outweighed by enthusiasm for the spectacular site – overlooking a rocky bay with views of mountains, shoreline and across the Sound of Harris.

Working with architect Stuart Bagshaw, Pete and Christine came up with a design that was driven by two overriding ambitions: to keep as much of the existing stonework as possible, and to end up with a building that blended into the surrounding landscape. They gathered stones from around the site to rebuild, re-shape and extend the metre-wide stone walls. Pete, a dry stone waller by trade, did the bulk of the work himself whilst a local craftsman made the timber frame that sits inside the stone walls. Pete and Christine turfed the roof, cutting each

Left **A local craftsman made the timber frame that sits inside the ancient stone walls.**
Above right **Strewn with wild flowers, the grass roof provides an effective camouflage against the Hebridean landscape.**
Right **The turfed roof offers spectacular views across the Sound of Harris.**

Grand Designs Award | 2008 | Scotland | Architect **Stuart Bagshawe**

sod by hand, carrying them up by ladder, and lovingly laying them one by one. Now strewn with wild flowers, the grass roof is such an effective camouflage that it's nigh on impossible to pick the building out on aerial photographs of the island. Even up close, it doesn't quite look like architecture. There's something ancient, and 'as-found' in its hobbit-like humility. It is almost anti-architecture. What I love about it is that it's as though Pete and Christine went up the mountain, collected bits of the mountain, brought them back down the mountain and built their house out of them. It doesn't simply blend with the landscape using clever visual tricks, it *is* the landscape.

LAU SUN HOUSE

▼

Paul Lau, the owner of Lau Sun House in London's Hackney Downs, set out to build himself a bachelor pad for the 21st century.

Like Suzanne Brewer's Courtyard House in Blackheath featured on pages 26-7, Lau Sun House occupies an extremely restricted back garden site that is overlooked on all four sides. Both projects respond by creating an enclosed secret world, one that shuts out the immediate surroundings and speaks of more exotic climes. Where the Courtyard House speaks of Mediterranean Modernism, Lau Sun

House speaks of oriental tranquility. The house, designed by Scott Kyson of Studio Kyson, takes its inspiration from Japanese ryokans, traditional guesthouses designed to offer travellers relaxation and respite. Whilst rural ryokans sit sympathetically with the landscape, those in cities offer carefully contained, framed views of the external world.

Both house and external terraces are contained within a compact near-cube. Whilst the building is finished in clean white render, the courtyard is enclosed by a seven-foot high wall of stacked slate topped by dark oak louvres, which ensure that external views are limited to the confines of this self-contained world.

It could have been claustrophobic were it not for the inherent elegance and grace of the oak slats, and the fact that the views, though highly contained, are composed with the utmost care. There is an almost reverential respect for the intrinsic qualities of the raw materials that form the house. Framed by panels of stark white render, planes of highly tactile rough slate take on the aura of a work

Left **The house edits views of the urban surroundings but emphasises views of the sky.**
Above right **House and terraces are contained within a compact near-cube built of stacked slate and dark oak louvres.**
Right **Floor-to-ceiling glazing creates a seamless relationship between internal and external space.**

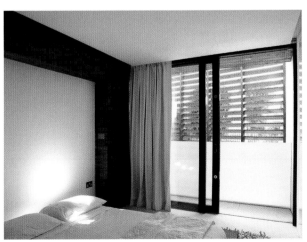

of art. The palette of render, slate and dark timber cladding is offset by the lush green of planted maples and bamboos. Internal finishes draw on the same palette of materials, with floor-to-ceiling glazing creating a seamless relationship between internal and external space.

It is a haven of peace, and a quiet, dignified challenge to the stereotypes associated with the term 'bachelor pad': squalid and unkempt or flashy and brash. Unassuming, detailed and, above all, serene, it speaks less of wild partying than of contemplation and retreat.

GAP HOUSE

▼

Luke Tozer belongs to a select band of architects who make themselves an exceptional family home by stealth; by outwitting the rest of us; by searching out a site that's deemed too tricky to develop, and using their design talent to prove the rest of the world wrong.

Luke reckons that he learnt to envisage extraordinary places as homes at a very early age, having spent his childhood in an eleventh-century priory that his architect father converted into the family home. His practice, Pitman Tozer, which he runs with Tim Pitman, specialises in converting unlikely spaces into desirable homes, so it's perhaps little surprise that he managed to fashion a spectacular house out of a site that, for the main part, is just eight foot wide.

Gap House lies in London's Bayswater. From the front it scarcely registers as a house at all; its clean-lined simplicity suggests a sensitive Modernist extension to one of the white stucco houses that sandwich it on either side.

But from the back, it's evident that this is a building that punches well above its weight. As the floors go upwards they get progressively smaller, creating an elegant stacked cascade. The upper floors have

Right **Full-height glass doors create a seamless link between the ground floor open-plan living space and the patio.**
Far right **At just eight feet wide, the house front reads as an extension to one of the white stucco houses that sandwich it on either side.**

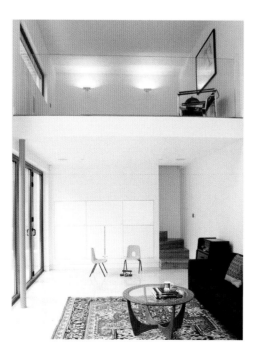

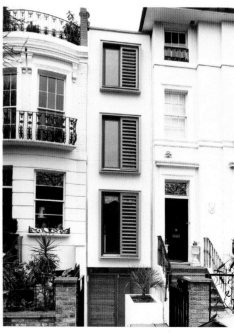

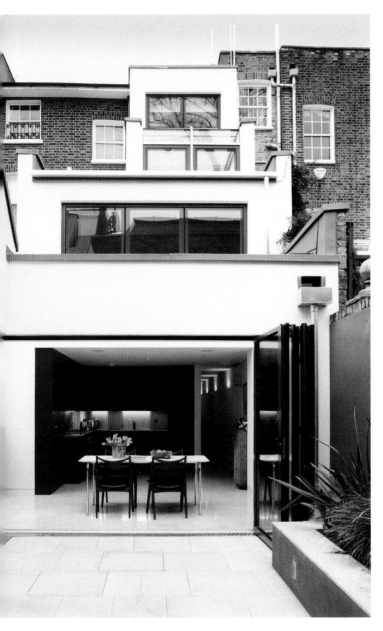

been cleverly organised to optimise daylight. A twisting timber staircase brings daylight deep into the centre of the plan. Smaller bedrooms are stacked at the front of the house facing onto the street, whilst wet rooms and storage occupy areas with no natural light. Larger rooms are towards the back where the site widens. The ground floor takes full advantage of the widest part of the site with a kitchen/living room that opens onto a patio to make one seamless indoor/outdoor living space.

Built in accordance with Pitman Tozer's 'fabric first' approach to sustainable design, Gap House is well insulated, double-glazed, airtight, and heated and cooled by a ground source pump – a formula designed to reduce energy consumption to 30 per cent of the amount consumed by a standard house built to current Building Regulations. Which makes its impact on the environment as modest as its street façade.

Above **Floors get progressively smaller, creating an elegant stacked cascade.** Right **A twisting staircase brings daylight deep into the centre of the plan.**

BUSHFIRE HOUSE

▼

Building your own house is always an intensely optimistic act. Bushfire House, at Callignee in Gippsland, Australia, is perhaps the ultimate example of hope over adversity.

This is the second house built by Chris Clarke on this particular site. The first one, Callignee 1 was, by all accounts, a very special place: a minimalist steel and timber house amidst the trees. It took two years to build – and one devastating natural disaster to demolish. Less than a week after its completion the 2009 Black Saturday bushfires burnt the house to the ground.

So Chris started again. This time, though, he determined to build a fire-proof house, using fire-resistant rusted Corten steel, along with anything that could be salvaged from the remains of the original house. Working with the remnants of the previous structure he fashioned a new home; an elegant amalgam of old, new, recycled and as-found elements.

Right **The new house is constructed of fire-resistant rusted Corten steel along with anything that could be salvaged from the remains of the original house.**

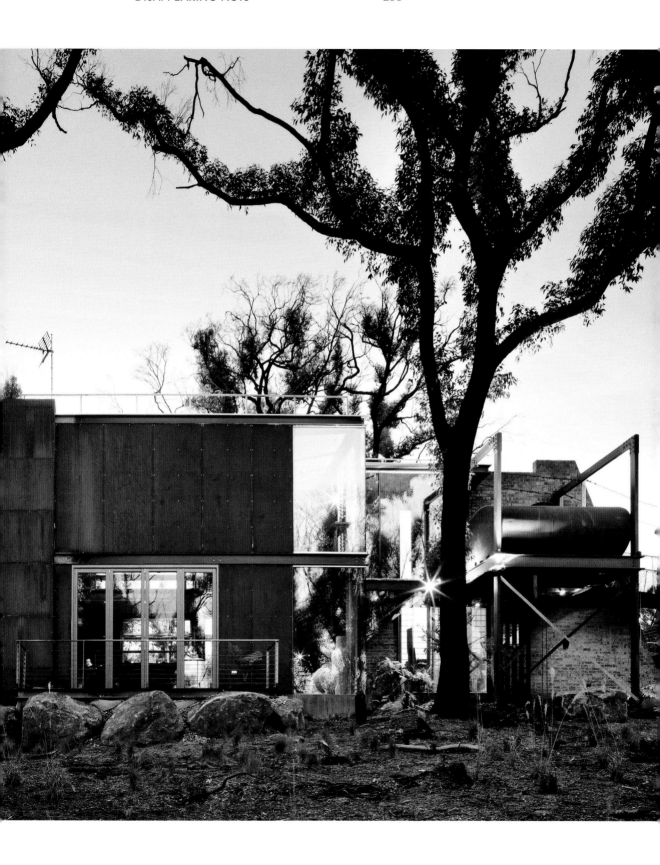

Right **Callignee 1,
the first house Chris
Clarke built on this site,
following its destruction
during the 2009 Black
Saturday bushfires.**
Below **The tactile
interior is perhaps best
described as Japanese
tea-house chic.**

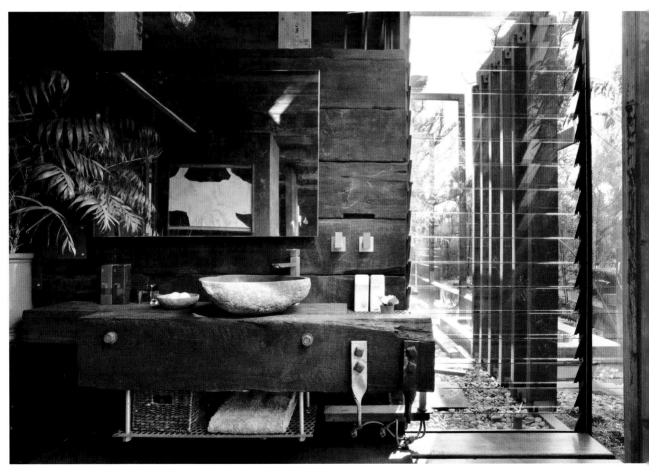

The entrance to the site is marked by a huge rock, which was already on the site, whilst many more were brought to site to define the outdoor space. The garden design incorporates a dried-up river bed along with man-made features including an outdoor shower, lap-pool and turtle pond. The house itself combines a surviving brick spine wall, burned concrete and fire-blackened structural steel with new butt-jointed glass walls and Corten lining both inside and out. The stair treads and kitchen worktops have been recycled from the previous house and still bear the burn marks from the blaze.

It may be a thrown-together approach, but the elements are juxtaposed with a care that makes the end result serene as opposed to chaotic – a style perhaps best described as Japanese tea-house chic.

You might have expected Chris to have gone for a defensive, defensible structure – a defiant challenge to nature's destructive powers. Yet Calignee 2 seems scarcely to be enclosed at all. It reads not as a solid object, but as a composition of abstract planes that dissolve into the landscape. It's tough and resilient, but it is anything but aggressive. This is a house that is at peace, not at war, with its surroundings.

Above **The lap-pool acts as a buffer zone between inside and out.** Right **Callignee 2 seems scarcely to be enclosed at all. It reads not as a solid object, but as a composition of abstract planes that dissolve into the landscape.**

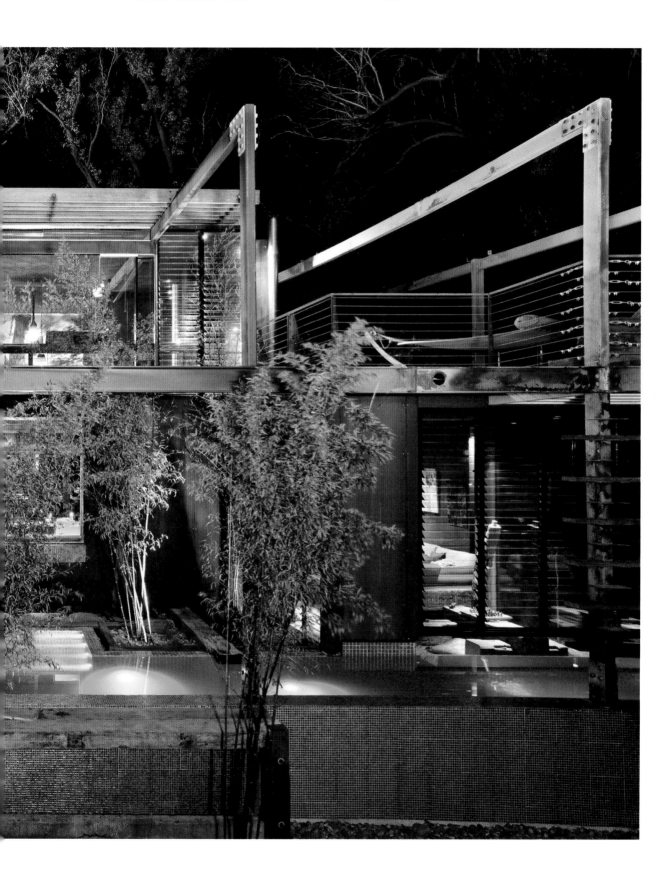

LAKE BENNETT HOUSE

When the presenter of the Australian version of *Grand Designs*, architect Peter Maddison, reviewed the first series, he remarked that the variety of projects demonstrated that the Aussie tradition of having a go is 'very much alive and well'. Certainly there were projects where the Grand Designers were a little bit more gung ho than their British counterparts.

Trevor and Francoise Sullivan, who built Lake Bennett House, south of Darwin, in Australia's Northern Territory, were perhaps the most memorable example.

Trevor and Francoise spent 17 years living in an open-sided shed with two children, not a whole lot of money, and an awful lot of animals. On the plus side, the site was spectacular: 33 acres of natural bushland. They dreamt of building a bigger house, a better house, a tropical tree house that would blend in with their beloved wilderness and give the family space to breathe.

They came up with a design based on the shape of a 50-cent piece. The house is built around a magnificent central staircase, with mahogany treads spiralling round the trunk of a nine-tonne, 800-year-old paperbark tree. It is an astonishing centrepiece, all the more so when you consider that the whole thing was designed – without drawings – in Trevor's head.

Far left **The house under construction: the steel structure is built around the trunk of an 800-year-old paperbark tree.**
Above **A tropical tree house with 360-degree views.**
Left **Trevor, Francoise and family at the top of their mahogany spiral staircase.**

Trevor, a wood carver, built the house, along with all the furniture, himself. More or less. He did get a little help from his friends, one of whom was 'paid' with the gift of a live crocodile. It was a Herculean task. And, not surprisingly, the stress took its toll on both his morale and his health. But with little or no funds he didn't have an awful lot of choice.

Designed to withstand cyclones, it has a steel structure and no windows. In fact there's no glass at all save for a single roof light that brings light into the centre of the deep plan. The sides are left open to the elements. This is probably about as open a structure as it's possible to be whilst still qualifying as a house. It is, essentially, a double-decker canopy with 360 degree views – the tropical tree house that Trevor and Francoise dreamt about when they were living in that shed.

STRANGE HOUSE

▼

This seductive little home is called Strange House, not on account of its eerie otherworldliness, but by dint of the fact that, by a serendipitous quirk of fate, it was built by the architect Hugh Strange for himself and his family. But it is a singularly apt epithet. The house exudes an almost dreamlike serenity. It's hard to believe you're in London, let alone Deptford.

Thanks to overlooking restrictions, the house is single storey, nestled behind – and a little set back from – an existing brick wall. Two bedrooms and a bathroom fill the northern half of the site, whilst a long, narrow living/kitchen/dining space occupies the southern side, spilling out onto a tiny outdoor terrace.

The outside world is reduced to a narrow, L-shaped courtyard between house and wall. The only acknowledgement of the wider neighbourhood is the view of a nearby church tower framed by a single, high-level window in the living space. This is an intimate, internalised world.

Built to a tight budget, and to puritanical tastes, it has a Spartan quality that is positively monastic; a poetic stillness that is entirely at odds with the hustle and bustle of city life. The palette of materials is controlled, verging on austere. The façade is composed of three layers: a concrete

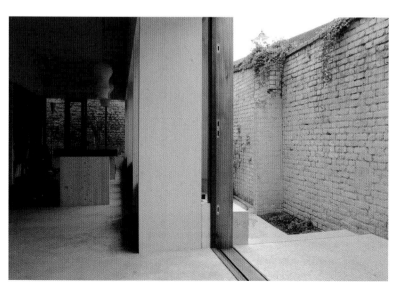

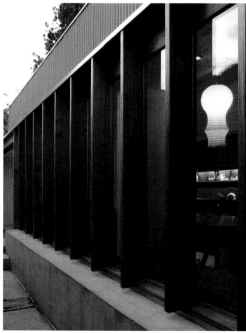

RIBA Award | 2011 | London | Architect **Hugh Strange**

base, a band of glazing and a top layer of fibrous cement.

The interior is an essay in timber or, perhaps more accurately, a duet. There are two distinct voices at play. The primary structure is composed of solid spruce panels imported from Switzerland. The second is an overlay of tropical hardwood joinery: furniture, doors and window frames made from trees that were felled in Hurricane Katrina.

The contrast between the two languages is both celebrated and exaggerated: the dark stain of the hardwood offsets the pale-washed timber walls. Door and window frames are face-fixed to the spruce panels, a trick that addresses the tolerances between components that were manufactured on different sides of the world.

This is a beautifully-crafted house. Small, but perfectly formed. And undeniably – triumphantly – strange.

Far left **The polished concrete floor extends outdoors to form a terrace.**
Left **The glazed southern elevation. The hardwood framing will weather to match the base and roof.**

Above **A rear door opens on to a small courtyard that links the house to Hugh's office.**
Right **Access to the site is through a narrow opening cut into the existing perimeter wall.**

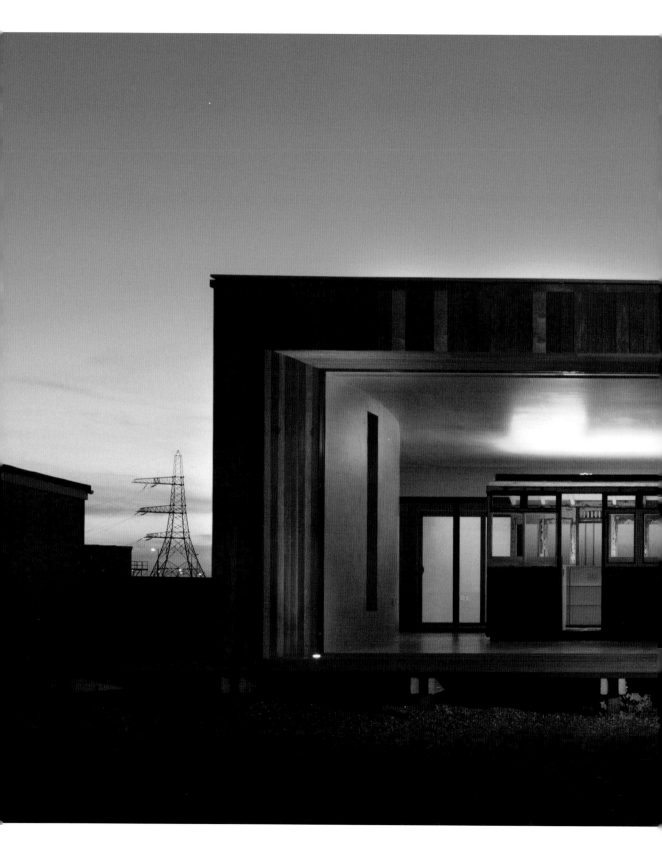

10
PERFORMANCE ARTISTS

And finally, ladies and gentlemen,
the redoubtable, the astonishing and
versatile, the flexible and adaptable.
Fitted with sliding panels, revolving doors
and a skin that glows when prodded;
endowed with the miraculous powers
of clairvoyance and wifi in every room.
I give you complexity, I give you the
chimerical and the quixotic. I give you
the performing house…

SUFFOLK SLIDING HOUSE

▼

Ross Russell and his wife Sally wanted a home in the East Anglian countryside that was beautiful, dynamic and unique. Architects de Rijke Marsh Morgan (dRMM) took them at their word, designing a house that can change its form and character at the flick of switch.

This is a house of five parts – glass house, main house, outside space, annexe and garage – but of infinite possibilities.

From a distance, the house is reminiscent of a traditional Suffolk barn: larch-clad walls with a steeply pitched roof. But this 20-tonne wall-and-roof structure is actually a 'second skin'. At the flick of a switch, it comes to life, sliding across the different parts of the house, allowing the constituent elements of the building to be covered or exposed according to season, weather, whimsy or mood.

Right **Sliding House** **shown with the outer 'sleeve' extended to encompass the glasshouse. See pages 250–51 for its pulled-back mode, which leaves the glazing exposed.**

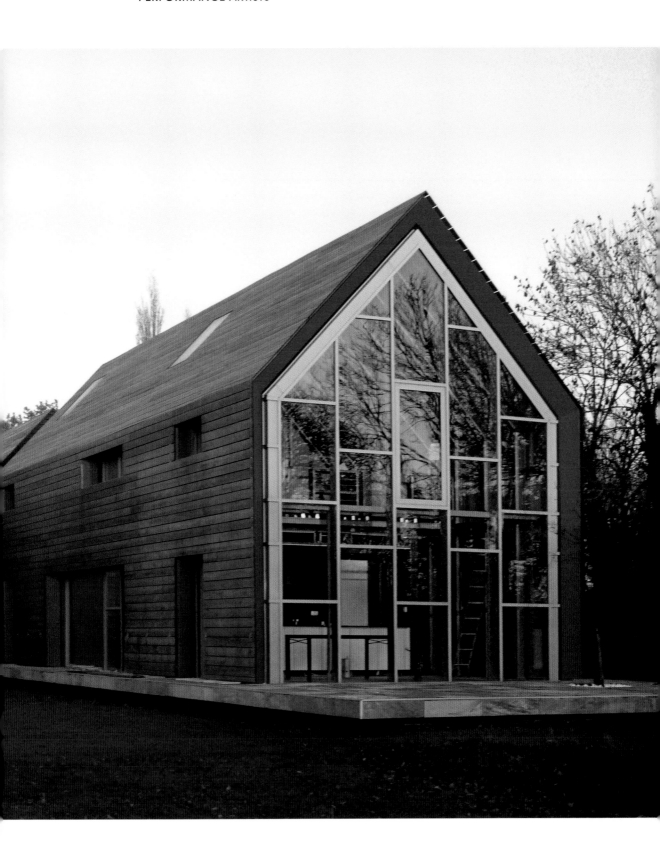

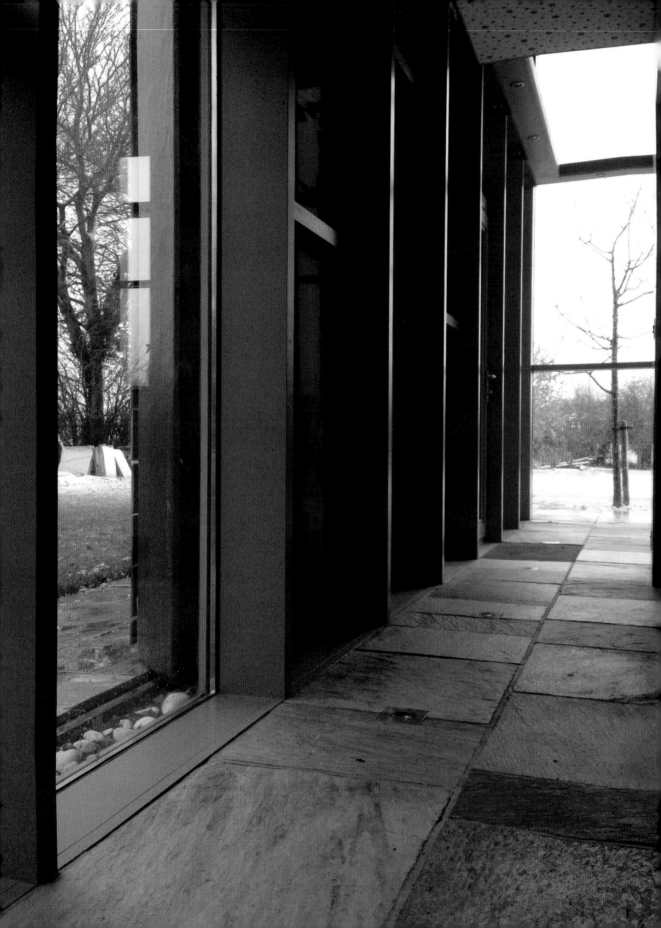

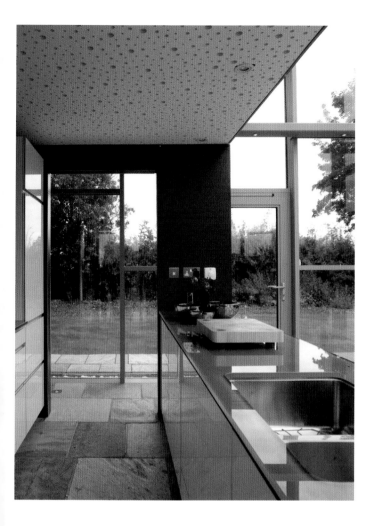

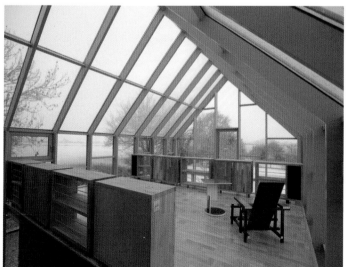

The glasshouse can become an enclosed, private living room; the open air courtyard can become a covered space; a patch of grass adjacent to the house can become a covered outdoor porch and the bathroom can become a space-without-a-roof, open to the stars. Views can be changed at will as different window openings are covered or revealed.

There are any number of permutations, but they all look 'right'. The abstract simplicity and agricultural feel of the house conveys the haphazard charm of a cluster of farm buildings or sheds. The 'solid' buildings are clad in larch that is stained either red, to look like a Monopoly hotel, or black. It's been dubbed 'Industrial Picturesque', and I love the idea of someone having to come up with a new label for a building.

It's an ingenious bit of engineering: the roof is powered by four electric motors that run off car batteries, and travels on hidden railway tracks set within a buried concrete raft. And it's a brilliant – and audacious – means of allowing for varying degrees of sunlight, insulation and shelter at different times of the day or year. But most of all, it's the ultimate party trick. It subverts all expectations by being a house that lives and breathes. It's fun and it makes me smile.

Far left **A corridor separates the service core – containing kitchen, utility and bathrooms – from the glazed outer walls.** Above and left **The glasshouse houses a kitchen and dining room at ground floor level and a living room on a first-floor mezzanine.**

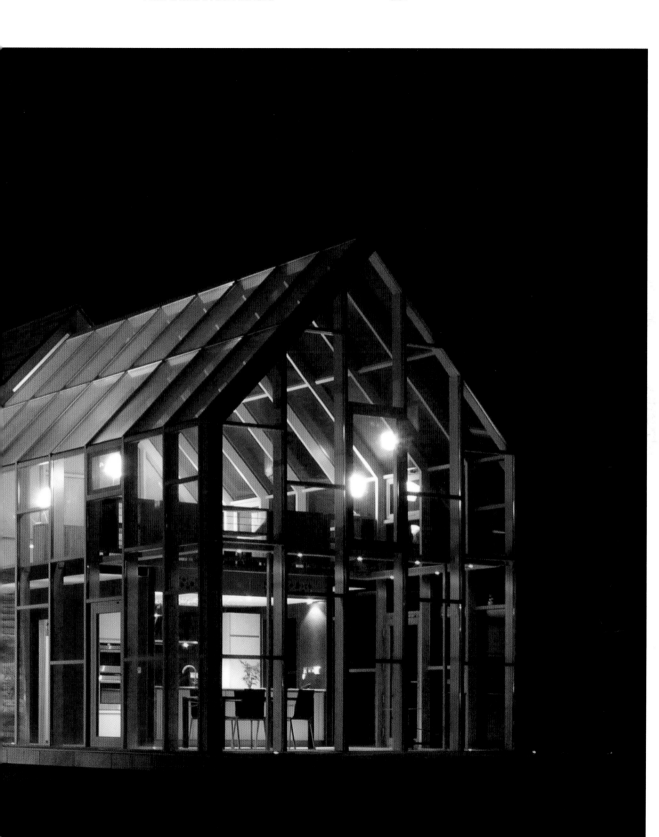

EL RAY

▼

El Ray, on Dungeness Beach, was once a crude shack built around the carcass of an 1870s railway carriage, and typical of the rough-and-ready dwellings that colonised Britain's coastline in the years between the wars.

Improvisation has played a major role in Dungeness's evolution. The vast nuclear power station sits alongside more familiar coastal building types – a lighthouse, a coastguard station and the ubiquitous fisherman's shacks. It is the antithesis of the coherent planned community: a landscape of architectural oddities and mismatched scale.

Which is perhaps why the architect Simon Conder has built not just one, but two, houses on this oddball stretch of beach, the first being Vista, or the 'rubber house' featured on pages 136–37. This is an architect with a taste for the surreal and a gift for subverting expectations, for making strangeness beautiful and beauty strange.

The new El Ray, a two-bedroom home built around the core of the railway carriage shack, is designed to encourage an active appreciation of its peculiar environment. Windows frame specific fragments of the landscape – coastguard station, power station, lighthouse – whilst the southern elevation is a sliding glass façade commanding views across the Channel. The roof is one big viewing platform with panoramic views. It watches, but also reflects, its surroundings. Its timber slat cladding echoes the native fishing huts, its bulging shape reflects the curve of the lighthouse walls.

Simon likes to include one 'truly perverse' move in everything he builds. Here it is the decision to preserve the battered railway carriage that lay at the heart of the original fishing shack, and to make it the centrepiece of a spanking

Right **The battered railway carriage houses the kitchen and stands, as a freestanding object, in the open-plan living and dining room.**
Above right **Timber slat cladding echoes the native fishing huts, whilst the house's bulging shape reflects the curve of the lighthouse wall.**
Far right **The southern elevation is a sliding glass façade that frames – and reflects – the extraordinary view.**

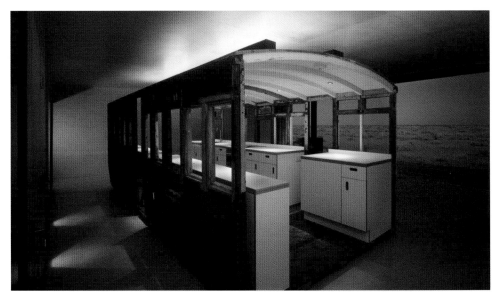

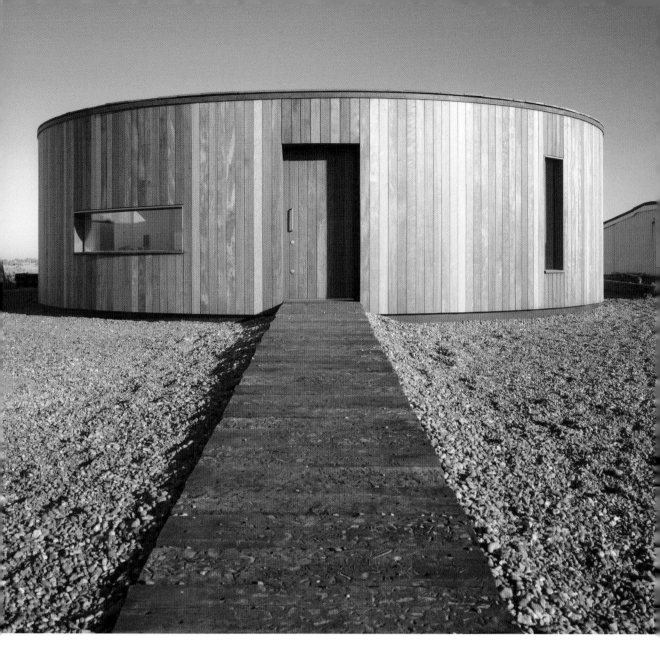

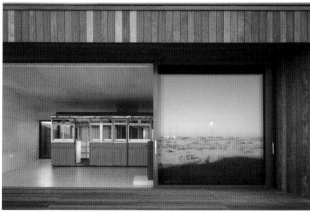

new home. It houses the kitchen and stands, as a freestanding object, in the open-plan living and dining room. Its peeling paint and vintage charm offer an unexpected riposte to the pale plywood lining of the ceilings, walls and floors: an island of camper-van-chic within a sea of honeyed gold.

The effect is theatrical, verging on surreal. And yet it seems utterly appropriate. Eccentricity is the local vernacular, and Simon a fitting guardian of the Dungeness spirit.

SALT HOUSE

▼

Salt House at St Lawrence Bay, Essex, is one of a succession of elegant and startling one-off houses by the architect Alison Brooks. This one is a beach house overlooking the Blackwater Estuary, an endstop to a row of Victorian cottages built by oyster fishermen. It is a rare instance of an experimental British beach house in the Modernist tradition; the house has neither front nor back, but reads as an irregular crystalline form.

There are various ways to try to make sense of the apparent arbitrariness of its singular sculptural form. The name Salt House is a reference to Maldon Salt, produced nearby, and the irregular contorted pyramidal shapes of each individual salt crystal. But there are more architectural influences at play. The timber cladding echoes the vernacular weather-boarding, whilst the roof profile and the geometry of the façade can be read as a contemporary reworking – or rather an abstract distortion – of the hipped roof bay-windowed cottages that are typical of the area.

The architect suggests that the shape is also informed by its particular coastal site, proffering the poetic observation that the façade 'expresses the movement of a building formed by sea winds'.

Or it can be read as a pragmatic response to the immediate context – the folds in the façade maximise views of the estuary and allow for passive solar gain, whilst the concrete stilts that lift it

Below **The roof light and atrium under construction. The timber framing between the structural steel elements is sheathed with marine ply.**

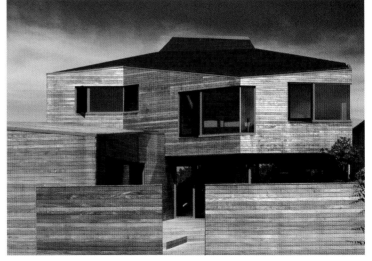

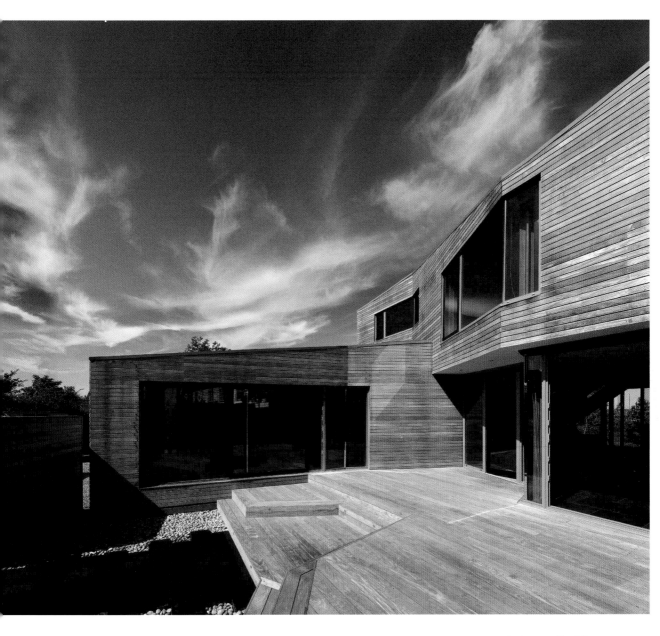

Above **House and terraces appear to be crafted from a single, continuous expanse of timber decking.**
Left **The roof profile and the geometry of the façade can be read as a contemporary reworking of the hipped-roof bay-windowed cottages that are typical of the area.**

off the ground are a practical response to the fact that the south east of England is increasingly vulnerable to flood.

But most of all, Salt House owes its extraordinary existence to sheer showmanship. It is conceived, not in terms of sections and plans or inside and out, but as a three-dimensional object composed of interconnected spaces defined by folded planes. House, terraces and courtyard seem to be crafted from a single continuous expanse of timber decking. Internal spaces flow not only from room to room but from floor to floor, as the folded timber staircase morphs seamlessly into the timber balustrades of the upper floor mezzanine.

Alison Brooks is a sculptor as well as an architect. And Salt House is architectural origami as well as being a home.

HOUSE FOR EVERYBODY

▼

House for Everybody lies within a distinguished Japanese tradition of building ingenious houses that squeeze multiple spaces and uses onto the tiniest of sites.

It is an indispensable skill in cities where land is in short supply, and one that has inspired countless inner-city housing projects across the globe, including Gap House and Lau Sun House, on pages 232–33 and 230–31 respectively, both in London. This project, in the city of Kusatsu in Shiga, Japan, occupies a plot that is 11 metres long and just 8 metres wide. The architect, Kohki Hiranuma, specialises in manipulating simple structures and materials to maximise visual impact and in the sophisticated use of natural light. House for Everybody is simultaneously straightforward and surprising. The house is shrouded in timber louvres, which let light in, ensuring that the house benefits from solar gain in winter, but doesn't overheat in summer. They also dissolve the distinction between windows and walls, bathing the interior with bands of light.

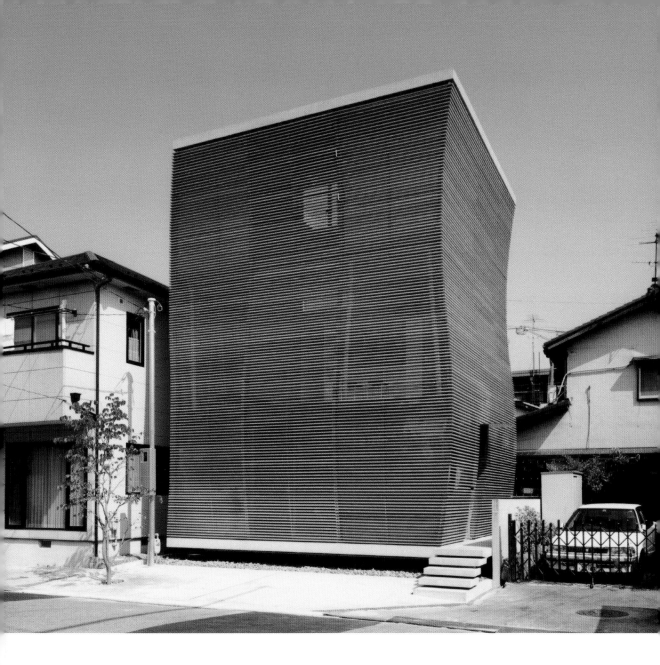

The rooms themselves are simple orthogonal spaces, but a stepped floor plan and plentiful internal glazing mean that they read not as contained boxes, but as a constituent part of a sophisticated volumetric game. This split-level arrangement reflects the fact that this tiny building was built to house not one, but two, households: the changes in level on each of the three floors help to express a degree of independence between the two halves of the house.

For all its spatial complexity, it is essentially a small simple box – three floors built around a glass and concrete core and wrapped in horizontal timber slats – with a twist. Quite literally. A kink in the façade means that the box has been distorted into a lazy, languid curve, as though the whole building is shrugging its shoulders or swinging its hips. The building may be tiny, but it is seriously big on attitude – this is about as close as you can get to a house that can actually dance.

SLICE HOUSE

▼

Slice House, in the Brazilian city of Porto Alegre, occupies a sliver of land that was left stranded when a new road was built to the west of the site.

The architects, Anglo-Brazilian practice Procter-Rihl, wanted the house to be a hybrid of British and Brazilian construction techniques. The rough concrete, which bears the texture, imperfections and grain of the timber boarding formwork, is typical of Brazil, where prefabrication and factory production are still relatively scarce. By contrast the crafted steel components – roof, gutters, grillwork and cladding – represent British precision engineering at its best.

The house gets its name – and character – from the decision to celebrate the linear nature of the site rather than trying to subdivide it into a sequence of smaller spaces of more conventional proportions. Hence the main living space is a strip that increases in width from the entrance, creating a false perspective that exaggerates the size of the room. The trick is repeated throughout the house with tilted ceilings and angled walls creating long views and the illusion of extra space.

Right **The house gets its name from the decision to celebrate the linear nature of the site rather than trying to subdivide it into more conventional proportions.**
Far right **The glass swimming pool wall forms part of the living room wall, framing the water and anyone having a swim.**

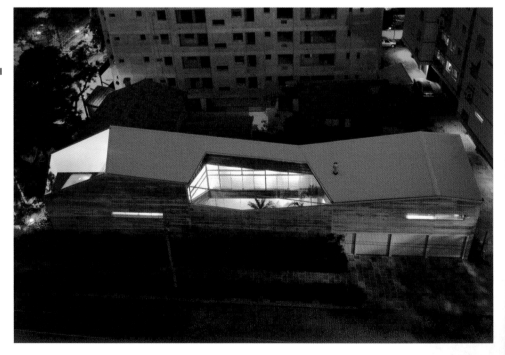

Grand Designs Award | 2006 | Brazil | Architect **Proctor-Rihl**

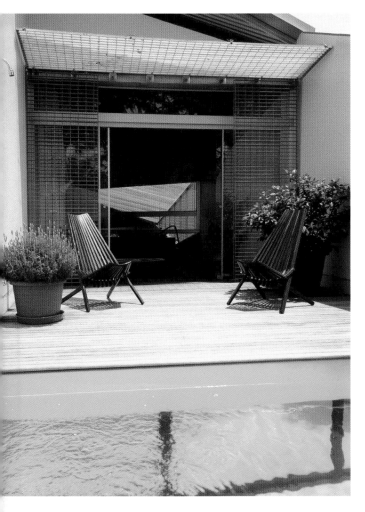

In terms of character, it's fair to say Brazilian sensuality wins out over English reserve. There are moments of sheer sculptural exuberance – the concertina staircase made from super-fine folded steel; a finely-crafted seven-metre long steel plane that serves as both dining table and kitchen counter and projects out into the courtyard. (Proctor-Rihl are furniture designers as well as architects, and one of the charms of this project is that it's impossible to determine where architecture ends and furniture begins.)

But perhaps the real showstopper in this long, thin box of tricks is the rooftop swimming pool. It has one glass wall, which is visible from the floor below, giving the impression of an outsize fish tank – or rather, human tank – built into the living room wall. By day it acts as a daylight filter casting rippled sunlight into the ground floor living space. By night, with the pool lights switched on, it becomes a vast coloured light box. Either way, the effect is intensely theatrical. And anybody taking a swim is immediately cast as the star of the show.

Left **Tilted ceilings and angled walls create elongated views and the illusion of extra space.**
Above **The rooftop swimming pool.**
Right **Moments of sculptural exuberance include the staircase made from folded steel and a seven-metre long worktop that serves as both kitchen counter and dining table.**

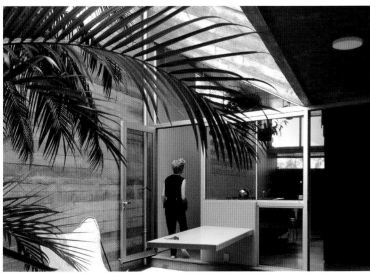

INDEX

A

Aalto, Alvar 74, 124
Acland, Paul 152
Ainsley, Andrew 52
Ainsley, Meryl 52
Allen, Isabel 11, 173
Alvaro, Domenic 106, 109
Amersham Water Tower 42–3, 58
Apprentice Store, The 182–5
Architype 70
Architects de Rijke Marsh Morgan (dRMM) 246
Architects' Journal 11, 173
Architecturally Efficient Powerhouse 116–19
architecture:
 ability to reflect energy of a place and speak
 to it's time 86
 agricultural 53, 130–3, 164–7, 190–5, 200–1,
 224–7, 249
 allows human beings to flourish 80
 anti- 229
 big changes of the last fifteen years or so 8–10
 celebrates intrinsic qualities of materials 134
 ecclesiastical 215, 218
 language, change in 10–11
 look-at-me 148, 149
 portraits of personalities in 16–19
 redemptive power of 50–1
 re-directs our thinking 77
 rich in references and meanings 46–7
 Roman/Greek 46, 76–7, 145, 156, 172, 180
 Scandinavian 114–15, 124
 sustainable 34, 70, 72, 74, 84, 102, 118, 124, 174,
 177, 200, 233
 taste, changes in 9–10
 urban 168
 zeitgeist and 120
 see also under individual architectural
 style name
Area of Outstanding Natural Beauty 200
Art Deco 19
Assertive Suburban Home 120–3
Attwood House 14, 28–33, 130
Attwood, David 28
Australia 106–9, 158–61, 210–13, 234–43

B

Baggy House, North Devon 224
Bagshawe, Stuart 228
Baker, Julian 58
barn conversions 188–93, 206–9
Base Architecture 114
Basing Farm 200–1
Bassett, Sue 106
Bavent House 132, 224–7
Bayswater, London 232–3
Belfast 144–5
Bellarine Peninsula, Australia 158–61
Bennett, Timothy 52
Berkshire 28–33
Beyton, Suffolk 134–5
Blackheath, London 26–7
Blacksheep House 228–9
Blair government 9
Bletchley Manor 204–5
Blower, Damien 164
Bradley, Bill 96, 99
Bradley, Sarah 96
Braintree Barn 190–5, 224
Brazil 258–61
Brewer, Suzanne 26, 27, 230
Brighton Borough Council 70, 71
Briscoe, Derek 50
Bristol Sugar Cube 20–3
Brittany, France 84–5
Brooks, Alison 254, 255
Buckinghamshire 42–3
Budgen, Andrew 92
Building Regulations 119, 233
Bushfire House 234–9

C

Callignee, Gippsland, Australia 234–9
Cambridgeshire 82–3
Campsie Fells, Scotland 116–19
carbon emissions 79, 83, 84, 89, 156, 176
Case Study Houses, Californian 28, 30, 124, 125
Castello di Brancialino, Tuscany 180
catharsis of building own home 164–7
chalet bungalows 120, 121

Cheshire 58–9
Chesterfield Waterworks, The 186–7
Chestnut House 34–5
Chew Valley 36–9
Chilterns 42–3
Chiswick Garden House 62–7
Christ Church, Spitalfields 202
Clapham Coach House 48–9
Clarke, Chris 234, 236, 237
Clarke, Phil 38
Clonakilty Clifftop Farmhouse 110–11
Coalition government 10
Colerne, Wiltshire 218–19
Commission for Architecture and the Built
 Environment (CABE) 9, 10
Conder, Simon 136, 137, 206, 209, 252
conservation/restoration 178–215
conservation areas 26–7, 130
Conservation Repair 199
Contemporary Nordic Longhouse 114–15
Coode-Adams, Ben 190, 193
Cooper, Ian 182, 183
Cooper, Sophie 182, 183
coppicing 78, 80
Coppin, Darren 44–5
Cornwall 124–7
Corten steel 234
Cosy Homes 112–37
Cotswolds Stealth House 220–3
Country House, English 76, 152
County Cork, Ireland 110–11
Courtyard House 26–7, 230
Crossway House, The 174–7
Cruck-Framed Woodland House 78–81

D

da Costa, Andre 104
da Costa, Mimi 103
Daly, Nigel 204
De Matos Ryan 200
del Tufo, Bruno 50–1
del Tufo, Denise 50–1
Deptford, London 242–3
Derbyshire 186–7

Devoy, Anjana 48–9
Devoy, David 48–9
de-zoning 144
dialogue between architect and client,
 importance of 14–15
Digesting the 20th century 12–39
Disappearing Acts 216–43
dissolving features 36, 156, 237
Dodsworth, Catriona 54
Dodsworth, John 54
Dome House 146–51
Doncaster 162–3
Drummer's Cottage 134–5
Duckett House 14, 130–3, 224
Dungeness 136–7, 252–3
Dyer, Jim 36, 39
Dyer, Rebecca 36, 39
Dyson, Chris 202, 203
Dyson, Sarah 202

E

East Anglia 246–51
eco-homes 95, 96, 124, 176, 223 see also
 sustainable architecture
El Ray 206, 252–3
Eldridge Smerin 104
Eldridge, Nick 104
11 Princelet Street 202–3
Ellis Williams Architects 58
Ellis, Jane 188
Ellis, Robert 188
Emerick, Keith 196, 198, 199
Emery, Joanna 54
Emery, Jonathan 54
English Arts and Crafts 134
English Country House 76, 152
English Heritage 196, 198
 Buildings At Risk Register 196
 'Conservation Principles' 198
Esher Modernist Villa 24–5
Esher, Surrey 24–5
Essex 190–5, 254–5

INDEX

F

'fabric' first approach 233
Fairweather, Lucie 116, 120, 123
Fairweather, Nat 123
Fehn, Sverre 124
Fish Creek, Victoria, Australia 210–13
'floating' features 24, 25, 36–9, 188
food cultivation, closed-loop cycle of 82
France 84–5
fresh air and natural light, modern
 preoccupation with 35
Full Projects List 268–9
Futuristic Bungalow 156–7
Futuristic Doncaster House 162–3

G

Gadget Houses 153–77
Gap House 232–3
Gaukroger, Milla 148
Gaukroger, Robert 146, 147
Gehry, Frank 74
Gormenghast mathematical staircase 148
Grade II Listed 54, 57, 58, 60, 164, 199, 204, 218
Grand Design Awards 8, 218, 232, 252, 256, 258
green belt land, building on 42–3
Green Deal for home refurbishment 10
Grimshaw, Nicholas 120
Groundhouse Partnership, The 84–5
ground-source heat pump 156
Gummer, John 9
Gwynne, Patrick 25

H

Hackney Downs, London 230–1
Hairy Houses 68–89
Hampson Williams 98, 99
Hand-Built Hexagon House 82–3
Hardingham, Samantha 76
Harris, Jannette 58
Harris, Russell 58
Harwood, Colin 162
Hawkes, Richard 174, 176, 177
Hawkes, Sophie 174, 176
Hawksmoor, Nicholas 202

heat-recovery ventilation system 94, 105,
 119, 124, 177, 220, 221, 223
Hedgehog Housing Cooperative 70–1
Hellifield Peel 196–9
Herefordshire Threshing Barn 188–9
Hill House 144–5
Hiranuma, Kohki 256
Hird, Michael 162
Hoffe-Tilley, Janne 180
Homewood, The 25
Hope, Christine 228–9
Hope, Pete 228–9
House for Everybody 256–7
Howarth, Darren 84, 85
Hudson, Anthony 192, 224
Hunsett Mill 54–7, 219
Hutchings, Victor 28

I

Icosis 102
Indented Head House 158–61
'Industrial Picturesque' 249
IQ Glass 104–5
Ireland 110–13, 214–17
Irvine, Pru 102, 103
Irvine, Richard 102, 103
Island of Harris, Scotland 228–9
Isle of Wight 16–19, 86–9
Italy 180–1

J

Japan 230, 236, 237, 256–7
Jay, Coneyl 46–7
Johnson, Philip 8
Jones, Leanne 186
Jordan, Sarah 46–7

K

KAP Architects 116, 122
Kent 50–1, 104–5, 136–7, 156–7, 174–7, 200–1, 252–3
Kent Modular House 104–5
Kilgallán Converted Chapel 214–15
Kusatsu, Shiga, Japan 256–7
Kyson, Scott 230

L

Lake Bennett House 240–1
Lake District 146–51
landscaping 102
Lau Shan House 230–1
Lau, Paul 230
Law, Ben 78, 80
Le Corbusier 24–5, 36, 139, 145, 173
Leisjer, Elaine 118, 119
Leisjer, Theo 118, 19
Leland, John 120, 123
Lime Kiln House 102–3
Liverpool 60–1
Localism Bill, 2011 10
Locher, Heidi 156
Loewe, Claire 168, 171, 173
lofts 46, 52, 54, 140, 186, 187, 189, 200, 201, 223
Lohan, Andrew 214
Lohan, Jackie 214
London 26–7, 34–5, 46–9, 62–7, 70, 72–5, 96–9,
 140–3, 168–73, 202–3, 230–3, 242–3
London Jewel House 46–7
Long, David 34
Lonsdale, Nathan 92
love-hate relationships with home 28–33
Lucas, Jim 94
Ludewig of Acme, Friedrich 54
Lutyens Water Tower 50–1
Lutyens, Sir Edwin 50, 198
Lymm Water Tower 58–9

M

Maddison, Peter 240
Manser Medal, RIBA 8
Manser Practice 16
Manser, Jonathan 16
Marto, Paulo 152
McAvoy, Andy 114
McDonald, Ian 158, 161
McLaughlin, Niall 110, 111
Memphis Group 44, 45
Merkel, Angela 220
Michelle 50
Midlothian, Scotland 102–3

Mikhail, David 62, 67
Miles, Lincoln 88, 89
Miller, Liz 134
Miller, Tom 134
Mills, Deborah 42–3
Modernism 13, 14, 20–3, 24–5, 27, 36, 39, 44, 45,
 48, 58, 60, 76, 144, 145, 152, 162, 230, 232, 254
Moffat, Jo 114
Moffat, Tony 114
Mole, Jennifer 94
Moore, Charles 8
Multiple Personality Order 40–67

N

National Planning Policy Framework, 2012 10
Neville, Kelly 82–3
Neville, Masoko 82–3
New Forest 14–15, 130–3
New Forest National Park 130
new normal 34–5
Norfolk Broads 54–7
Northamptonshire 92, 206–9
Northern Ireland 144–5
Nortje, Adrianna 84, 85

O

O'Hare, Dervla 145
O'Hare, Thomas 144
Oak Farm 60–1
open-plan 14, 25, 28, 30, 36, 38, 39, 42, 52, 56, 58,
 60, 61, 92, 93, 114, 118, 119, 120, 122, 124, 142,
 162, 164, 166, 184, 186, 200, 201, 220, 221,
 252, 253
Ostendorf, Louise 140, 143
Ostendorf, Milko 139, 143

P

Palladio 76, 77
Pardey, John 14, 15, 28
Parisian Hotel 76
part home, part workplace 46–7
Passivhaus 94–5, 220–3
Paul + O Architects 152

INDEX

Paxton, Richard 156, 168, 172–3
Pease, Katherine 20–1
Pease, Martin 20–1, 23
Peckham Box of Tricks 168–73
Performance Artists 244–61
Permaculture 83
Peterborough 92–3
Pett Level, East Sussex 44
Philips, Graham 58
photovoltaic/thermal panels 80, 177, 223
Pinions Barn 206–9
Pirelli Building, Milan 162
Pitman Tozer 232, 233
Pitman, Tim 232
planning law/permission 9–10, 26, 98,
 152, 153, 180, 192, 223
Planning Policy Statement 7 9, 152, 153, 223
Platt, Chris 116, 120, 122
Platts-Mills, Ben 82
Pontfaen, Brecon Beacons 128–9
Ponti, Gio 162
Porte Alegre, Brazil 258
Proctor-Rihl 258, 61
Providence Chapel 218–19

R

rainwater recycling 82, 124, 201
Ravenscroft, Monty 168, 171, 173
reed-bed sewage system 82
renewable building materials 34
restoration 11, 178–215
Reynolds, Michael 84
RIBA 8, 14, 54, 242
Riedel, Mary 210, 213
Riedel, Peter 210, 213
Robbins, Freddie 190, 193
Romaniuk, Peter 48
Rossneath Peninsula, Scotland 114–15
RRA Architects 188
Russell, Ross 246
Russell, Sally 246

S

Saarinen, Eero 27

Salt House 254–5
Sarah Featherstone 128
Scandinavian architecture 14, 114–15, 120,
 121, 124, 125
Scheduled Ancient Monument 196, 199
Scotland 114–19, 228–9
Seacombe, Debbie 71
Seacombe, Rosa 71
Seafront Sugar Cube 44–5
Segal, Walter 70
Seymour-Smith, Chris 220
Seymour-Smith, Helen 220
Shaw, Francis 196, 198, 199
Shaw, Karen 196
Shedkm 60
Sheehan, Andrew 26, 27
Shropshire 204–5
Skywood 58
Slice House 258–61
Small House 106–9
Smith, Chris 186
Smooth and Polished, The 92–111
Smyth, Howard 180
Society for Protection of Ancient Buildings 199
Somerset 36–9
South Down's Brighton 70–1
South London Family Housing Association 70
Space Ships 138–53
Spacelab 92
Spitalfields, London 202–3
St Lawrence Bay, Essex 254–5
Stedman Blower 164
Strange House 242–3
Strange, Hugh 242
Straw House 72–7
Sudjic, Deyan 74
Suffolk 120–3, 134–5, 152–3, 224–7, 246–51
Suffolk Sliding House 246–51
Sullivan, Francoise 240, 241
Sullivan, Trevor 240, 241
Sunnybank Passivhaus 94–5
Surrey 24–5, 164–7
Surrey Hills, Sydney, Australia 106
Surrey Threshing Barn 164–7

Sussex 78–81

sustainability 9, 10, 34, 70, 72, 74, 84, 102, 118, 124, 174, 177, 200, 233

T

Tarling, Bill 156

Tarling, Jean 156

Tarling, Jo 156

Tarling, Paul 156

Tate, Andrew 42–3

Tate, Jerry 116, 120, 123

thermal insulation 34, 77, 84, 96, 98, 105, 124, 134, 148, 156, 177, 201, 223

The Wilderness 152-3

Threefold 182

Thurley, Simon 196

Till, Jeremy 72, 74, 76, 77, 120

'Tin Tabernacle' 218, 219

Tonkin Liu 46

Tonkin, Mike 46

Tozer, Luke 232

Trail, Angela 164

Traill, Philip 164, 166, 167

Tranter, Jane 28

Traxler, Lisa 88

Trees 36–9

Tuckey, Jonathan 218

Turvill, Lucy 224

Turvill, Richard 224

Tuscan Castle, Italy 180-1

21st-Century Farmhouse 52–3

Two Timber Eco Houses 96–101

Ty-Hedfan 128-9

Tyler, Kathryn 124, 126, 127

Tyrell, Ian 124

U

Understated Hillside House 124–7

Upcycled Bungalow 86-9

V

Van der Bij, Robin 124

van der Rohe, Mies 27, 144

ventilation systems 16, 25, 77, 94, 99, 105, 119, 124, 177, 189, 220, 221, 223

Villa Savoye, Poissy 24, 25

villa, Roman 46, 76-7

Vista 136-7

Vitruvian lines of orientation 76

Vowles, Brian 204

Voysey, C F A 134

W

Washington, George 76

Waterloo Violin Factory 140-3

Watkins, Tom 44-5

Watson House 14-15, 130

Watson, Charles 14, 15

Watson, Fiona 14, 15

Welch House 16–19

Welch, John 16

West, Cleve 67

Westlake, John 92, 93

Westlake, Terri 92, 93

White Box Syndrome 20-3

Wigglesworth, Sarah 72, 74, 76, 77, 120

Wilhelm, Rob 158, 161

Wilkinson King Architects 24

Wiltshire 52–3, 218-19

Windermere 146-9

wood-burners 84, 85, 119

Wooden Box, The 92-3

Woods Bagot 109

Worsley, Giles 74

Wrecks and Their Flotsam 178-215

Wright, David 62

Wright, Mary 62, 65

Y

Yorkshire 162–3, 196-9

Young, Jeremy 128

Z

zeitgeist 120

Ziegel blockwork 156

FULL PROJECTS LIST

01
**DIGESTING
THE
TWENTIETH
CENTURY**

02
**MULTIPLE
PERSONALITY
ORDER**

03
HAIRY HOUSES

04
**THE SMOOTH
AND THE
POLISHED**

05
COSY HOMES

06
SPACE SHIPS

07
**GADGET
BOXES**

08
**WRECKS AND
THEIR FLOTSAM**

09
**DISAPPEARING
ACTS**

10
**PERFORMANCE
ARTISTS**

UK TV		AWARD WINNER	
Bristol Sugar Cube Trees		Watson House 2011 Welch House 2009 Esher Modernist Villa 2006 Courtyard House 2006	Attwood House 2006 Chestnut House 2010
Amersham Water Tower Seafront Sugar Cube London Jewel House Clapham Coach House	Lutyens Water Tower 21st-Century Farmhouse Hunsett Mill	Lymm Water Tower 2006 Oak Farm 2006 Chiswick Garden House 2006	
Hedgehog Housing Cooperative Cruck-Framed Woodland House	The Straw House Hand-Built Hexagon House The Groundhouse Earthship Upcycled Bungalow		
The Wooden Box Two Timber Eco Houses Lime Kiln House Kent Modular House		Sunnybank Passivhaus 2011 Clonakilty Clifftop Farmhouse 2006	
Contemporary Nordic Longhouse Assertive Suburban Home	Architecturally Efficient Powerhouse Understated Hillside House	Ty-Hedfan 2011 Duckett House 2006	Drummer's Cottage 2006 Vista 2006
Waterloo Violin Factory Hill House Dome House		The Wilderness 2008	
Futuristic Bungalow Futuristic Doncaster House	Surrey Threshing Barn Peckham Box of Tricks The Crossway House		
Tuscan Castle The Apprentice Store The Chesterfield Waterworks	Herefordshire Threshing Barn Braintree Barn Hellifield Peel	Basing Farm 2009 11 Princelet Street 2008 Bletchley Manor 2008 Pinions Barn 2006	Kilgallán Converted Chapel 2006
Cotswolds Stealth House		Providence Chapel 2008 Bavent House 2011 Blacksheep House 2008	Lau Sun House 2008 Strange House 2011 Gap house 2008
		Suffolk Sliding House 2008 El Ray 2009 Salt House 2006	House for Everybody 2004 Slice House 2006

PHOTOGRAPHY CREDITS

Page 2 © Edina van der Wyck/Media 10 Images; Page 10 © Jefferson Smith/Media 10 Images; Pages 14–15 © James Morris/VIEW; Page 16 © Morley Von Sternberg; Page 17 © Jonathan Manser; Page 18–19 © Morley Von Sternberg; Pages 20¬–23 © Jefferson Smith/Media 10 Images; Pages 24–25 © Wilkinson King Architects; Pages 26–27 © Tom Scott; Pages 28–33 © Jefferson Smith/Media 10 Images; Pages 34–35 © Michele Panzeri; Pages 36–37 © Ray Main; Page 38 top © Nigel Rigden; Page 38 bottom and page 39 © Ray Main; Pages 40–41 ©ACME; Pages 42–43 © Jefferson Smith/Media 10 Images; Pages 44–45 © Mel Yates/Media 10 Images; Pages 46–47 © Mike Tonkin; Pages 48–49 © Edina van der Wyck/Media 10 Images; Pages 50–51 © Elizabeth Zeschin/Media 10 Images; Pages 52–53 © Dave Young/Media 10 Images; Pages 54–56 © ACME; Page 57 © Cristobal Palma; Page 58–59 © Jeremy Phillips; Pages 61 © Jefferson Smith/Media 10 Images; Pages 62–67 © Mel Yates/Media 10 Images; Pages 68–69 © Rachael Smith/Media 10 Images; Pages 70–71 © Edina van der Wyck/Media 10 Images; Pages 72–77 © Jefferson Smith/Media 10 Images; Pages 78–81 © Ben Law; Pages 82–85 © Chris Tubbs/Media 10 Images; Pages 86–89 © Rachael Smith/Media 10 Images; Pages 90–91 © Niall McLaughlin; Pages 92–93 © Graham Atkins Hughes/Media 10 Images; Pages 94–95 © Chris Humphreys; Pages 96–97 © Mel Yates/Media 10 Images; Page 98 © Jefferson Smith/Media 10 Images; Page 99 © Mel Yates/Media 10 Images; Pages 100–105 © Jefferson Smith/Media 10 Images; and 106–109 © FremantleMedia Australia Pty Ltd. Licensed by FremantleMedia Enterprises. www.fremantlemedia.com. Photos supplied courtesy of XYZnetworks; Page 110 © Nick Kane; Page 111 © Niall McLaughlin; Pages 112–113 © James Morris; Pages 114–119 © Jefferson Smith/Media 10 Images; Pages 120–123 © Jake Curtis/Media 10 Images; Pages 124–129 © Chris Tubbs/Media 10 Images; Pages 130–133 © James Morris/VIEW; Pages 134–135 © Emma Lee/Media 10 Images; Page 136 © Chris Gascoigne/VIEW; Page 137 © top left © John Maclean/VIEW; Page 137 bottom images © Chris Gascoigne/VIEW; Pages 138–139 © Fernando Guerra; Page 140 © Sean Myers/Media 10 Images; Page 141 © Jefferson Smith/Media 10 Images; Pages 143 top and bottom right © Jefferson Smith/Media 10 Images; Page 143 bottom left © Sean Myers/Media 10 Images; Pages 144–145 © Alun Callender/Media 10 Images; Pages 146–151 © Jefferson Smith/Media 10 Images; Pages 152–153 © Fernando Guerra; Pages 156–157 © Mel Yates/Media 10 Images; Pages 154–155 and 158–161 © FremantleMedia Australia Pty Ltd. Licensed by FremantleMedia Enterprises. www.fremantlemedia.com. Photos supplied courtesy of XYZnetworks; Pages 162–163 © Nigel Rigden; Pages 164–165 © Paul Massey/Media 10 Images; Page 166 © Elizabeth Zeschin/Media 10 Images; Page 167 © Paul Massey/Media 10 Images; Pages 168–169 © Edina van der Wyck/Media 10 Images; Pages 170–172 © Jefferson Smith/Media 10 Images; Page 173 © Edina van der Wyck/Media 10 Images; Pages 174–177 © Jefferson Smith/Media 10 Images; Pages 178–179 © Thomas Stewart/Media 10 Images; Pages 180–181 © Chris Tubbs/Media 10 Images; Pages 182–185 © Thomas Stewart/Media 10 Images; Pages 186–189 © Jefferson Smith/Media 10 Images; Pages 190–195 © Rachael Smith/Media 10 Images; Page 196 © Francis Shaw/Media 10 Images; Pages 197–199 © Jefferson Smith/Media 10 Images; Pages 200–201 © David Grandorge; Pages 202–203 © Kristen Perers/Media 10 Images; Pages 204–205 © Tim Imrie Photography (timimrie.co.uk); Pages 206–209 © Chris Gascoigne/VIEW; Pages 210–213 © FremantleMedia Australia Pty Ltd. Licensed by FremantleMedia Enterprises. www.fremantlemedia.com. Photos supplied courtesy of XYZnetworks; Pages 214–215 © Mark Luscombe-Whyte/Media 10 Images; Pages 216–217 © James Brittain/VIEW; Pages 218–219 © Dirk Lindner; Pages 220–223 © Chris Tubbs/Media 10 Images; Pages 224–227 © James Brittain/VIEW; Pages 228–229 © Chris Tubbs/Media 10 Images; Pages 230–231 © Jefferson Smith/Media 10 Images; Pages 232–233 Sean Myers/Media 10 Images; Pages 234–241 © FremantleMedia Australia Pty Ltd. Licensed by FremantleMedia Enterprises. www.fremantlemedia.com. Photos supplied courtesy of XYZnetworks; Pages 242–243 © Hugh Strange; Pages 244–245 © Chris Gascoigne/VIEW; Pages 246–251 © Alex de Rijke (dRMM) and Ross Russell; Page 252–253 © Chris Gascoigne/VIEW; Page 254 bottom left © Alison Brooks Architects Ltd; Page 254 bottom right and page 255 © Cristobal Palma; Pages 256–257 Kohki Hiranuma/KHAA; Pages 258–261 © Fernando Rhil/Proctor-Rihl; Page 271 © John Maclean/VIEW

The publisher would like express their thanks to all the owners and architects who supplied images for the book and to Kerry Garwood at Media 10 and Fiona Caldwell at Boundless.

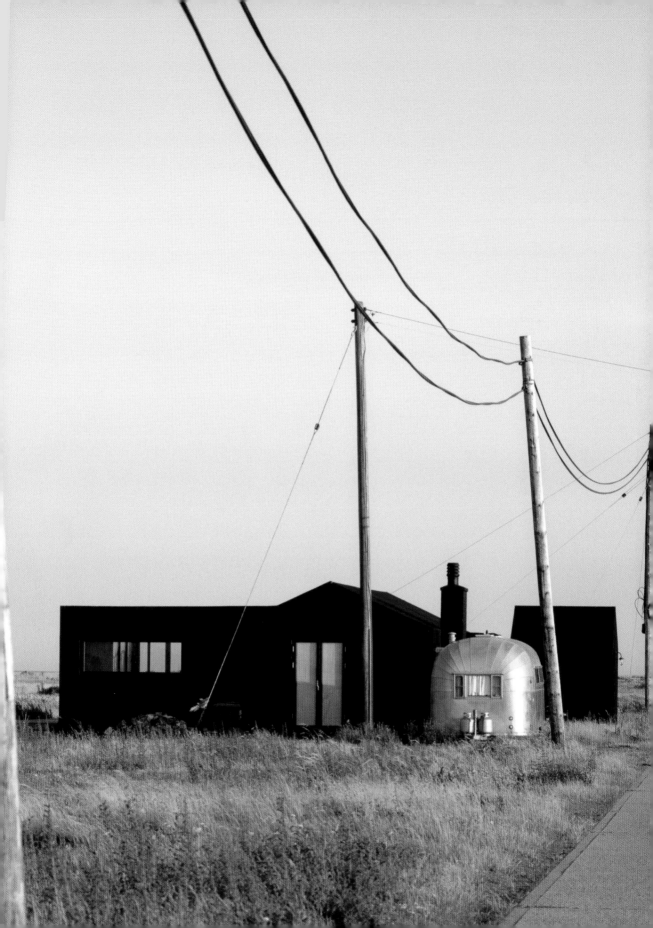

Thanks to Hannah and everyone at HarperCollins; to all the directors, producers, editors, cameramen and sound technicians and assistants of Grand Designs who over the years have crafted the series and made me sound intelligent; to the hard-working team at the magazine and everyone at Media 10; to the commissioning editors at Channel 4 who have championed this series; to its inceptors, Daisy Goodwin and John Silver; to the contributing builders who pluckily proffered their projects; to the architects who agreed to be filmed and who designed such magnificent buildings. And to my Hab co-director, critic and co-author, Isabel Allen. Thank you.